Glasgow

— A HISTORY —

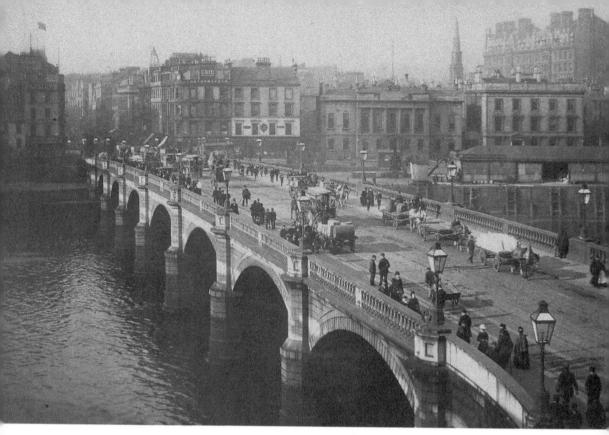

Jamaica Bridge, 1880s.
Thomas Annan's photograph of Glasgow Bridge. While it is now called Jamaica Bridge because
it is at the foot of Jamaica Street, it was sometimes called Glasgow Bridge, Broomielaw Bridge
or Telford's Bridge, having been designed by Thomas Telford. The building in the top right is
the St Enoch's Hotel and Station, opened in 1876.

Glasgow

— A HISTORY —

Michael Meighan

AMBERLEY

For Mum and Dad Christie

First published 2013, this edition 2015

Amberley Publishing
The Hill, Stroud
Gloucestershire, GL5 4EP

www.amberley-books.com

British Library Cataloguing in Publication Data.
A catalogue record for this book is available from the British Library.

ISBN 978 1 4456 4719 7
E-book ISBN 978 1 4456 1865 4

Typeset in 10pt on 12pt Sabon.
Typesetting and Origination by Amberley Publishing.
Printed in the UK.

Contents

Acknowledgements

In writing this book I have received enormous support from a number of people, many of whom I have bounced ideas off. In particular I would like to thank the following for their support and advice: Jill Meighan, Martin Meighan, Catriona Meighan, Winnie Meighan, Chris Meighan, Stephen Meighan, Henry Mennie, Pat Whitley, Paul McBeth and Alan and Wendy Price.

Image Credits

Fiona Frank for Hannah Frank's 'Moon Ballet'.

International Federation of Football History and Statistics for the photo of Robert Smyth McColl.

James Reid & Co., Lime Merchants – Howie Minerals Ltd. Part of the Leith's Group of Companies.

Jessie Bremner and Matthew Lloyd at www.arthurlloyd.com for the image of Jimmy Logan's Metropole Theatre.

Scottish Television for the photographs of the *One O'Clock Gang* stars.

Dag Nilsen – Hielenman's Umbrella.

Stewart Macartney and Blyth & Blyth – Glasgow Central Station bridges.

Mr George Bergius – Image of the Kelvin at Glasgow International Exhibition 1901.

Imperial Tobacco Company – Image of Three Nuns and Wills Tobacco Factory.

R. M. Casserley – Glasgow Central Station low level.

Janette and Campbell McCutcheon for various images from their extensive collection.

Glasgow's Miles Better: This was the highly successful marketing slogan introduced by Lord Provost Michael Kelly in 1983 to counter Glasgow's dark and depressing image of the time. Edinburgh had an informal motto: 'Edinburgh's Quietly Superior'.

Introduction

Having lived in different parts of Great Britain over the years, we have made friends wherever we lived. Over the past couple of years we have become accustomed to arrange a 'Glasgow Weekend' to introduce them to the city. Some have not set foot in Glasgow, or possibly just passed through, without taking in the sights and the sounds of the city.

Without exception, they have been surprised, even astonished, at the sculpture, art and culture of Glasgow. We have taken them from the gothic Glasgow Cathedral and the Necropolis to the splendour of Kelvingrove Park and the Art Gallery and Museum. We have shown them the wonderful Burrell Collection and the new Clydeside Museum. We have taken them to the Glasgow School of Art and the People's Palace.

We ate in Italian and Indian restaurants and in the Winter Gardens at the People's Palace, where they were impressed by the restored Doulton Fountain. Mackintosh's Willow Tea Rooms also featured. We took them to Coia's in Dennistoun for fish and chips. They loved it. We also simply spent time in the Merchant City or Byres Road, taking in the sights and sounds of this great city.

For it is a great city. Like our friends, we find that many people outside haven't realised it. Yet word gets around. The city has become a destination for many young people, for study at all levels, for the music, for work, and simply because it is a buzzing, thriving place to be. Glaswegians are open, friendly and communicative. For visitors and new citizens, this makes a difference, for Glaswegians are welcoming.

In 1935, the novel *No Mean City* was published. It painted a picture of a dark and violent city of razor gangs, of slum dwellers. True or false, it became the accepted description of Glasgow. Thereafter, the media would focus on this book when they needed quick words to describe Glasgow. Yet it described a small part of Glasgow over a small period of time.

There is absolutely no doubt that there was sub-standard housing in Glasgow. However, the impression that some people might get is that the city is all slum and dangerous to visit. In the totality of what is Glasgow, the buildings, suburbs and 'villages' of Glasgow can equal many and surpass many of those in Europe.

When you take into account the quality of life provided through sport, art and music then what you have is a strong city, redefining itself after years of self-doubt. Yes, there are many rough edges. Some Glaswegians still drink more than they should.

Our general health is poor and there is a view that there is too much violence. There is a lot which needs attention.

This book catalogues some of our past greatness, our position as Second City of the Empire, of shipbuilder and locomotive builder to the world. I mention the medical and educational advances that have come from Glasgow. But I also describe some of the downsides: how the sub-standard housing came about, the growth of violence and bigotry and how we have been trying to deal with our failings.

We are aware of these things and with a positive vision we can overcome our faults. No-one can doubt the success of Glasgow's 2014 Commonwealth Games, which has done as much for the spirit of Glasgow as the great Garden Festival of 1988 and is spurring us on to much greater things.

Michael Meighan
November 2013

The Growth of Glasgow

Glasgow in Prehistory

In the ice ages, great frozen blankets covered the northern hemisphere, including what we now know as Scotland. The ice had moved south, carrying with it great boulders to scour the landscape, moving mountains and reshaping seas. It came and it went through hundreds of thousands of years and finally retreated from Scotland around 15,000 BC, a meaningless figure in the totality of geological history.

The going of the ice itself created changes in the landscape, depositing previously captured rocks, enlarging waters, creating islands and leaving what we know as drumlins, which were to be Glasgow's hills.

The climate began to get a bit warmer. Plants took root and soon small animals populated the land. Eventually, around 7,000 BC, there was enough to encourage the hunter gatherers to move north in search of those animals and plants.

In time, the hunter gatherers with their stone tools settled in rough timber buildings covered with branches, hide and bracken. Some of these were crannogs, huts built on wooden piles or islands on lochs or rivers. Around 4,500 BC they began to cultivate what they could and what would survive. They fashioned tools from stone, bone and antler. They cleared forest with their tools and with fire. They cooked deer, fish and shellfish on hot stones. They ate wild berries and roots; then they began to cultivate wheat, barley and rye. They decorated themselves with dyes from plants and fish and fashioned beads from shells.

They came together in settlements to share the work and for security and the settlements grew. They grew around crossroads or river crossings or at the centre of fertile areas. In Scotland, along what was to become known as the Clyde, settlements grew at Dumbarton, Renfrew, Rutherglen, Lanark, and at Cathures, which was to eventually become known as Glasgow.

The Romans in Scotland

But before that were the Romans, whose brief stop just above Glasgow was marked by the Antonine Wall. In AD 43 the Romans invaded Britain and gradually made their

way north, pacifying the tribes. By AD 79 the governor, Agricola, was ready to have a look at Scotland, first sending ships round to discover that it was actually an island. He invaded and had conquered the south by AD 83 but met huge armed resistance from the tribes of Caledonia.

Agricola was rather put out by all of this and sent his troops north to confront the Caledonians. The Cals however were apt to avoid confrontation. This only proved workable until the Romans approached the grain stores where the winter's foodstuffs were stored. This meant fight or die so the Caledonians fought. They mustered 30,000 warriors to meet the Romans at Mons Graupius, of uncertain location, but possibly near Stonehaven. This was a huge encounter. The Roman army was half as big again. The warriors held the higher ground but they did not have the discipline the Roman legions were well known for.

They followed their leader, a chap called Calgacus ('Possessing a blade' – it has a familiar ring to it). In fearful hand-to-hand combat the Caledonians were getting the upper hand, almost outflanking the Romans. The Romans overcame this tactic by hiding their cavalry, who then bore down on the warriors, who broke and fled. The death toll was awful, as were the reprisals. While they fought ferociously till the end it is claimed that 10,000 Caledonians were killed and the rest fled, being pursued by the Romans.

To the Caledonians, it must have seemed like half-time because the pursuit stopped just as winter was approaching. For possibly political reasons, in AD 85 Emperor Domitian recalled Agricola to Rome where he went into retirement and died in AD 93.

In AD 122 Emperor Hadrian built his wall from the Solway to the Tyne, marking the frontier of the Roman Empire. His successor Antoninus Pius extended the frontier further north and built the Antonine Wall from the Forth to the Clyde. The use of the wall as a barrier lasted only about twenty years and it was abandoned in AD 144. Antoninus was unable to conquer the Caledonian tribes and when he was succeeded by Marcus Aurelius, the wall was abandoned and Hadrian's Wall again became the northern frontier.

We are left with very little of the Antonine Wall. Along the 37-mile wall there would have been a manned fort every couple of miles. There was one of these in Bearsden, which was uncovered in 1973. The best example of a bathhouse found in Scotland was uncovered here and is looked after by Historic Scotland. There is very little evidence of the Romans in Glasgow although it is thought that they may have had a fort overlooking the Clyde at what is now Yorkhill.

By the late fourth century, Rome was losing its grip. Political strife, military coups, invasions and decline were bringing about its fall. By AD 383 they were gone from the North and by 410 they had exited Britain, leaving the way open for new kingdoms and new conflicts in tribal Scotland.

Tribal Kingdoms of Scotland

We can look at recent conflicts throughout the world to see how tribes and their warlords can cause human misery and suffering as they establish control of their wee bit territories. This often happens when great powers leave occupied countries to their

own devices. This was true when the British left India and many African states, and when the Russian Federation disintegrated.

This was just the same in Scotland after the Romans left. The most important tribes in Scotland eventually emerged as the Scots of Dal Riata in the north-west, the Angles in Bernicia in the south-east, the Picts in the north-east and the Britons of Strathclyde in the south-west. It is these Britons in whom we are most interested.

The kingdom of the Britons was ruled from Dumbarton Rock (or Alt Clut) until about AD 870, when the rock was captured by a Viking army from Dublin after a four-month siege. The surrounding lands were ravaged by these Norsemen.

The seat of the kingdom then moved to Govan, from where the Britons established a new kingdom – Strathclyde. In fact it is only chance that Glasgow was to develop faster than Govan and swallow up the latter. It may well have been the other way around! In the Middle Ages, Strathclyde was captured by the Kingdom of Alba, eventually becoming part of the Kingdom of Scotland.

It was in the years leading up to the creation of the Kingdom of Alba that the story of Christian Glasgow starts. Or rather, it actually started in East Lothian, and Culross in Fife.

St Kentigern, St Enoch and the Beginnings of the City

Kentigern was born and brought up in Culross in Fife. East Lothian was the birthplace of his mother, in the sixth century. His mother was Thenew, a princess from the family of King Lot, who ruled in the Haddington area and after whom Lothian is named.

Kentigern was born soon after the time the Roman Legions had suddenly been recalled. Where dictatorship had previously existed, Lot's kingdom was one of those emerging from the shake-out.

Thenew was a Christian saint who was raped by her cousin, Welsh prince Owain mab Urien, who dressed like a woman in order to get close to her. Pregnant and unmarried, her father Lot was furious and threw her off his hill fort on Traprain Law in East Lothian, now near the town of East Linton. Thenew survived the fall, but now thought of as a witch, she was put into a coracle and set adrift in the Firth of Forth. She drifted over the Forth and landed at Culross in Fife where she was given refuge by a priest, and where her son Kentigern was born. He is said to have been brought up in a monastery established there by St Serf.

At age twenty-five Kentigern, known popularly as Mungo ('Dear One'), began his Christian ministry in Glasgow, then called Cathures, its earliest known name. At that time, the King of Strathclyde was a Christian, Roderick Hael. King Roderick welcomed Kentigern. Becoming a bishop around 540, Mungo established his seat in Glasgow. For thirteen years he carried on his mission while living a simple life. Glasgow began where a tributary, the Molendinar, met the Clyde. It was the lowest fording point on the river. While this assisted its growth, much of its later growth is put down to the fact that it was Scotland's second-largest bishopric and recognised as such by King David I of Scotland.

Around Mungo the town thrived and grew, becoming known as Glasgu, 'the dear green place'. However, around 550 there was an anti-Christian movement in the Kingdom of Strathclyde. This forced Mungo to travel to Wales, where he stayed for some time with St David and founded a monastery at modern-day St Asaph. In 581 he returned to Glasgow, where he re-established his see. On his death he was buried where Glasgow Cathedral, dedicated to him, now stands. A very important fact left to us is that he died in his bath on 13 January 603. His remains are said to be within the crypt.

St Mungo is the patron saint of Glasgow but his mother is also recognised in Glasgow, for another version of her name is Enoch. She was venerated in medieval Glasgow and the present-day St Enoch's Square marks the site of her grave. While they go down the subway escalator or into the St Enoch's Centre, Glaswegians may not know that this was once holy ground and that a series of churches once stood there, the last one, built in 1827, being demolished in 1926. It stood on the square, separated by a lane and directly behind the gothic subway station, which has been moved in recent years towards the centre of the square.

In 1924, the Corporation of Glasgow decided that the existing church would have to go to improve traffic flow in the area. At the same time the new housing at Riddrie was increasing the population, with around 3,000 people moving in.

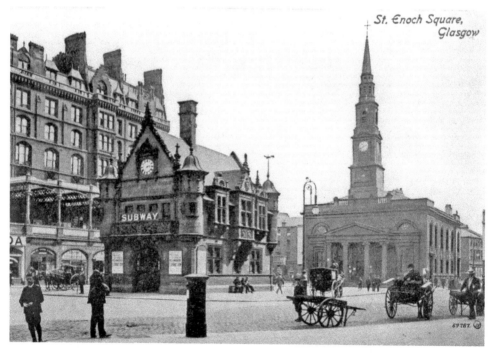

St Enoch's church, St Enoch's Square, Glasgow. Another St Enoch's church once stood at the 'gushet' of Argyll Street and Sauchiehall Street.

It was decided by the Presbytery of Glasgow to combine the existing church at Hogganfield with the congregation from St Enoch. The congregation still exists, having combined with the existing parish in 1924 with the new church of St Enoch Hogganfield opening in 1930.

Some of the old church still exists at Hogganfield. Because of problems with the ground, some of the stone from St Enoch was used as foundation. In demolishing the old church, a previous foundation stone laid in 1720 was found and sits in the transept of the church, which celebrated its centenary in 1984.

St Enoch is commemorated on 18 July and while St Mungo has taken precedence, most Glaswegians would be surprised to learn that she was previously regarded as a co-patron of the city.

The Legends of St Mungo

When I was at school, every schoolboy knew the explanation behind the different emblems on the Glasgow coat of arms, all of them related to the life of St Mungo.

The arms include 'the tree that never grew'. The legend says that St Mungo was tending a fire in St Serf's monastery but he fell asleep. Some lads who were envious of Mungo's favoured position with St Serf put out the fire while he was asleep. However, Mungo broke off branches from a frozen hazel tree and by praying over them, made them burst into flame, relighting the fire. Over time the hazel branches were transformed into a fully grown tree.

The 'bird that never flew' remembers a robin which had been tamed by St Serf and which was accidentally killed. Mungo took the poor wee birdie, prayed over it and brought it back to life.

The 'fish which never swam' is all about the present of a ring which the King of Strathclyde, Roderick Hael, gave to his wife Langeoreth. The shameless hussy gave it to a knight, her lover. The king took the ring while the knight was asleep and threw it into the River Clyde. He then demanded of his queen to see the ring, threatening to put to death the knight who had lost it. Langeoreth confessed this to St Mungo, who dispatched a monk to catch a fish in the river. The fish was cut open and there was the ring inside. It is said that they lived happily ever after. It doesn't have the ring of truth about it. The Bishop of Glasgow used the image in his own seal around 1271 and the story was carried down through the years.

The bell may be one which was reputedly given to Mungo by the Pope and thereafter became an institution. This was strengthened by John Stewart, the first Lord Provost of Glasgow, who in 1450 left an endowment so that a St Mungo bell would be made and rung throughout the city so that the citizens could pray for the soul of the saint. A subsequent bell cast in 1641 is in the People's Palace. In 1631 another bell was made for the Tron Church. On the bell were the words 'Lord, let Glasgow Flourish by the preaching of thy word and the praising of thy name', which were said to have been in a sermon preached by St Mungo. This was adopted by the city but shortened for the Glasgow coat of arms to 'Let Glasgow Flourish'.

Yes, the stories are probably myths, but in those days the myths may have been reality to those who heard them. The fact that there are various versions is accounted for by the oral nature of these legends, handed down through the ages. The same is true of the wide variation in the names of the cast of characters. The myths may be no more than allegory used to illustrate a point. These, like the Good Samaritan, were used extensively to tell a story. Rather than give the variations I have adopted the latest or most used variants.

When I say that the myth is probably true, the reservations are because the story of St Mungo was perpetuated by one person who was already a promoter of saintliness.

Archbishop Jocelin was promoted from his post of abbot at Melrose Abbey, where he had been instrumental in promoting Waltheof, a previous abbot, as a saint. When he arrived in Glasgow as archbishop in 1174 he again took up the role of promoter of saints. Until that time, the story of Kentigern/Mungo had only existed in one obscure document, and in folklore.

Jocelin commissioned the life story of Kentigern, from which emerged the myths which surround the Glasgow coat of arms. However the author, Jocelyn of Furness, a monk, does freely admit that he has omitted what he considers 'ungodly things or things contrary to faith' and has otherwise embellished the stories.

The myths which we are used to in modern times about St Mungo have generally been confined to a few fairly innocent tales which could have different interpretations. It is not surprising that others have been airbrushed out of popular history. One concerns St Mungo bringing back to life a cook who had been dead for at least a day and was already buried. Apparently St Mungo was pressured to do this because he was such a good cook. The food must have otherwise been terrible if they wanted him back. Anyway, Mungo prayed over the grave and the cook rose through the earth! He apparently lived on for another seven years, at which time he was buried in a fine sarcophagus with the story of his earlier rising carved upon it. I wonder where that is buried? I can understand why the cook wasn't included in the crest.

Another story is even more cheesy and relates to jugs of milk sent by Mungo to a builder that he was employing. However, as they were being carried across the Clyde by a porter, they spilled. Rather than mix with the river water, the milk suddenly turned into blocks of cheese. Apparently this cheese was wondered at, cut into little pieces and eaten. Some of it was apparently kept as relics.

What is probably true is that both Enoch and Mungo existed to some degree and they have been celebrated through the ages. Glasgow has been very poor at celebrating the role of women and while the square and two churches may have been named after Enoch, St Mungo has been more celebrated. Besides appearing prominently in many publications, St Mungo's Catholic church in Townhead is named after him, as well as St Mungo's Academy in the East End. There is also the St Mungo Museum of Religious Life and Art beside the cathedral. In recent years a St Mungo's Festival has been started to celebrate the life of St Mungo and the history and culture of the city. The festival is held round the feast of St Mungo on 13 January.

Glasgow and the Wars of Independence

In 1286 Alexander III of Scotland died, leaving his granddaughter as his heir to the Scottish throne. Three-year-old Margaret, 'The Maid of Norway', was betrothed in a marriage treaty to Edward of Caernarvon, the son of Edward I. The treaty declared, however, that Scotland was still a separate nation and that the marriage would have no effect on this. However, wee Margaret died in Orkney on her journey from Norway to her new kingdom. With her death, there were thirteen rivals for the throne and all hell broke loose.

Edward I agreed to arbitrate but also declared that he should be recognised as Lord Paramount of Scotland. The claimants to the throne, many of whom already had estates in England, agreed to his terms, particularly as he had brought a rather large army with him. The resultant arbitration established King John Balliol in 1292. However, when Edward insisted that the Scots provide troops for an invasion of France, the response to this was to defy Edward's orders and create a truce with France, who would come to Scotland's help if Edward invaded. This was the origins of the 'Auld Alliance' which would come in useful in the future as well as causing difficulties in forthcoming religious issues.

This was the beginning of the two Scottish Wars of Independence which lasted in total from 1296 to 1357. The first was that which featured 'Braveheart' William Wallace, who led attacks into England and was himself defeated at the Battle of Falkirk in 1298. Wallace escaped and there are various myths about his capture. The one that involves Glasgow is that he was captured in 1305 at the spot in Robroyston which is called the Wallace Well. He was hanged, drawn and quartered by Edward I.

Scotland was back in English hands and things were quiet for a period until the second war. This is the period in which Robert the Bruce came to the fore, giving himself the Crown and beginning a campaign to free Scotland. The 1314 Battle of Bannockburn was a decisive battle and the campaign was to eventually lead to a separate Scottish kingdom with Bruce as king. This was initially a military kingdom and it was the time of the Declaration of Arbroath, telling the Pope that Scotland was an independent kingdom and asking for Papal recognition, which wasn't forthcoming.

It was eventually recognised as such by Edward III after Bruce threatened to annexe much of the north of England after an invasion. Edward III had succeeded to the throne after the murder of his father and England was in turbulent times. Bruce had chosen the right moment and the new king conceded the Scottish crown. The Kingdom of Scotland would last until the Union of the Crowns in 1603 with the accession of James VI, King of Scots, to the thrones of England and Ireland.

Glasgow and World Trade

We have to remember that during all of this time Glasgow was still a small town, so during one of his advances, in 1335, Edward III's army of 13,000 would have swamped Glasgow when it camped there before moving on to Perth.

Glasgow grew in importance, mainly because it had been recognised as a bishopric and it became a place of worship and of pilgrimage to the tombs of Saint Mungo and of Saint Enoch. It was one of a number of settlements along the Clyde but being the lowest possible fording place, it would naturally attract settlers.

At the time of the Roman occupation, Scotland had nothing that could be called a town. This was true until the twelfth century, when chartered towns, or burghs, were created. Glasgow was made a burgh by King William the Lion in 1175. Archbishop Jocelin was instrumental in this, and also in establishing a local market and annual fair in the town with protection for the traders. The trade continued with the development of specific markets trading in flesh, milk, fruit, vegetables, salt and fish. This fair was to become the Glasgow holiday, 'Fair Fortnight'.

Crafts developed to service ecclesiastical and trade customers as well as travellers and pilgrims visiting the cathedral and tombs of Mungo and Enoch. These included tanners, fullers, weavers and fleshers. There is very little evidence of dramatic growth of the town or in trade over the centuries. In fact, other towns in Scotland like medieval Roxburgh, Stirling and Perth were all larger trading towns.

With the Union of the Crowns in 1603 James VI, King of Scotland and only son of Mary, Queen of Scots, acceded to both the thrones of England and Scotland following the death of Elizabeth I. From that point on there was some improvement in trade in linen, cloths and hardware. While modern-day traders may complain about the 'red tape' around a business, this is nothing new. The operation of any business was regulated by burghs and by the Crown, which levied customs on goods both entering and leaving the country.

While trade from England to Europe and the rest of the world had been growing over the centuries as ships and trading routes improved, Scotland had largely been excluded from this. By the late 1600s the country was in a parlous state. It had no export trade to speak of and had no power to compete with its neighbour England, to whom, since 1603, it had been joined through the Union of the Crowns by a common monarch rather than any economic union. In fact, English legislation which protected English trade prevented Scottish traders competing in English markets and in their colonies in North America and the West Indies.

This was all to change and a disastrous event was to lead indirectly to Glasgow eventually becoming 'The Second City of the Empire'. This event was the Darien Scheme, which bankrupted the country and led to the Acts of Union in 1707.

The Darien Scheme

The origins of 'The Company of Scotland trading to Africa and the Indies' lie in Scotland's political and economic discontent over many preceding decades. Since 1603 Scotland and England had shared a monarch, but both countries had kept their own parliaments. From 1685 the ruler was King James VII of Scotland and II of England. James was unpopular in Scotland. He was a Catholic in a Calvinist country and also autocratic. The term Jacobite is usually connected to Prince Charles Stuart, the 'Young Pretender'. In reality, the term is derived from the Latin for James.

The 'Glorious Revolution' in 1688 brought an end to James' reign, when he was replaced on both thrones by the Protestant William of Orange, his Dutch son-in-law. There had been a gathering opposition to James' Catholicism, religious tolerance and ties with France. The birth of his son, James Francis Edward Stuart, dangerously promised a Roman Catholic monarchy. Tories and Whigs united to invite the Protestant William to invade. William was the husband of James' first child Mary, an Anglican. After a successful invasion William and Mary went on to run the country jointly. James and his Jacobite followers fled to France.

From 1688, a succession of Jacobite rebellions was a thorn in William's side. The first, the Battle of Killiekrankie in 1689, was a much-feted success for the Jacobites but with the strength of the British army against them it was a short-term victory.

This rising persuaded William to strengthen his garrisons in the Highlands to control the clan chiefs. He built a fort which was to become Fort William, and from here and other fortresses he was to reach out and punish the Jacobite MacDonalds at the Massacre of Glencoe in 1692. The Jacobites were eventually despatched at the Battle of Culloden in 1745, when James' grandson Bonnie Prince Charlie was routed and once again fled.

You can't separate the history of Scotland from the history of Glasgow, particularly because of William's crushing of one of the Jacobite uprisings. With French troops, James was back and landed in Ireland in 1689. With the support of many senior Irish figures he raised an army. This was intended to wrest back for Catholics their lost lands, their country, and their right to sit in Parliament as well as to defend their faith. These were all lost to Oliver Cromwell in 1649. For Protestants it was about maintaining Ireland as a Protestant country under English rule. James was soundly defeated at the Battle of the Boyne on 1 July 1690 and again fled back to France.

While this battle in Ireland was over 300 years ago, there are many in Northern Ireland and the west of Scotland, particularly in the Orange Order, who still celebrate it and in doing so it has become the source of conflict between Catholic and non-Catholic over many years and the resultant violence has been a blight on the life of Glasgow. We will look at this in a later chapter.

While all of this political and religious turmoil was going on there was also a growing resentment about the state of Scottish trade and the economy. Following the Union of the Crowns, Scotland saw itself become increasingly poorer and increasingly detached from its king in London. It had also been enmeshed in England's wars, which had been affecting what trade it had with the world. The Anglo-French wars between 1627 and 1629 led to Scotland's infant colony in Nova Scotia being lost. The Anglo-Dutch Wars also interrupted the vibrant trade and contacts between Scotland's east coast and the Netherlands.

The English Navigation Acts further eroded the ability of Scotland to trade. Enacted from 1651, these were designed to protect trade between England and its growing empire. Basically they meant that only English ships would be allowed to trade with English colonies. They also banned non-English ships from carrying goods from outside Europe to England or English colonies. In addition to this, the English-based

East India Company and the Royal African Company had effective monopolies on those continents. These and other aspects detrimental to anything other than English interests created resentment, and in some a determination to overcome the barriers.

In response to this, a number of remedies were enacted by the entirely separate Parliament of Scotland. In 1695 the Bank of Scotland was established specifically to support Scottish business. Shortly afterwards, a new 'Company of Scotland Trading to Africa and the Indies' was set up. There were those who would have liked to compete with the East India Company, which had an effective monopoly. However, the scheme adopted was one put forward by William Paterson, who was a co-founder of the Bank of England and a recent director. The project set up was to trade to India, the Americas and Africa and it became known as the Darien Scheme.

The company launched its first expedition to Darien on the Isthmus of Panama. Paterson had heard of it or read about it in an account of a former Welsh privateer and surgeon, Lionel Wafer. The idea was to establish a colony there which could be developed as a foothold on that continent and also be a stepping stone to the Far East.

We in Scotland should not be surprised to learn about the number of our citizens who poured money into this ridiculous scheme, which was to fail miserably but only after good money had been poured in after bad. In fact, a quarter of Scotland's capital went into the Darien Scheme.

In July 1698, five ships set out carrying 1,200 ambitious and excited Scottish colonists and arrived in Darien. The project was badly planned and not enough initial provisions had been brought. Not only that, but the Spanish claimed the area and did not take kindly to this invasion of their territories. The settlers began to fall ill in the stifling, swampy atmosphere. The settlement was abandoned but not before a new and larger expedition had set out from Scotland. They took over the abandoned settlement but were besieged by the Spanish forces and eventually succumbed to hunger and disease. The Spanish allowed them to leave and in April 1700, two ships carried the survivors home. More than 1,000 had succumbed and not surprisingly those that returned arrived with tales of bitterness, including how the sailors and high heid yins had made themselves at home on board ship, leaving the rest to struggle in the swamps.

The Treaty of Union

While the political and economic union of Scotland with England had been discussed and tried, it was probably the Darien Scheme which finally brought about the name 'Great Britain'. Scotland was bankrupt and there were those who thought that on its own, Scotland could not possibly compete with England.

Without any thought of a referendum, a Treaty of Union was debated, approved and the Union enacted in May 1707. On that date both parliaments combined to form the Parliament of Great Britain, based in the Palace of Westminster in London, the home of the English Parliament. To many people it looked like a takeover.

The idea of a united kingdom was very unpopular with the Scottish people, to the extent that riots took place in some Scottish cities, including Glasgow. The Act was carried, although with great suspicions that the passing of money was involved to smooth the way and to compensate senior Scottish figures for their losses in the Darien Scheme. Surely not. This suspicion led Burns to write 'Such a Parcel of Rogues in a Nation', from which this is an extract:

O would, ere I had seen the day
That Treason thus could sell us,
My auld grey head had lien in clay,
Wi' Bruce and loyal Wallace!
But pith and power, till my last hour,
I'll mak this declaration;
We're bought and sold for English gold –
Such a parcel of rogues in a nation!

I don't want to give the impression that Glasgow had no foreign trade at all prior to 1707 because it had, although much of it was in contravention of the rules that said only English ports should deal with English colonies. In fact, Scottish merchants had been importing, that is smuggling, sugar from Barbados from the early 1600s and the first cargo of tobacco was to arrive from Virginia in 1674, thirty years before the Union.

The Union was a double-edged claymore. The opening up of trade adversely affected some manufacturers in Scotland but it opened up the way for the development of the linen industry. Linen had already been important, employing 12,000 people around 1680. The use of linen was promoted by government, particularly in the 1686 Act of Parliament which stated that all Scots should be buried in linen winding sheets that had been manufactured in Scotland from Scottish raw materials. It was assisted further by a 1748 embargo on the import or wearing of French cambrics. Further beneficial tax measures and bounties also promoted the industry. By 1850 there were around 32,000 workers.

Glasgow merchants were also involved in the trade across the North Sea to Scandinavia, the Baltic ports and with the Low Countries, the Netherlands, northern France and Belgium. Obviously, the distance to the market was the problem. While some ships may have weathered the route round the Pentland Firth in the north, traders from Glasgow also made use of Linlithgow's port, Bo'ness on the Forth, moving their goods overland. This was to change in 1790 with the opening of the Forth and Clyde Canal, which we will look at later.

No Plain Sailing – Corruption at the Heart of Business

You can't have world trade if you don't have the credit to keep companies afloat when their goods are on the high sea, sometimes for months at a time, and often the goods and ships would be lost. Tempests, war and piracy all took their toll.

In recent years, Britain and the world has been rocked by a series of banking scandals which have had a huge impact on individuals, countries and governments. Well, I can quite honestly say that history was simply repeating itself, as it seems to do regularly in business affairs.

In Edinburgh, the Royal Bank of Scotland was established in 1727, followed by the British Linen Bank in the mid-1770s. During the growth of the sugar, rum, slave and tobacco trades, Glasgow had no bank, which clearly limited trade. There had been short-lived banks but the situation was resolved with the opening, in 1749, of the Ship Bank on the Saltmarket. The principals were Dunlop, Houston & Company but the ship in full sail on its banknotes gave the bank its name.

Other Glasgow banks and trading companies collapsed with the American War of Independence, which lasted from 1775 to 1783. However, the Ship Bank survived and grew, eventually to become the Glasgow & Ship Bank, and then to be acquired by the Union Bank of Scotland in 1843. The Union Bank had a relatively long life and became part of the Bank of Scotland in 1955.

This was one of the success stories but in contrast to this is the story of the City of Glasgow Bank, which was founded in 1839 to serve small investors. The main office was opened in Virginia Street in 1842, with a move to Glassford Street in 1851. In 1878, not long after an announcement that there were now 133 branches with deposits of £8 million, the bank suddenly closed.

It was discovered after closure that the bank had liabilities of over £6 million but also a large portfolio of poorly secured loans and investments. Many of the investments turned out to be in companies in which the bank directors had an interest. It emerged that they were falsifying reports of gold holdings as well as the profit and loss statements. The directors were arrested and found guilty at the Edinburgh High Court in 1879. They all served terms of imprisonment.

The failure is seen as one of the city's greatest financial disasters. It caused the collapse of hundreds of firms as well as huge losses to the 1,200 shareholders. But just as more recent financial scandals, it had other far-reaching consequences.

The 1886 City of Glasgow Improvement Act gave Glasgow Town Council powers to set up a City Improvement Trust. This was to purchase slum property and demolish it and to widen and re-align narrow city centre streets. The Act was also responsible for a new Cleansing Department. The areas targeted for slum clearance were mainly around Glasgow Cross. The idea was to demolish the slums of the time, widen roads and then encourage private builders to build on the cleared areas.

However, restrictions were imposed, such as limiting the buildings to four storeys. There was to be only one single apartment in each level, the remainder to be two or three apartments. However, building on the cleared land was very slow, attributed partly to the collapse of the City of Glasgow Bank, as well as a recession at the time. At one time the Improvement Trust had to cease demolishing properties and found itself to be Glasgow's biggest slum landlord. Building did eventually re-start, and by the 1890s the Trust had built thirty-four tenements containing 1,200 homes. For example, Howard Street was built with sixteen single-room houses and thirty-two two-room apartments. By 1913, the Corporation, which

had taken over responsibility for housing from the Trust, had built 2,199 tenement houses in the city.

When we later look at housing issues, we can see that the authorities and philanthropists were actually doing all they could to relieve the plight of those living in the overcrowded buildings. It is the case that over the history of Glasgow, when it has received bad press for the 'slums', the city itself was in fact ashamed of the conditions and was doing its best to deal with them. Unfortunately, corruption and incompetence got in the way of good intentions and was to do so again, as we have found out to our cost.

The Clyde

One of the other barriers to trade in Glasgow was the state of the River Clyde. It was too shallow and not navigable for large ships as far up as the city. Larger ships berthed at the village of Newark and their cargos were transferred to smaller craft to be taken up-river. The increasing trade demanded expansion so in 1667 Glasgow Town Council purchased land at Newark for the construction of a harbour. This was to become Port Glasgow and an essential ingredient in Glasgow's further development.

This was to continue as such for the next 100 years, when the decision was taken to deepen and straighten the river. Attempts had been made to straighten it in 1556 by removing a sandbank at Dumbreck but the sand had simply come back.

A new attempt could not bring any immediate results as it turned out to be a huge undertaking, not least because a huge volcanic plug, Elderslie Rock, stood in the way. The removal of the rock was finally achieved in 1886 and huge ships were then able to move up to the Broomielaw, marking a transformation of the riverbank from fields and farms into docks, warehouses, shipyards and wharves. It didn't leave Port Glasgow bereft as it was to continue as a major trading port in competition with Glasgow as well as develop shipbuilding, eventually becoming the second-largest town in Inverclyde.

Clyde Navigation Trust

Many of the new river developments would never have been accomplished without the co-operation of the Glasgow merchants. They worked with the Glasgow Council to manage the affairs of the Clyde and in 1858, separating the affairs of town and river, the council left the arrangement, setting up the Clyde Navigation Trust. From 1759 the council had had the responsibility 'to cleanse, scour, straighten and improve' the river between Glasgow Bridge and Dumbarton. The River Improvement Trust in 1770 made the Town Council trustees responsible for this as well as ferries.

The 1858 Act of Parliament extended this and allowed for major improvements. The Trust's representation included traders, ship owners and builders, industrialists, Council representatives, Merchant's Hall and Trades Hall.

Ever since I was a wee boy walking along the Broomielaw I have been impressed by the magnificent Clyde Navigation Trust building at the foot of Robertson Street.

The Italianate building was another of Glasgow architect J. J. Burnet's designs, embellished by the sculptural work of Glasgow's John Mossman. The façade includes figures of Father Clyde on his throne with Poseidon and Triton. Figures of James Watt, Thomas Telford and Henry Bell were sculpted by Albert Hodge.

The Clyde Navigation Trust continued to develop the river until 1966, when it amalgamated with the previously competing Greenock Harbour Trust and the Clyde Lighthouses Trust to form the Clyde Port Authority. Clydeport is Scotland's major west coast port operator and manages the River Clyde and port facilities covering 450 square miles. This includes the ports of Glasgow, Hunterston and Ardrossan.

One of the trustees of the Clyde Navigation Trust was Merchant's Hall. As far back as the granting of burgh status, Glasgow merchants had been cooperating and this had been demonstrated in a written constitution for the Merchant's House of Glasgow in 1605. A Merchant's Hall was built and also served as an almshouse for destitute traders. In 1843 the Merchant's Hall moved to a site in Hutcheson Street beside the Sheriff Court House. The original building was redeveloped as tenements and an extension to the fish market. The original steeple was retained and still stands. With the forthcoming redevelopment of George Square, a new building for the merchants was built there and completed in 1877.

In 2012 there was a highly contentious and divisive plan to modernise George Square. A number of adventurous plans were submitted but after a winner was chosen, the plan was suddenly dropped. The Leader of the Council said that, 'The people of

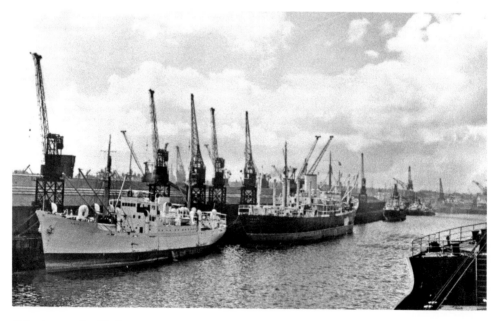

Shipping on the Clyde at Princes Dock. Princes Dock was filled in and became the site of the 1988 Glasgow Garden Festival and is now the home of BBC Scotland and a digital media quarter.

Glasgow have made it clear that they do not want a radical redesign of the square. They want a place where they can while away a sunny afternoon or get together and celebrate the big occasions in the life of the city.' So we are back to square one, but after tidying, it does look nice.

The Tobacco Lords and the Growth of the Merchant City

A custom loathsome to the eye, hateful to the nose, harmful to the brain, dangerous to the lungs, and in the black, stinking fume thereof, nearest resembling the horrible Stygian smoke of the pit that is bottomless.

James VI and I

While business in Glasgow was growing, it was the trade in tobacco, sugar, rum and cotton which would catapult the city into a major world trader and the Tobacco Lords were instrumental in this. The Tobacco Lords were mostly a product of the 1707 Treaty of Union, which allowed trade between Scottish merchants and what had been exclusively English colonies. The position of the Clyde also gave it an edge when sailing ships took such a long time to cross the Atlantic. The Firth of Clyde was where the Trade Winds first hit Europe and this gave up to three weeks' time advantage.

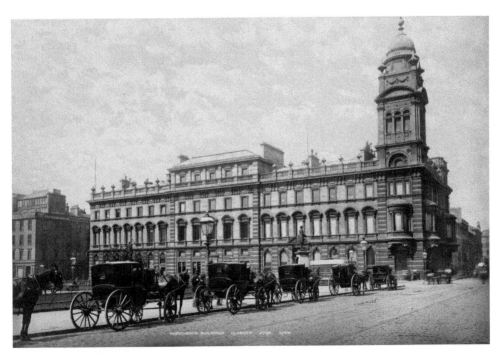

The Merchant's Buildings, George Square, Glasgow, in a photograph by George Washington Wilson.

The merchants had also developed and built large ships specifically for the American tobacco trade and had built personal networks in the New World, particularly in Virginia on the east coast. They also managed the intake of the crop and warehousing so that ships would turn around quickly. The Navigation Acts which had previously acted against Scottish interests now allowed Scotland to benefit. In addition, in 1747, they managed to negotiate an agreement with France as the sole importers of tobacco into French territories.

By 1760, with tobacco being trans-shipped from Glasgow to most areas in Europe, the town had outstripped London as the main port for tobacco in Great Britain, mostly because of the recognised entrepreneurship of the Glasgow merchant. Unfortunately, some of the Scottish merchants were accused of sharp practices. The merchants would offer cheap credit to the growers to purchase goods from Glasgow and elsewhere such as ironware, machinery, linens and luxury goods. This would be repaid at the harvest. However, this caused great indebtedness and hardship, particularly since the merchants, knowing how pressed the growers were, lowered the prices offered for crops.

The growers were forced to sell at the prices offered to get out of debt and bankruptcy. This manipulation of prices does seem to have been one of the many factors which caused the American War of Independence. This offering of cheap credit from Scottish institutions does seem to have a modern ring to it.

The lords were ostentatious in their black silk breeches, three-cornered hats and red jackets, sporting silver and ebony sticks. They would strut about on their own pavement, the Plainstanes, in the Trongate near to where the statue of King William of Orange had originally stood for 160 years before being moved to Cathedral Square in 1923.

The wealth created by the tobacco merchants is well illustrated by the houses in which they lived. None was so ostentatious as William Cunninghame's mansion in Royal Exchange Square which, added to, became a bank, then Stirling's Library, and is now the Gallery of Modern Art, GOMA.

The coming of the American War of Independence in 1775 brought a halt to most of the American trade, and financial ruin to those who had not foreseen it. Some of the canny Tobacco Lords and other Glasgow merchants had already been investing in other trades and continents, including coffee, sugar, rum and cotton. The sugar trade had been going on probably as long as tobacco, with a high proportion of Scots being involved in the ownership and management of plantations and slave ownership. One reason given for the disproportionate number of Scots involved was the fact that they were extremely well educated in the skills of managing estates, including accounting, surveying and medicine. Scotland was also a net exporter of people who would form their own support systems. Jobs would be handed on within the family or between friends. It was also common for marriage to take place in these circles and this promoted an élite in the New World and in Glasgow. They really were our first 'ex-pats'.

As Glasgow expanded, its enterprising citizens and merchants began to take the trading opportunities now available to them. Not only did they have the will and the means to trade with the world but they had a growing home market in Scotland which gave them a critical mass to build on. One of our most famous traders was Tommy Lipton, born in 1850 to Irish immigrants.

Glasgow has had a proud record of producing great grocers. Names such as Cochrane, Coopers and Henry Healy trip off the tongue in Glasgow but while many of them are long gone, Thomas Lipton was to make both an international

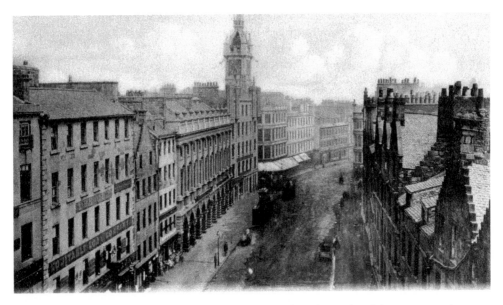

Trongate with the original Town House (on the left with arches). The Plainstanes were between the building and the statue of King William, which was subsequently moved to the back of the Glasgow Cross Station, still to be built at this time. The Tontine Hotel was built behind this façade in 1781 by William Hamilton. The keystones of the arches were decorated with heads, 'the Tontine Heads'. Most of the rediscovered Tontine Heads can be seen in St Nicholas' Garden, behind the Provand's Lordship

name and a reputation which continues today. You can't go anywhere in the world without being able to buy Lipton's Teas.

Tommy Lipton was a marketing genius who also understood the need for quality and efficiency in the organisation and running of food shops. He also fully understood the need to control production as well as distribution and sale. In fact, he started what the major supermarkets now do, buying fresh produce directly from Irish farmers.

Thomas Lipton was born in the Gorbals on 10 May 1850, of parents who had arrived from Fermanagh. Thomas Lipton Senior and Frances Lipton (née Johnstone) were two of the huge influx of Irish immigrants to arrive and settle in the Gorbals and in Anderston at that time. They lived at 10 Crown Street and his parents had a grocery shop there at No. 11.

A fascinating fact which emerged was that it was Thomas Lipton who started the football World Cup in 1910. The Sir Thomas Lipton Trophy was played for on two occasions in Turin. It was said to be the first World Cup, although there had been another competing claim in Turin in 1908. For Lipton's competition, the Football Association of England refused to send representation. Undaunted, the great Lipton invited West Auckland FC, a miners' club from County Durham, to play against some of the most prestigious teams from Europe.

Triumphantly, West Auckland won in 1909, beating Swiss team FC Winterthur. They returned to Italy in 1911 to beat Juventus 6-1 in the final. They were awarded the trophy in perpetuity. The sad end was that the trophy was stolen in 1994 and never recovered. A replica is now held at the club.

Tommy Lipton was knighted by Queen Victoria in 1898, aged forty-eight, and was also made a baronet. However, the accounts are that he was an ordinary type of person without any snobbishness.

His legacy is indeed heroic. He helped medical organisations during the First World War, fitting out his yacht *Erin* as a hospital ship for the Red Cross and others. During his travels supporting and encouraging medical staff overseas, he asked for no better conditions than local people had at those times. He wanted modest food and lodgings and joined the locals in their pursuits such as fishing.

Thomas Lipton died in October 1931, leaving no family. He is interred besides his parents in Glasgow's Southern Necropolis. While we remember him for his business successes and his racing, we also should remember him for his gift to Glasgow. Besides his yachting trophies and his collection of papers and photographs of the America's Cup, he gifted his entire estate to the poor of Glasgow.

One of Lipton's competitors was Andrew Cochrane, who also entered the tea trade and amassed a chain of 1,000 grocery shops in Greater Glasgow by 1914. The smell of freshly-ground coffee in Cooper & Company's stores was also well known to Glaswegians between 1871 and the 1980s. Founded by Thomas Bishop, it was to become a major chain of grocery shops throughout Scotland. Their 1886 building in Great Western Road was probably the pride of the chain. It is now a bar, and now called Coopers.

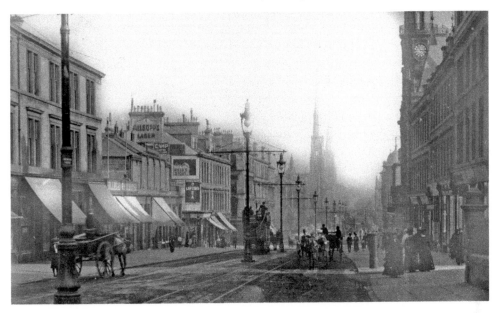

The Great Western Road at Kelvinbridge; Cooper's Corner is on the right with the round clock tower. The posters on the left show the popularity of Camp Coffee and Lipton's Tea. Sir William Arrol's 1890 Great Western (or Kelvinbridge) just beyond helped to expand the city westwards.

The Growth of Glasgow Shipping

One of literature's great stereotypes is the Scottish ship's engineer, solid and reliable, protective of his machinery and with a fierce loyalty to his captain and his ship. It was no surprise to discover Scottie at the engines of the USS *Enterprise* telling Captain Kirk that, 'Ah cannae get any mair oot o' this engine Captain or she'll blow up.'

It was true that you would find Scottish mariners in every corner of the globe, serving on Scottish ships. We not only built the ships but also owned them, managed them, gave them cargos and provided the crews, many of them Scots with their famous engineering skills. But while the Scots were to take their engineering skills to the far corners of the world, it was local trade which was to come before world trade.

Modern folk who travel around Scotland and beyond might complain about the traffic holdups, about train breakdowns and delays and about cancelled flights. If they lived over 100 years ago then the biggest complaint would have been the state of the roads, in that there were no roads to speak of. When Queen Victoria ascended the throne in 1837 there were still very few railways in Scotland, and those that existed were mainly for the transportation of goods and raw materials such as coal from the coalfields of Fife and Lanarkshire.

Before the railways, local travel was on poor roads and by horse or by stagecoach. For longer distances or speed, the sea was the only option. People from the north of Scotland who wanted to travel to Edinburgh would do it by sea as it was the quickest method. This same would be true of travel between Edinburgh and London.

This gave opportunities to Scotland's entrepreneurs, who were ever-ready to seize on a profitable venture. They established a great merchant fleet that plied the waters round our shores just as if they were today's motorways. The seas were teeming with boats of all sizes, trading from port to port and carrying any and every cargo. There were many, many companies and rather than try to catalogue them I have chosen a couple as illustrations.

It was Henry Bell of Helensburgh who, in 1812, built the *Comet* and started the first passenger service between Glasgow and Greenock. On either bank of the Clyde grew communities who needed served, and this gave rise to the famous puffers immortalised in Neil Munro's Para Handy tales. This was the beginning of the Caledonian MacBrayne services still plying their trade and connecting the Western Isles to the mainland.

And to the Clyde from Ireland came the thousands of 'navvies' to build our railways, dig our canals and, like my grandfather, work in our steelworks. The ferries between Scotland and Ireland are legendary and continue to operate, although they are now much more modern than the *Laird's Loch* on which I sailed from the Broomielaw to Ireland in 1960. The *Laird's Loch* belonged to Burns & Laird Lines Ltd, which was an example of the ferry companies that were set up for passengers and cargo throughout Great Britain, with services to our islands and to the Continent.

In 1821 James and George Burns introduced a passenger steamer service between Glasgow and Ayr, and later expanded these to Liverpool and Belfast. George Burns was the co-founder, along with Samuel Cunard and David McIver, of the company which became the famous Cunard Steam Ship Company. John Burns, George's son,

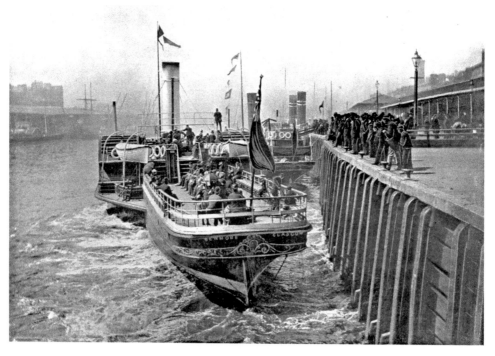

On a Glasgow Fair Saturday morning in 1885, the paddle steamer *Benmore* leaves the Broomielaw headed for Kilmun on the Holy Loch.

became the chairman of the Cunard Line and 1st Baron Inverclyde. The Cunard Line prospered under his chairmanship and then that of his son, George A. Burns.

Cunard was very quick to start replacing wooden paddle steamers with iron steamers and adopting screw steamers, its first being the *China* in 1862. Its first steel vessel was the *Servia*, which was second in size only to the *Great Eastern*. Built by J. & G. Thomson of Glasgow in 1881, she was the first steel ship to have a Royal Mail contract and was therefore named the RMS *Servia*.

There were those entrepreneurs who went beyond serving our own shores to join us to the Americas and to the British Empire. This great merchant enterprise was to last up to the Second World War, when disruption, competition and cost were to bring the beginning of the end for the operation of liners, and then of cargo steamers.

It was the Scottish entrepreneur, like George and John Burns, who grew this great merchant fleet. Another of these, perhaps the greatest name in Scottish shipping as well as Scottish art and culture, was Sir William Burrell, born in 1861 into a shipping family. William and his brother took over the running of the firm from their father. They were astute at ordering modern ships at low cost when the market was in a slump and then selling these on at profit when the market picked up. This made them very rich and this allowed William Burrell to indulge his passion for collecting art and antiques.

The company had started in William's grandfather George's time, plying trade along the Forth and Clyde Canal. After the purchase of a share in a steamship in 1866, their business expanded worldwide, acquiring six more steamers by 1875. After years of

Burns & Laird: the Irish boat.

successful trading, the brothers again used the rise in the market value of ships, caused by the outbreak of the First World War, to sell. Between 1913 and 1916 almost the entire fleet was sold, including vessels which were still on the stocks. William Burrell invested the proceeds and embarked on his passion for collecting works of art, which he was to gift to the City of Glasgow.

Not only did our enterprising merchants and seafarers penetrate the farthest reaches of the globe, when they got there they also stayed and developed industries. Typical of this was Patrick Henderson. P. Henderson & Co. was a Glasgow company formed in 1829 and which exported coal and imported marble. When Patrick died in 1841, the business was taken over by his brother George, a sea-captain. James Galbraith joined as a partner and was instrumental in expanding the business. They started a service to Bombay and Australia and then New Zealand for emigrants and the Royal Mail.

The British & Burmese Steam Navigation Co. was set up to run liners to Burma. Expansion and new capital was required so the Albion Shipping Company was set up with P. Henderson & Co. managing. These were sold to the Elder Dempster Line in 1952. Hendersons continued to operate to Burma. The company was acquired by the Ocean Steamship Co. in 1965. However, the Arab-Israeli Six-Day War closed the Suez Canal and the Burma trade ceased. The Hendersons' last ship was sold in 1972 and their ship-owning days were over.

You can see that there were a great many reasons why Scottish merchant shipping declined and containerisation is only one of these. There was a boom in ship building after the Second World War, when sunk and damaged ships had to be replaced. But a number of developments weighed against the continued success of a home merchant fleet. With the improvement in our road systems and the introduction of motorways there was less need for coastal cargo boats. The huge expansion in air passenger travel and freight also took passengers away from the liners and cargo away from the steamers.

But one of the major factors is that Scotland is no longer a manufacturing country. So much of our industrial output in the past went on boats owned by Scottish lines and built in Scottish yards. The buildings in Glasgow's Merchant City are a 'Who's Who' of the Scottish Merchant Marine. Here, from the Atlantic Chambers, the Baltic Chambers, from Pacific Quay and Atlantic Quay products were sent round the world.

Railway engines went to South Africa and we received cotton from the Indian sub-continent. Sugar refining equipment was sent and sugar received in return. Our coal and our steel went out by ship, as did boilers, bridges, cranes and machinery for power stations, for gasworks and for mills. Jute came into Dundee and left as linoleum. Granite went from Aberdeen and marble came from Italy. Rags and esparto grass came into Leith and left as paper and board. When products leave now, they leave in container ships or bulk carriers and normally from ports in England.

The Canals

We have talked about the opening up of the Clyde and the growth of shipping on the river. Almost as important in opening up trade to Europe and the Baltic was the opening of the Forth & Clyde Canal, once called The Great Canal.

We have already looked at how Glasgow traders would move their goods overland to Bo'ness on the Firth of Forth. With the condition of the roads, this was clearly an expensive and lengthy business. The alternative was the danger of navigating the Pentland Firth around the north coast.

Not only that, but with the close proximity of ironstone and coal, the birth of Scotland's iron and steel industry had taken place in 1759 at the Carron Iron Works in the east and there emerged an urgent need to move this heavy product.

The need to join east and west coasts produced what was Scotland's largest civil engineering project to date. When it opened in 1790, it was quickly being used to transport over 3 million tons of goods carried each year.

The canal also produced an impetus to growth, encouraging the building of factories, breweries, distilleries and foundries. Besides iron coming to the foundries in the west, firebricks came from G. R. Stein's works at Manuel, once the largest maker of the fireclay brick in the Empire, and which was to be so important in the manufacture of steel.

The Forth & Clyde Canal Co. was incorporated under a 1768 Act of Parliament as The Company of Proprietors of the Forth & Clyde Navigation. It was opened finally in 1790, having suffered a hiatus for several years from 1775 due to lack of funds. It was resurrected with the help of government funds, much of it from estates confiscated from the defeated Jacobites after the 1746 Battle of Culloden.

The canal was a highly successful enterprise. Not only did it allow for the transportation of iron, ironstone and coal to the works and factories in the west, but it allowed those on the east to trade with Ireland and beyond. A major advantage was the fact that vessels could head for the Atlantic via the canal and not go round the south coast. In time of war this was a hazardous journey, with ships sometimes having to travel in convoy and with high insurance premiums because of the danger of attack from French ships during the Napoleonic Wars.

The canal was also successful in carrying passengers. By 1812, 44,000 passengers had been carried in relative luxury with the provision of refreshments and newspapers. John Scott Russell, the famous Glasgow marine engineer, even introduced a unique sleeper service on the canal in 1841. I wonder if they will bring that back now that the canal has re-opened?

Also, around 1800, the canal was used for trials of the *Charlotte Dundas*, William Symington's first practical steamboat. From 1828 a steamboat service was also available, operated by Thomas Grahame.

The best alignment of the canal took it north of the city, through Bishopbriggs, Maryhill, Anniesland and Clydebank, finally joining the Clyde at Bowling. In order to bring the canal into the city centre as well as to connect with the previously isolated Monkland Canal, a spur was built from Maryhill to Port Dundas.

Port Dundas was to quickly become a major industrial area, hosting the famous, now-closed White Horse Distillery as well as chemical factories, textile mills and glass and pottery works. It was also the site of the Pinkston Power Station, which was built in 1900 to provide electricity for the newly electrified Glasgow Corporation Tramways.

Here also was the connection to the Monkland Canal which I remember so well from my youth, when it was rarely used but still full of stinking water. The locks were in decay and through the east of the city it was used as a dump but was also a magnet for little boys like me who risked life and limb to make rafts to float on the water. Some young people lost their lives in such a venture, and still do for that matter. But the Monkland Canal was closed and filled in as part of the great Bruce Plan, which we will come back to.

It was first opened to bring coal from the Lanarkshire coalfields but as the nineteenth century wore on and as the Lanarkshire steelworks developed, the canal played an ever more important part in transporting steel, iron and finished goods to Glasgow and the Clyde.

With the coming of the railways, both canals became a second transport option and began to lose profit. The Forth & Clyde was taken over by the Caledonian Railway Company, who didn't have a great deal of interest in making it competitive. It fell into disuse as trains and lorries began to transport heavy goods. I lived fairly near both canals in the 1950s and I can't remember any vessels at all using the waterway. In the 1960s, as I cycled along it to Bowling, it had become a dangerous tract of weeds and rotting lock gates, filled with rubbish, and there was local pressure simply to fill it in. All along the route, as it wasn't used, new traffic bridges simply spanned it without room for passage underneath.

The Monkland Canal was eventually only useful in that it provided a ready route for the new M8 motorway, completed by 1980 with some help from myself, who worked on the drainage tunnels taking run-off from the roads to the Clyde. Parts of the canal still hold water and are stocked with fish.

The new Millennium celebrations brought support from the National Lottery to fund the redevelopment and opening of the canal. With the new Falkirk Wheel, a major tourist attraction, the canal is again open east to west, another major civil engineering project. The canal now allows the passage of pleasure craft, bringing a new leisure attraction to Glasgow.

While British canals were successful between 1770 and 1830 during what is called the 'Golden Age', they were eventually usurped by both the railways and by improving road transport.

The Railway Age

The railways were originally built primarily for industry, for the haulage of coal and for other raw materials, as well as the finished product, for oil and for chemicals. At the beginning, railway companies had little interest in passengers, often confining them to open carriages or primitive coaches. But the cities were expanding. The Glasgow Improvement Act recognised the urban squalor and the poor condition of the houses in which people were living and gave powers to do something about it. In the meantime, those with the means were desperate to escape the filth and smoke of the city. Towns outside Glasgow and along the banks of the Clyde expanded to meet the demands for clean air as well as the growth of the population needed to fuel the huge rises in industrial production.

Before the railways, it was the coach or Clyde and coastal steamers which met this need. But the journeys were long and could be dangerous. The Clyde was a massive factory and along it were boats and ships moving in and out and across.

In the same way that modern trains are opening (or re-opening) access to towns and villages throughout Scotland, the railways were to bring closer the counties of Scotland as well as bringing London and the industrial parts of England ever nearer and nearer. With the coming of the First World War, they were to become an essential part of the war effort.

They were also eventually to close down the busy Clyde steamer traffic as well as the coastal steamer trade. As the railways continued to spread their tentacles throughout Scotland, they enabled the growth of the city and this is reflected in the magnificent Central Station, Glasgow's station.

It may seem strange that while Glasgow Central Station is now Glasgow's main railway terminal, it was not always so. Until the Central and St Enoch were opened, Glasgow's main terminal for south-bound trains was at Bridge Street, on the other side of the river.

Bridge Street Station had been the terminal of the Glasgow & Paisley Joint Railway and opened for traffic in 1840, quickly becoming popular, particularly for those passengers used to the much longer steamer journeys from the Broomielaw down the River Clyde and the west coast to Ayr and beyond.

While we are familiar today with the plethora of different operating companies, it was much the same in the early days, before the grouping of the railways under the Railways Act of 1921 and eventual nationalisation under the Transport Act of 1947.

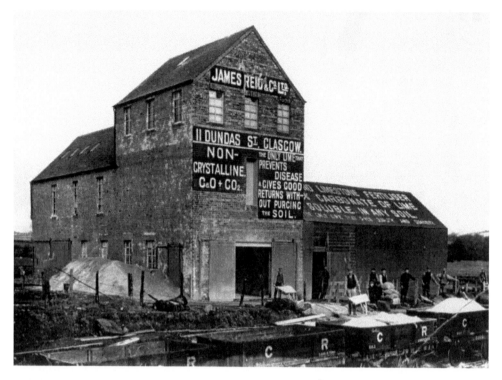

Caledonian Railway trucks taking on lime from James Reid's lime warehouses.

Old Bridge Street Station, serving both the Glasgow & South Western and the Caledonian railways.

Bridge Street Station had been jointly managed by the Glasgow, Paisley, Kilmarnock & Ayrshire (GPK&AR) and the Glasgow, Paisley & Greenock (GP&G) railway companies.

The GPK&AR merged with the Glasgow, Dumfries & Carlisle Railway to form the Glasgow & South Western Railway (G&SWR) in 1850. This became part of the London Midland & Scottish Railway company in 1923.

The GP&G became part of the Caledonian Railway in 1847, which in turn was also to become part of LMS in 1923.

For thirty years the station served both the Caledonian Railway and the Glasgow & South Western Railway well. However, both companies wanted to get across the river, into the heart of the city.

Crossing the river was never going to be easy, even in entrepreneurial Victorian times when coal and the railways reigned supreme. Bridge Street Station was on the south bank and the Clyde was a major obstacle. The Clyde Navigation Trust objected to the proposed bridge. While that end of the Clyde may be quiet now, at that time it was a bustling thoroughfare, and crossing it would have restricted trade up and down the river.

In 1870, it was the Glasgow & South Western which was to be first over the river on the still existing bridge, but not to St Enoch, their eventual terminus. Given the difficulties they had in securing properties on the north bank, they decided to build a temporary station in Dunlop Street. This was used from 1870 until 1876, closing on the day that St Enoch Station opened. The hotel was to open three years later. The hotel had actually been built by the City of Glasgow Union Railway but was acquired in 1883 by the Glasgow & South Western.

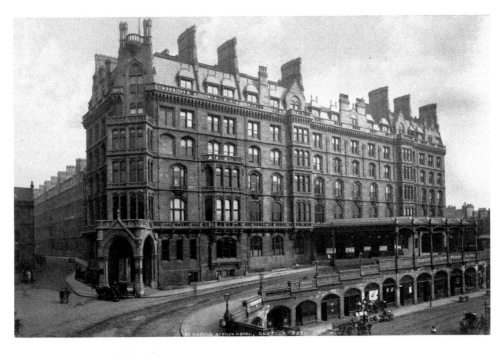

St Enoch Station and Hotel.

St Enoch's was the city's largest hotel, with 200 rooms, and the hotel and station were the first buildings in Glasgow to be lit by electricity. St Enoch's Station suffered the same fate as many other routes and stations under Dr Beeching's railway rationalisation programme and closed in 1966. The hotel limped on for a number of years, but times and poor fire precautions caused its closure by British Railways in 1977, in the face of protest from Glaswegians. It was demolished. It was after all an amazing building and a favourite in the city.

Glasgow Central Station

You would have thought it sensible for both 'operating companies' to collaborate on both a crossing and a terminal but it was not to be. There had been a certain amount of acrimony in jointly operating Bridge Street and this carried on. The 'Caley' thought that the G&SWR wanted too much for use of the station so they decided to build their own, with plans drawn up in 1866 for a station at Gordon Street in the heart of the city.

But it was not until August 1879 that trains finally departed the platforms at Gordon Street which would become Central Station. This was after the completion of the station buildings and the construction of the bridge over the Clyde designed by Blyth & Cunningham and built by Sir William Arrol.

After only a few years, the demands on the station were greater than expected. By widening the station and installing a ninth platform, a temporary solution was found. It was only temporary in that shortly after the station was again congested. The demand for passenger traffic was booming and more dramatic measures were needed.

From 1899 to 1905 the station was substantially extended to give thirteen platforms. The new work was designed by architect J. Miller and engineer Donald Mathieson, with the steelwork being erected by the Motherwell Bridge & Engineering Co. This resulted in the familiar façade in Hope Street along with new platforms extending over Argyle Street served by an additional bridge over the Clyde. At the same time, the Central Hotel was extended and a new office block, designed by J. Miller, was built in Union Street.

With the redeveloped Central Station, it was felt that there was no need for Bridge Street Station and it closed in 1905.

From then, Glasgow Central Station remained mostly unaltered until its part-renovation in the 1980s. The ticket office moved to a new Travel Centre next to the Gordon Street entrance and a new electro-mechanical destination board appeared above the platform entrances. The building hosting the destination boards and booking offices became shops with a bar and restaurant upstairs. The floor was covered with terrazzo tiles.

A new five-year renovation programme started in 1998 with the biggest alteration to date. The station roof was completely re-roofed and the building cleaned. Around 2005, a new LED destination board appeared. Further platform improvements are ongoing and automatic ticket barriers have been installed on most platforms.

Central Station, Glasgow.

The Glasgow Central Station concourse after the 1905 redevelopment. Prior to this the platforms to the right were in line with those on the left. The station improvements moved them back to provide lots of space which is being well used today with concerts and exhibitions.

The regeneration work on the station earned a prestigious Europa Nostra European cultural heritage award for its architects, Gordon Murray and Alan Dunlop, and builders Arup Scotland: 'Awarded for the research and exemplary conservation of an important 19th century train station, including important protection measures to the roof, executed with sensitivity and meticulous attention to detail.'

Queen Street Station was built by the Edinburgh & Glasgow Railway in 1842. With the re-arrangement of companies, the E&GR was absorbed into the North British Railway in 1865 and subsequently this became part of the London & North Eastern Railway in 1923. The building of the Cowlairs Tunnel to take trains from the centre of Glasgow underground to Springburn was a major engineering accomplishment.

The gradient through the tunnel was originally so steep that early steam engines couldn't manage it. Until 1909 they had to be hauled up on a rope attached to a stationery engine. A second (banking) engine was then used until the 1980s.

Today's diesels have no problems with the gradient but there were operating difficulties in 1996 when Buchanan Street Station closed. From then, the services to Aberdeen, Dundee and other destinations transferred to Queen Street. The problem was that the station is in a very confined space with a very small distance between platforms and the tunnel entrance. I still remember, in the 1980s I think, leaving for Fort William from the lower level platforms. Now, Scotrail generally operates the trains, which have no problems managing the platforms and the gradient.

I have already said that the railways were originally built for industrial purposes. While their use for passengers increased, so did their role in developing Scottish

industry. While goods trains are now rarely seen on Glasgow's railways, at one time the city was a network of tracks serving factories, shipyards and docks, bringing raw materials into the city and imports and finished goods out of it. In fact, the track of the Glasgow Corporation Tramways was the same gauge as the railways so that locomotives could use their tracks moving in and out of the docks.

One of the first tracks to be laid was the Garnkirk & Glasgow Railway, built to carry coal from Monklands into the city, where the price of the commodity was high because of monopolistic charging by the canal company and profiteering by some mine owners. It opened in 1831 with horse-drawn wagons but soon moved to steam power provided by the locomotive *St Rollox*. Its Glasgow terminus was at Townhead, at the junction of the Forth & Clyde and Monklands canals. The Caledonian Railway eventually bought the company, using its routes into the city.

The company was one of the first to carry passengers although they were not a priority. A passenger wagon was attached to the end of the train but while there were four journeys every day, the passengers had to take their chances as there were no timetables. They might eventually reach the end of their journey but at an uncertain time.

While railways served the docks all along the Clyde, the greatest development was the General Terminus & Glasgow Harbour Railway, which was to come into its own with the development of the Ravenscraig integrated steel mills.

First opened in 1848, its role was to provide a link and a facility for the movement of coal from the Lanarkshire and Ayrshire coalfields to the Clyde. In 1954 the Terminus saw a new lease of life as it was a perfect location for the 12,000-ton ships arriving to deliver iron ore for the steelworks in Motherwell. In 1954 1.5 million tons of ore from Sweden, Newfoundland and from North Africa were offloaded.

I lived in Anderston in the 1950s and I saw the huge iron ore cranes built. I also saw them demolished in the 1980s with the opening of the Hunterston deep-water ore terminal in North Ayrshire. I often watched the offloading as the ore was dumped by the cranes in the midst of great clouds of 'stoor'. The ore was then transported to Ravenscraig via the Glasgow Harbour Railway. The railway, General Terminus Quay and the ore handlers have now all disappeared, replaced by business parks and housing.

It must be difficult for citizens to imagine the extent to which steam trains permeated life in Glasgow. At the turn of the century, rail lines criss-crossed the city with stations as numerous as the London Underground map. We also had central stations at Maryhill, Bridgeton, Gallowgate and Partick.

Coal was the heaviest and most needed commodity for residents in Glasgow and this came into the city by train to be dispersed to numerous goods yards like Hyndland. Workers travelled back and forward to the huge factories, including the giant Singer sewing machine factory at Clydebank, which had a special station built for it.

Walter McFarlane's great Saracen Iron Works was based in Possil and a station was built there to accommodate the influx of workers. The same was true of the long closed Glasgow Green Station, which served the huge Templeton's carpet factories and the cotton mills in the east end. The now partially closed Lanarkshire & Dumbartonshire Railway served the shipyards and factories burgeoning along the

banks of the Clyde as well as the 'new town' of Clydebank and it connected to the growing town of Helensburgh and townships along the lower Clyde. Many of these railway tracks have now become walkways and cycle ways.

When the Caledonian Railway company finally got approval to cross the Clyde, they did it with style, bringing in the services of Edinburgh consultants Blyth & Cunningham and the great Glasgow engineer Sir William Arrol to design and build their first bridge, because there were, in fact, two.

The bridge was designed for four tracks and rested on piers of Dalbeattie granite on top of cast-iron cylinders sunk into the river bed. The first bridge can easily be identified in later photographs as the one which has the high, arched overhead lattice structures. These high arches were a later addition as the permanent way had to be raised to the same level as the second bridge. This involved raising the arches to allow clearance.

The crossing of the Clyde came at a cost to the Caley as the Clyde Navigation Trustees were putting up a fight. It cost £95,000 in compensation as well as ensuring that the piers of the new bridge were in line with the piers of the Jamaica Bridge to allow unhindered navigation.

The bridge was built between 1876 and 1878 and there might have been some concerns given that the Tay Bridge Disaster occurred soon after, during a violent storm on 28 December 1879. The bridge, designed by Sir Thomas Bouch, collapsed while a train from Wormit to Dundee was passing over. The train went into the Tay and all on board were killed. The disaster was blamed on a number of things, including the lack of provision for wind loading and the quality of castings. Bouch had also submitted a design for the new Forth rail crossing but, unsurprisingly, the design wasn't used. The Forth Rail Bridge was built by Sir William Arrol so there were obviously no concerns about quality and reputation. The building of the Forth Bridge showed the advances in metallurgy and engineering in a short period of time as the bridge was the first structure in the world to be built entirely of steel.

The first Central bridge survived to be demolished between 1966 and 1967. It was at the end of its life and new signaling systems had made the new bridge more efficient. However, the removal of the bridge opened up possibilities for re-use of the piers as sculpture.

Without the railways, Glasgow could not have become the industrial city it did, the 'Second City of the Empire'. Without the improvements to the Clyde we could not have built the great ships and the ocean liners. Without the industrialists and the merchants we would not have had the wealth of architecturally delightful buildings that made Glasgow the City of Architecture in 1999.

We are in a new railway age and while Glasgow has made mistakes in an imposed love match with the car driven through the heart of the city, it has come back to the train. The continually expanding network is well used and even loved by the Glaswegian. I was a young passenger on the new electric 'Blue Train' as it took its place in railway history, linking Airdrie to Milngavie, Helensburgh and Balloch. While Glaswegians had used the steam train for day trips to Balloch, the Blue Train made travel warm and comfortable.

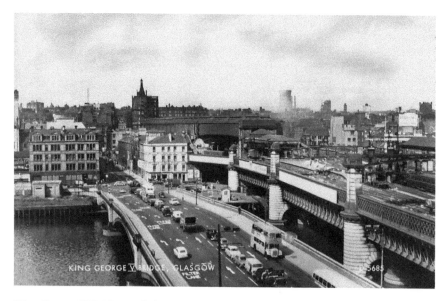

King George V Bridge and the new railway bridge in the 1960s. In the background you can see the Pinkston Power Station, which provided power for the tram and subway system.

Perhaps the most dramatic comeback, and one almost demanded by Glaswegians for many years, was the re-opening of the Glasgow Central Railway tunnels. Closed under the Beeching Axe in 1965, the tunnels re-opened in 1979 to join the north Clyde services to Lanark. As part of this, Argyle Street Station was opened and another new station, on the site of the old Finnieston Station, became Exhibition Centre to serve the new Scottish Exhibition and Conference Centre.

And now the Glasgow railway infrastructure is such that we can we can travel from Helensburgh, Balloch and Milngavie through the city directly to Edinburgh Waverley on the re-opened Bathgate line, which is joined to Airdrie. I take it often through the once heavily industrialised Lanarkshire countryside.

If the railways have had such an effect on the growth and success of Glasgow, it has been hard to understand why, in 2009, the Scottish Government chose to cancel the new Glasgow Airport link from Glasgow Central given that it was originally approved by a Parliamentary vote of 118 to 8 and that many millions had already been committed to it. While some of the plans went ahead, such as new platforms at Glasgow Central as well as infrastructure development, it would seem that politics or cost cutting had got in the way of a development which was enormously welcomed. Glasgow is now among the few major European cities not to have a direct rail link to its airport.

On the other hand, here, in 2013, Glasgow is looking forward to hosting the 2014 Commonwealth Games, which will be based in the east end. More of that later. As part of this redevelopment a brand new station has opened at Dalmarnock and this will be an important transport hub for the games. The original station opened in

The Low Level station in July 1957. You can see the smoke emerging from the adjoining platform. There was a high level of smoke from trains, and from chimneys, as well as the regular 'pea-souper' smogs. Smoking, often pipes, was prolific and spitting was common. Perhaps this is a plea not to spit in the fire buckets? Beyond the façade is Wellington Street. Above the station buildings, supported on steel beams, is a line of shops fronting Argyle Street. (R. M. Casserley)

1895 and was closed in 1964, courtesy of Beeching, but being on the Argyle Line, it re-opened in 1979.

The Glaswegian should notice that an enormous amount of effort has gone into the refurbishment of, or building of, new stations. The impressive work in re-opening connections including Edinburgh via Airdrie, and Queen Street to Anniesland and Kirkcaldy shows that there is a commitment to serving the passenger well. We look forward to the eventual opening of the airport link.

The Glasgow Underground

It would be remiss of me were I not to include a bit about the history of the much-loved Glasgow Underground, now almost 120 years old. A major achievement given that it was apparently cobbled together from old tram cars! I'm afraid that's another myth. But the Glaswegian is rightly proud of 'The Clockwork Orange', as they named the trains following their refurbishment. *A Clockwork Orange* was a film by Stanley Kubrick starring Malcolm MacDowell.

It has a smell of its own and I don't know if it is unique but once you have visited the great subway systems of London and Paris, our tiddly one seems like an

embarrassment in comparison. It is small and goes round and round the city on an 'inner circle' and an 'outer circle', reinforcing the clockwork theme.

The system, originally built by the Glasgow District Subway Company, dates from 1896 and is the third light subway system in the world after London and Budapest. The trains were originally hauled by cable. These were pulled from a power house between West Street and Shields Road and the cars clamped on to the wire to move forward. Originally, the cars had to be lifted through a huge shaft at Govan to reach the maintenance yards.

The offices, one of the gems of Glasgow architecture, were above the St Enoch Square Station. Now a coffee shop, the building was designed by Glaswegian architect James Miller, who also designed the iconic Wemyss Bay railway station and the Caledonian Chambers, offices of the Caledonian Railway Company.

James Miller is one of Scotland's unsung architects and designed a number of iconic buildings in Glasgow and elsewhere in Scotland. Miller joined the Caledonian Railway as an architect in 1888 and began designing railway stations. In 1892 he struck out on his own but retained contacts with the Caledonian Railway. Working from his offices in West George Street, he continued work for the Caley but also did work for other railway companies. He died in 1940.

This was the only substantial building on the circular route as it was anything but ostentatious, with most of the stations having discrete entrances in tenement blocks. Some of these were little more than a passage with a little glass ticket office. Kelvinbridge Station was even reached by a lift directly off Great Western Road before a new escalator was added.

The twenty original wooden gripper carriages were actually built by the Oldbury Railway Carriage & Wagon Company, Worcestershire. Many of these continued to run until 1977, although refurbished. Additional carriages came from Motherwell-based Hurst, Nelson & Company.

In 1935, the system was converted to electricity. This reduced the time for a complete circuit from thirty-eight to twenty-eight minutes. Who would ever do a complete circuit? Well, I used to as a young lad, getting on at St Enoch's, my nearest station, to emerge at exotic places like Cessnock and Ibrox and the bohemian Hillhead. I'm not sure how I was able to get round on one ticket but I suspect that I was probably being ignored by the conductors, who were getting used to me or similar youngsters 'getting a hurl for nothing'.

The original system was built by the famous Robert McAlpine & Sons, 'Concrete Bob', who started his business in Lanarkshire and went on to become a household name and a major employer of many Irish immigrant 'navigators'. It was the building of Singer's sewing machine factory in Clydebank which laid the concrete foundations for this great Scottish company.

By the time the Greater Glasgow Passenger Transport Authority took responsibility for the lines in the late 1960s, the system was in dire condition. Increasing breakdowns on the old rolling stock meant that the whole system stopped as there was nowhere for broken trains to go. The stations were eyesores and the tunnel walls were cracking in places.

It was decided to restore the railway, so in 1977 it was closed for a three-year building programme. In the meantime thirty-three new carriages were ordered from Metro-Cammell. The prevailing style of the carriages, now described as retro, was developed with Glasgow School of Art. The Clockwork Orange had been born. Stations were modernised and platforms added. Gone was the big sign on the platform floor which said 'Q here'.

Since then, and under ownership of Strathclyde Passenger Transport, the line has continued to improve with the trains now dark red and cream. Apparently it has now been rebranded as the 'Subway' but try getting residents of my age to change from calling it 'The Underground'.

From time to time it has been suggested that the line should be expanded to use some of the still redundant lines throughout Glasgow. Besides major refurbishment of rolling stock, in 2007 consultants recommended an expansion into the east end to serve an area which has not been well served in the past. This would include stations at St Mungo's, Duke Street, Celtic Park and Dalmarnock.

The Underground is a wonderful asset and a real part of Glasgow history and culture, as was its famous musty smell. It is good to see it back in the centre of the transport infrastructure. It was almost forgotten about by a generation so welcome back! And you can see a rebuilt Underground station in the new Riverside Transport Museum. You must go for a hurl.

It is indeed difficult to imagine the extent to which the railways have contributed to the growth of the city, for both goods and passenger transport as well as in the manufacture of the locomotive. For the building of railway locomotives was an important ingredient in the recipe for Glasgow's success as a major industrial city.

Getting a Hurl – The Glasgow Trams

Glasgow was in love with its trams and I was there on the last day when its existing and antique collection gave its last bow. In 1962, at the corner of Argyle Street and Jamaica Street, I watched as the trams from through the ages passed. At the front was car No. 543, dating from 1894, followed by the 'room and kitchen' car with a salon at either end. I think one room was for ladies. There was the early 'Standard' car where I would hang out of the top front window. There was the streamlined 'Coronation' car introduced from the mid-1930s, then the 'Cunarder', developed from the Coronation car.

250,000 came to see the trams on their last journey through the city. It was a celebration, but also a sad day. Hundreds of people did what they had done before and jumped into the parade to place a penny on the rails where it would be flattened. I wonder if anyone has one now?

Over time Glasgow Corporation Tramways took under its control outlying tram systems and became the largest urban tramway system in Europe, covering over 100 miles by 1922. It had a huge fleet of around 1,200 vehicles, the spookiest ones working through the night on maintenance work. You rarely saw them through the day.

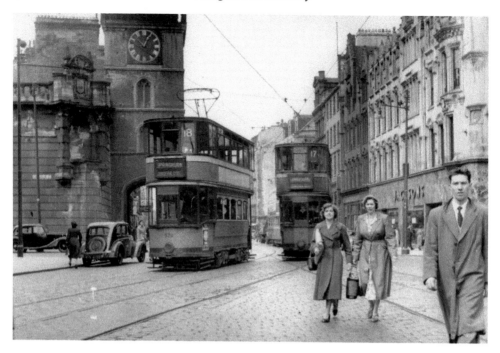

Trams in the Trongate.

Trams were in our lifeblood and the passing of them was to many equivalent to the loss of steam trains. As a young boy, at Anderston Cross, I would help the conductors and drivers change the points to set back off towards Glasgow Cross. I would also go through the car, changing over the moveable seat backs to face in the right direction. The memory of the leather, electrics and the strong tobacco smoke still lingers in my memory.

The Growth of Industrial Glasgow

When Linen Reigned

While these elements combined to enable the growth and success of Glasgow, manufacture of linen had begun before industrialisation and it was to be the city's largest industry, long before shipbuilding. From the death of Elizabeth I and the accession by James to the joint throne, there was a gradual growth in the linen trade and manufacture.

This was further enhanced by the Acts of Union which formally joined Scotland to England in 1707 and allowed Scotland access to England's markets. By 1770 Glasgow was the largest manufacturer of linen in Britain.

This industry had started with individuals or communities of handloom weavers in Glasgow and the numerous villages such as Calton and Bridgeton that would eventually be subsumed into the city as districts. My own village, Anderston, was one of these. In fact, my family stayed in a tenement block at the corner of North Street and Argyle Street which had been constructed as homes for weavers, built by the Weavers Society of Anderston, which was instituted in 1738.

Calton was another weaving village and, in 1787, it was the site of Scotland's first industrial dispute. The story of the celebrated Calton weavers is a common story of the changes from craft working and high wages to mechanisation and the use of semi or unskilled labour. This was to be a precursor of the 'Red Clydesiders' and many such disputes over the coming years.

Following the collapse of the tobacco trade with the American War of Independence, weaving had become Glasgow's biggest employer and by 1787 there were 60,000 employed.

Calton, in the east end, was a community of hand weavers whose home workers earned high wages and enjoyed a high status and a comfortable living. Mechanisation, the import of cheaper cloths and the use of unskilled workers by bosses depressed wages and prompted 7,000 weavers to rally at Glasgow Green, with a subsequent resolution to strike.

A march by the striking workers took place through Glasgow to protest a 25 per cent cut in wages and a lockout. The organised demonstration got out of hand, with attacks on strikebreakers and the lighting of bonfires with goods from robbed

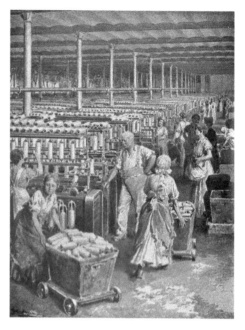

Above left: Glasgow also produced many of the machines which replaced weavers. From an 1883 trade magazine: 'A cheaper and less experienced class of worker may be employed.'

Above right: Cotton mill.

warehouses. In response, the city magistrates, who had been repulsed by the mob, sent in the 39th Regiment of Foot. A pitched battle at Parkhouse, in Duke Street, resulted in rifle fire, killing three rioters and wounding many others, three of whom died of their injuries. There was continuing but decreasing violence as it was realised there was no hope of success in the face of the military.

One of the ringleaders, James Granger, was found guilty of conspiracy and was publicly whipped before being exiled for seven years. He returned to take part in another strike in 1811.

A look at Pollokshaws shows vividly the change from home to factory. This village to the south of Glasgow was home to around 300 home weavers. In 1801, using the power of the River Cart, a mill was built. With 200 power looms, it saw the demise of the handloom weaver, something that had completely disappeared by 1850. It also saw the first textile printing works and with dye and bleach works, the manufactory had swelled to thirty acres. Two cotton mills employing 600 people were soon built.

This pattern was repeated many times over throughout the villages surrounding Glasgow. As mechanisation replaced craft working, so the works moved away from the traditional areas to greenfield sites on rivers where the power of the water could be harnessed to run the machines. The clean waters above the city of Glasgow at the Falls of Clyde were an attraction for David Dale's huge new Lanark Mills. By 1800, King Cotton was reigning supreme and the New Lanark Mills were the largest in the world.

The River Kelvin would become home to dye and paper works and the River Leven, taking water from Loch Lomond to the Clyde, would be the home for the Turkey red dyeing industry, founded in Pollokshaws and Barrowfield.

While the weaving industry had been based on linen, there was a general move towards the more profitable cotton. The industry was slow to adopt the steam engine, possibly because the water mills had been successful and a great deal of investment had already been made in them. Nevertheless, steam-driven mills did appear in Glasgow. Possibly the first was the Springfield Print & Dye Works, built in 1792. This mill, which was closed in 1914, has recently been excavated as it is on the site of the Glasgow Commonwealth Games Village. It has unearthed evidence of the engines and furnaces.

A very particular piece of history was recorded in the 'Shaws'. The story is that a group of Flemish Protestant weavers had come to Scotland to avoid persecution and follow the Protestant faith. They settled in Pollokshaws but those from outside the village began to refer to 'The queer folk of the Shaws', a name that was eventually applied to the area.

It was the growth of trade which was to fuel the growth of industrial Glasgow. While most early tobacco was re-exported to Europe, it was the other early commodities, sugar, cotton and linen, which would see Glasgow become a manufacturing city. These industries began to show us the way, not simply in processing the raw materials but in building the machinery which would be used in processing the same materials where it came from. So, very early, we began to sow the seeds which would eventually see many other countries replicate the process and then cut out the originator.

For Glasgow became adept at exporting the machinery of industry, from the cast iron sugar boilers and sugar mills to the machine tools and presses which would allow ships and locomotives to be built in other lands. But for the moment it was all in front of us. Glasgow was to move fairly effortlessly from a great cotton manufacturer to the world's greatest ship and locomotive builder.

From HMS *Nelson* to HMS *Queen Elizabeth* – Shipbuilding on the Clyde

Much of the growth of shipbuilding was fuelled by the 1707 Treaty of Union, which opened up England's markets to Scottish entrepreneurs and adventurers. Mills and factories were opening and we were beginning to build the steam engines and other machinery which drove the Industrial Revolution. All of this required ships to bring in the raw materials and export the finished product. And where else would the enterprising Scot go other than Scotland, as we now had the skills and the engineering experience?

It was remarked by one speaker that 40,000 men are now employed in shipbuilding on the Clyde, and that the Clyde shipyards could reconstruct the British Navy in two years.

Report in *The Illustrated London News*, November 1876

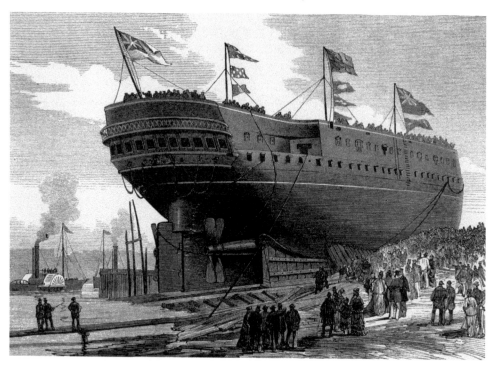

Launch of HMS *Nelson* at Govan in 1876.

Changed days. In 1876, Glasgow was considered the Second City of the Empire and 100 years after the start of the Industrial Revolution it was already in the forefront of developments in shipping, shipbuilding and marine engineering. A further 100 years and shipbuilding was dead in the water with, ironically, only successors to HMS *Nelson* being built in Glasgow, by BAE Systems. BAE is also in Govan, from where was launched the HMS *Nelson*, a twin-screw iron corvette which was built by John Elder & Co. at the Fairfield works.

This tradition in shipbuilding was to last until the 1970s. Scotland was to become the shipbuilder to the world and at the centre of this were the Clyde and her shipbuilding entrepreneurs. One of these was John Elder, whose Govan yards were to form an unbroken line of naval shipbuilding from HMS *Nelson* to the latest Type 45 frigates and Queen Elizabeth Class aircraft carriers.

The first of the new aircraft carriers, the HMS *Queen Elizabeth*, has recently left Govan. The Queen Elizabeth Class aircraft carriers will be the biggest warships ever constructed in the United Kingdom. These are being manufactured by a consortium of companies with the final completion at the BAE yard in Rosyth. The aircraft carriers are now the only ships of any size being built in Scotland and these at the former Fairfield yards now operated by BAE Systems in Govan. Just as this book is going for publication, it has been announced that BAE Systems will be closing its Portsmouth yards as part of a spending review. While the Govan and Scotstoun yards will stay open, there will be redundancies.

In 1919, Fairfield, one of the great names of Scottish shipbuilding, became part of the Northumberland Shipbuilding Group until it was taken over by Lithgows of Port Glasgow in 1935.

Fairfield Shipyard, Govan.

The years following the Second World War were a boom time for Scottish shipbuilding as countries replaced their destroyed fleets and came to Scotland to do so. A major criticism of the shipbuilding industry is that it failed to invest in new technology after the war but Fairfield took this opportunity to do so, embarking on a major £4 million investment programme, planned over several years to minimise disruption.

However, like many other yards, tough times were ahead as other countries were already ahead in all-weather construction and were building massive tankers in more technologically advanced yards. In 1963 Fairfield went into liquidation and was sold by Lithgows in 1965.

However, the modernised yards were reopened as Fairfield (Govan) Ltd. The Fairfield Experiment was an attempt to implement new management and production techniques in shipbuilding. This was to last until the new company became part of Upper Clyde Shipbuilders, which collapsed in 1971 following a famous 'work-in'. The closure saw the company become Govan Shipbuilders and it was enveloped in the new nationalised British Shipbuilders in 1977.

On de-nationalisation in 1988, the Norwegian Kvaerner Group took over and the yard was named Kvaerner Govan and finally passed to BAE Systems in 1999. The Fairfield story is not unique as it mirrors the fate of many Scottish shipyards too numerous to detail. This is an account of only some of them.

During its long history, like many other yards, Fairfield produced many famous ships. These included the Cunard Blue Riband liners RMS *Campania* and RMS *Lucania*. Another ship launched by Fairfield was the first British vessel sunk by the

enemy during the Second World War, the RMS *Athenia*, which was torpedoed in 1939 and led to German fears that, as it carried American citizens, it would bring the United States into the war.

The *Athenia*, out of Glasgow bound for Montreal, was carrying around 1,700 passengers and crew. There were over 300 Americans on board when it was sunk. It caused outrage in America and Canada.

Next down the slipway is William Beardmore & Company. The name of William Beardmore is probably slightly less well-known that John Brown but it is a name than runs through virtually every facet of Scottish engineering, including aircraft, airships, vehicles, munitions and shipbuilding.

Sir William Beardmore of Parkhead Forge had been in the engineering business since 1886 and took over Robert Napier's Govan shipyard in 1900. Beardmore's was already a specialist in making massive propeller shafts and other marine forgings so shipbuilding was a natural progression. The purchase of the Govan yard was followed by the building of his Naval Construction Yard at Dalmuir, also on the Clyde. This was the most modern shipyard in Britain and well suited for warship construction. Production included the 1914 light cruiser HMS *Inconstant*, which took part in the Battle of Jutland in 1916.

Beardmore's also built Dreadnoughts HMS *Conqueror* and HMS *Benbow* as well as the first flat-topped aircraft carrier, HMS *Argus*.

Following the First World War, the company had been quite successful in the merchant field, building a number of tankers as well as three transatlantic liners for the Lloyd Sabaudo Line of Genoa. The first, the luxurious SS *Conte Rosso*, was the first new transatlantic liner to be built after the war.

At Dalmuir, activities had grown to employ 13,000 workers and encompassed the manufacture of armaments. However, the shipbuilding arm of Beardmore's suffered just as much as its other activities in the recession following the First World War and the shipyard closed in 1931.

Beardmore's Dalmuir Yard was right next door to John Brown of Clydebank. John Brown's yard at one time exemplified the quality of Scottish shipbuilding and its finest ambassadors were the *Queen Mary* and the *Queen Elizabeth 2*.

John Brown was actually started by James and George Thompson. Thomson's first yard, founded in my own Anderston in 1847, was called the Clyde Bank Foundry and this name was taken with the company, now run by his sons, to Dalmuir further down the river. The shipyard, its workers' houses and the town which sprung up round it would become one of Scotland's first new towns – Clydebank. John Brown & Company, a steel company from Sheffield, bought the company in 1899 and so was established the engineering giant and town that have become synonymous with Clyde shipbuilding and which suffered some of the worst ravages of the Second World War in what we now call the Clydebank Blitz.

In the inter-war years the company suffered like most other shipyards and engineering works and only survived thanks to the construction of the RMS *Empress of Britain*, the RMS *Queen Mary* and the RMS *Queen Elizabeth*.

But this was not all plain sailing. Construction of the *Queen Mary* (or Hull No. 534) had started in 1930 but the Depression saw work being halted in 1931 and the

Men like these carry on the tradition.

workers laid off. Cunard applied to the British Government for a loan to finish the ship and it was granted on the understanding that Cunard would merge with the White Star Line. The merger took place and with a great sigh of relief in Clydebank, work recommenced and the ship was launched in 1934. The *Queen Mary*, which was called the Grey Ghost because of her wartime colours, went on to make a major contribution as a troop ship during the Second World War.

John Brown's shipyard unfortunately suffered a similar fate to others on the Clyde. With falling orders, it was taken into Upper Clyde Shipyards, which failed in 1971. John Brown's shipyard was sold by the liquidators of UCS and operated by Marathon Oil and then UiE, who built oil rigs from 1980 to 2001 when the yard finally closed.

It is estimated that at one time there had been around 700 shipbuilding companies in Scotland, although with between fifty and sixty operating at any one time. In 1876, 50,000 were employed in the shipyards. At various times we produced between 20 per cent and 50 per cent of the world's shipping. During the Second World War five ships were being completed in Scotland each week and we built some of the world's greatest liners.

Amazing statistics. So how did it all end? The demise of Scottish shipbuilding probably produces as much acrimonious debate as Scottish independence and Scottish football. Possibly this is because it was the last of our great industries and mirrored what had already been lost in other industries.

The end was already in sight as the yards were struggling in the 1960s. The Geddes Report had been commissioned by Tony Benn's Labour Ministry of Technology.

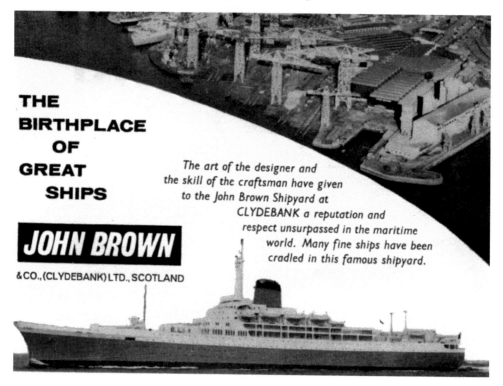

THE
BIRTHPLACE
OF
GREAT
SHIPS

The art of the designer and the skill of the craftsman have given to the John Brown Shipyard at CLYDEBANK a reputation and respect unsurpassed in the maritime world. Many fine ships have been cradled in this famous shipyard.

JOHN BROWN
& CO., (CLYDEBANK) LTD., SCOTLAND

John Brown of Clydebank.

The resultant Shipbuilding Act of 1967 recommended the rationalisation and integration of shipbuilding and aircraft manufacturers in order to successfully compete in a global market. It was thought that what were needed were economies of scale, investment and horizontal integration.

Among the groupings created with government backing were Upper Clyde Shipbuilders (UCS), Scott Lithgow on the lower Clyde and Robb Caledon on the east coast. UCS, even with a substantial order book, was becoming unprofitable and went into receivership in 1971 and started perhaps one of the most contentious periods in Scottish industrial history.

The Conservative government of Edward Heath refused state aid to the company, which resulted in severe cash flow problems. The workforce, headed by Jimmy Reid and Jimmy Airlie, took the unusual decision not to strike but to carry out a work-in. They would complete the jobs which they had started and they would do this with dignity. Jimmy Reid spoke to the men, demanding discipline: 'There will be no hooliganism, there will be no vandalism and there will be no bevvying!'

Amazingly, the tactic worked. The work-in had attracted enormous publicity and was supported by demonstrations and donations, including one of £5,000 from Beatle John Lennon. The Heath Government restructured the enterprise and created Govan Shipbuilders. Yarrow had already withdrawn from the merger and was again independent. John Brown's was sold to Marathon Oil.

There is an argument that the UCS work-in was a resounding success in forcing the Conservative government into a U-turn and stopping a general move towards a free-market economy in which there would be no state intervention. This was to be short-lived as these policies were again adopted by Margaret Thatcher and some said there was no regard to the future wellbeing of those industrial areas that would be affected.

However, before that was to happen, it was recognised that British industry was in a dire state. The Labour manifesto for the 1974 election made a commitment to nationalise shipbuilding and the aircraft industry. The success of the Wilson campaign brought into being British Shipbuilders and British Aerospace in the Aircraft and Shipbuilding Industries Act of 1977. In Scotland these included the Ailsa Shipbuilding Company of Troon, Ferguson Shipbuilders, Govan Shipbuilders, Hall Russell, Scott Lithgow, Robb Caledon and Yarrow of Scotstoun. These represented the last of the great shipbuilding nation.

It was to get worse. Margaret Thatcher's British Shipbuilding Act of 1983 returned the nationalised companies to the private sector. However, the closure of unprofitable and unsupported shipyards continued through the 1980s and 1990s and now we are left with only one shipbuilding company on the upper Clyde producing naval vessels.

Glasgow – Locomotive Builder to the World

There are hardly any of my father's generation left in Glasgow. If you met them they would tell you that a common sight was the transportation of brand-new railway locomotives from the works to the Glasgow docks, where they would be lifted into ships ready for transport to all corners of the world. The locomotives would have been hauled on a low loader by steam traction engines, making an amazing spectacle in the Glasgow streets.

For Glasgow was a locomotive maker to the world, and while I may have missed the movement of the locomotives, nevertheless, as a young boy being brought up in Anderston, I played around the docks where the locomotives were loaded. In particular I played at Finnieston where the great crane still remains as a monument to those thousands of engines manufactured in Glasgow and sent worldwide.

The North British Locomotive Company was to become the largest builder in the world and was formed through an amalgamation of three venerable and successful Glasgow engineering companies: Neilson & Co., Dubs & Co., and Sharp, Stewart & Co.

In the face of increasing competition from home and abroad, the three companies decided to combine their efforts and technologies and in 1903 the great North British Locomotive Company was formed and became the world's largest locomotive builder. Its capacity was 700 locomotives per year, which it never achieved, although 570 in 1905 was credible. By 1909 it had produced 3,000 locomotives and by the First World War had produced the staggering sum of 5,000

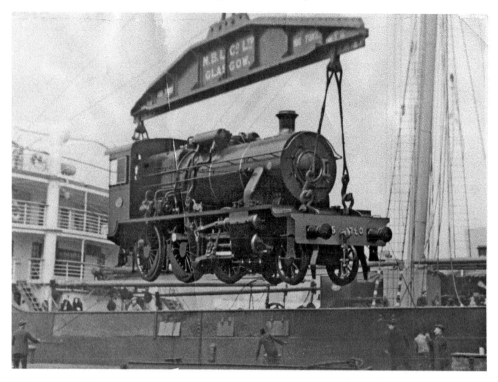

A locomotive for Egypt being shipped aboard Paddy Henderson's steamer *Burma*.

when, besides producing 1,400 locomotives, the North British became part of the huge munitions operation.

Between the wars, locomotive manufacture experienced the same difficulties as many other areas of engineering and manufacture. The changing demands resulted in redundancies, with work being concentrated at the Springburn and Queens Park works. The Great Depression had a major impact, with no locomotives being built at all in 1932. The company was then operating at a loss. Again, like many other firms, the Second World War was to revive its fortunes temporarily when it again survived by supplying locomotives and munitions to the Ministry of Supply.

It was after the Second World War that the company ran into trouble. Immediately after the conflict, when countries were repairing their infrastructures, the order book at North British was looking good for both steam and diesel engines. However, the forthcoming move from steam to diesel was to bring challenges and would ultimately see the downfall of this great company. Once known for its quality, it achieved a reputation for providing pretty worthless diesel engines. This was a situation not entirely of its own making.

While there had been experiments with diesel locomotives as early as the 1930s, these were generally underpowered compared to steam engines, which continued to improve technically. While there may have been an opportunity post-war to convert to diesel or electric, the decision was a long time coming as Britain was a nation with a lot of coal and coal-produced steam. While other countries were reconstructing

after the war and running their railways on diesel and electric, the nationalised British railway companies were continuing to invest in steam locomotives.

When decisions on conversion were finally taken, the railways, starved of investment, were in a dire state. Cheap imported oil had become available and in the 1960s the change to diesel was implemented. However, it was too late for North British Locomotives. They were slow in investigating diesel and when they signed a deal with a German company to manufacture diesels under license, it all went wrong. Manufacturing and operational problems caused breakdowns. Many of the locomotives had to be returned by British Railways for repair under warranty.

On top of this, the company had been selling the locomotives at a loss in order to stimulate profit on future sales which, not surprisingly, did not materialise. North British went bankrupt in April 1962 and the manufacture of locomotives in Glasgow was over.

Vehicle Manufacturing

The manufacture of powered vehicles in Scotland lasted less than a century but that century proved to be adventurous and innovative. But enterprise and innovation often can't translate into success in the long term. There was an abundance of engineering skills in Scotland ready for the development of the internal combustion engine. Unfortunately, lack of management ability, lack of cost control and over-reaching ambition were the downfall of the fledgling vehicle companies. That is not to say that some of them were not extremely successful in their time and contributed substantially to the effort in both World Wars.

Albion Motors was the only company to survive the 1930s until it was joined in modern times by the ill-fated Rootes Linwood plant producing the Hillman Imp and other marques.

Albion Motors – 'Sure as the Sunrise'

Albion Motors is the best known name in car and lorry manufacture in Scotland and is to Scotstoun what John Brown's is to Clydebank, just up the road. However, while the Albion badge is still seen on the walls of the Scotstoun works, the days of manufacture of lorries and cars have long passed, with the last lorry rolling off the production line in the 1970s. The Albion brand is now owned by American Axle & Manufacturing, a company which makes chassis and drive components. Only ghosts of the Albion drive down Argyle Street these days.

While it no longer makes vehicles, its 1899 founders, Thomas Blackwood Murray and Norman Osborne Fulton, would have been pleased to see their name still in existence over a century later.

Murray and Fulton were previously involved in the production of another famous Scottish car, the Arrol-Johnston, but left the syndicate to form the Albion Motor Car Company. Albion was originally based at 169 Finnieston Street and their first cars were offered at £280 as 'suitable for the country house'.

Engine manufacture at Albion, Scotstoun.

The company moved to their Scotstoun works in 1903 and here car production continued until 1915, when competition and good sense made the company switch entirely to commercial vehicles, production of which had begun in 1909. This now included large numbers of 3-ton trucks destined for the War Office for service in France.

Albion was a successful brand, building up a solid following and a good reputation for quality. It was probably this that attracted a successful takeover bid in 1951 from acquisitive Leyland Motors, who had a similar vehicle portfolio. At that time the main products were the Albion Chieftain, Reiver and Clydesdale trucks and the Viking bus.

In 1968 the now renamed Leyland Motor Corporation merged with British Motor Holdings (including Jaguar, Daimler, Riley and Morris). This formed the behemoth British Leyland Motor Corporation (BLMC).

Trucks and buses continued to be produced fully, then partly, at the Scotstoun works until 1980 and these have been exported throughout the world.

While Scotland was most successful at manufacturing commercial vehicles, cars were also produced with varying degrees of success. The Arrol-Johnston, which is considered by some to have been the very first vehicle manufactured in Great Britain, was built from 1896 to 1931. The company began its production at Camlachie, Glasgow, and then in Paisley before moving to a purpose-built factory at Heathall, Dumfries, said to be a replica of Henry Ford's Model T factory in Michigan.

Walter Bergius and 'The Kelvin'
The start of the twentieth century was clearly a boom time for the fledgling automobile

industry in Scotland, for another famous but short-lived car made its appearance in 1904: 'The Kelvin'.

Walter Bergius was an entrepreneur who quite appreciated the need to have a car with a reliable engine. The availability and patent issues surrounding the use of engines in the early days was problematic. Bergius' adoption of the word 'engine' in the company name turned out to be rather clever.

Walter Bergius set up his Bergius Car & Engine Company at 169 Finnieston Street in Glasgow, a hub for early vehicle production in Glasgow as 'The Albion' also started there. His Kelvin was a worthy car but only fifteen were built around 1904 to become extremely successful as the British fishing fleet was installing engines. The production of cars was wisely abandoned given the costs and competition, and development focused on diesel engines. Kelvin Diesels was eventually purchased in 2000 by British Polar Engines, based in Helen Street in Glasgow.

The Argyll car had its origins in the Hozier Engineering Company, started by Alex Govan in Bridgeton in 1899 on behalf of the businessman William Smith, who already had substantial interests in Scottish industry. His first car, the Argyll Voiturette, was basically a copy of a Renault with a de Dion engine.

The early success of the Argyll, said by some to be a product of its unique gearbox, brought it to a grand purpose-built factory in Alexandria opened by Lord Montague

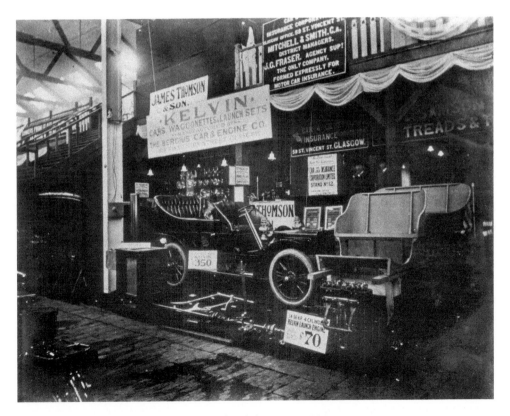

The 'Kelvin' at the Glasgow International Exhibition in 1901.

of Beaulieu in 1905. The factory, with its imposing sandstone and marble frontage, was never used to capacity. Just as soon as it was being built, the American economy was in decline and throughout Europe the demand for cars was falling even as competition was fierce. Govan had invested huge, some would say disproportionate, amounts in the new factory, including lavish staff facilities. His attempts at emulating American mass production techniques were in difficulty and in the middle of this Alex Govan died of a brain clot in 1907. The company never recovered from its difficulties and after a short resurgence between 1910 and 1914, the factory closed, with the buildings being sold to the Admiralty even while ambulances were still being built for the War Office.

Not so the Halley Industrial Motor Company, which saw openings in the commercial market at the start of the twentieth century.

Halley's Industrial Motors

The Halley Industrial Motor Company of 1906 had its origins in the Glasgow Motor Lorry Company formed by George Halley in 1901, with one of its first and most popular products being their fire engine. Originally based in Finnieston, it acquired premises at Yoker.

Halley's introduction of its lorry body clearly came at the right time for municipalities and companies the length and breadth of Great Britain who were moving from horse-drawn wagons to motorised vehicles. Fire engines, ambulances and other municipal vehicles were clearly in demand and as the Great War approached there was a need for the army to be motorised. Halley answered this call and by 1914 was considered one of Great Britain's largest vehicle manufacturers.

It was probably by astute management that Halley survived during the tough trading decade that was the 1920s, particularly when in 1922 the government was reported as having 'dumped' 18,000 ex-services vehicles through the Slough Trading Company. This was to have the effect of swamping the market and putting British lorry manufacturers into jeopardy. Halley seems to have weathered this, possibly through sales of parts, more diversification into omnibuses, and street cleaning lorries.

The company eventually succumbed to the Great Depression in 1935 and closed, with the Yoker works being taken over by Albion.

Halley vehicles exist in small numbers and are highly prized for restoration. There are fine examples of the 1911 Leith fire engine and 1914 lorry in the Grampian Transport Museum in Alford, which is one of the finest small museums in Scotland. And if you are in Alford you really must visit the Alford Heritage Centre, which gives an insight into the life of the ordinary working people of Donside and north-east Scotland and includes an amazing range of tractors.

The name of Halley lives on in Halley Street, in Yoker, now mostly housing, and Halley Motors of Milngavie, which was founded by the son of George Halley.

For those who know of William Beardmore, it will come as no surprise that his company was involved in vehicle manufacture. The Beardmore Motor Company started to manufacture vehicles in factories at Anniesland, Coatbridge and Paisley. Their first car was a tourer which, with teething problems, was renamed the 12/30 and was produced from 1923. Their move into taxis was in 1919, with the Mark 1 Taxi

produced in Paisley. The taxi and its variants proved to be sturdy vehicles, meeting the strict requirements set by the Metropolitan Police.

For many successful offshoot companies, their success is often affected by the success of their parents. Following the First World War and moving into the Depression, Beardmore's ran out of steam as demand for its engineering products declined. In 1929, with the company in financial difficulties, William Beardmore was removed from the boardroom. One casualty was the taxi, which was sold to the company directors with production moving to Hendon, in London, where in various forms it had a rather longer life, surviving until 1966.

Aircraft Manufacturing

In virtually every area of industry in Scotland the name of William Beardmore & Company is to the fore and this was also the case with aviation as they started aircraft development in 1913, just before the First World War. Their first venture was the building of the Sopwith Pup at their Dalmuir factory. They followed that with a ship-launched version of the Pup, the Beardmore WB III, with 100 being delivered to the Royal Naval Air Service.

The company was, as ever, happy to be involved in experimental work and such was the case with their Inverness flying boat, built with a new metal 'stressed skin'. The first was produced for Beardmore by its inventors, the Rohrbach Metal Aeroplane Company of Copenhagen, but they built the second one themselves. The design was unsuccessful and was scrapped. The Beardmore Inflexible was a large transport aircraft with three engines, also built at Dalmuir between 1925 and 1927, first flying in 1928 and appearing at RAF Hendon the same year. Unfortunately, the huge Inflexible lived up to its name. It was underpowered and received little interest, being scrapped in 1930.

In fact, between 1913 and its demise in 1930, Beardmore's produced around twelve diverse aircraft, none of them as successful as the original Sopwith and its shipboard variant. To be fair, some of these were experimental and for evaluation purposes. These were still the early days of military flight and the Air Ministry and other services were looking at submissions from various manufacturers. Some had to be unsuccessful. On the other hand, Beardmore's was very successful in producing a range of engines which powered their own and many other aircraft. I should also point out that other shipyards produced airplanes during the First World War. These included Alexander Stephen of Linthouse and Barclay Curle of Whiteinch, who both produced aeroplanes for the Royal Aircraft Factory.

It was also an experimental time for airships and Beardmore's was fully involved in developments in the field, building and operating the Inchinnan Airship Constructional Station, where they produced airships R27, R32, R34 and R36.

As the First World War was drawing to a close, the possible uses of airships began to be investigated. This resulted in the production of the R36 using ideas as well as components from a German Zeppelin which had crashed in England in June 1917. Although destined for military use, the airship was redesigned for civilian

use to carry fifty passengers and with folding beds in individual compartments. It used German Maybach engines salvaged from the downed Zeppelin.

The R36 was the first ever airship to carry a civilian registration: G-FAAF. Launched at Inchinnan in 1921, it was built with a high degree of comfort, comparable to that in ocean-going liners. It was indeed experimental and found use in a number of contexts including by the Metropolitan Police as an 'eye in the sky' at the Ascot races. Journalists and police dined well together (not for the last time!), with the racing correspondents sending their reports by parachute to be picked up by dispatch riders and taken to Fleet Street.

While there were a number of incidents in flying and landing the R36, it nevertheless established that airships could be used successfully for commercial purposes. However, following the R38 disaster, and given her age, she was finally scrapped in 1926. She had, however, been given her place in history. (The R38 was a Short Brothers-built airship which crashed at Hull in August 1921, killing forty-four out of a crew of forty-nine, more people than would be killed in the Hindenburg Disaster of 1937).

With the recession following the First World War, there were no further military contracts forthcoming so Beardmore exited the field. The Construction Station was closed. The massive company was also in trouble, with reduced demand in all of its markets. It was forced to close in 1930, with part of its Dalmuir site becoming Royal Ordnance Factory Dalmuir.

G. & W. Weir of Cathcart and the Cierva Autogiro Company
Weir of Cathcart was and still is a famous name in Scottish engineering and its 1871 founders, George and James Weir, can be said to be two of Scotland's great entrepreneurs, inventing and developing pumps and equipment, particularly for the great Clyde shipbuilding industry, and surviving successfully today as the Weir Group with its headquarters in Glasgow and operations in oil and gas, mining, minerals and power generation. It is one of Scotland's industrial success stories.

During the First World War, Weir's received contracts for the manufacture of aircraft and parts. These included the BE2 single-seat biplane and the Airco DH9 bomber. These contracts gave them extensive experience which would be drawn on with the development of gyrocopters and helicopters.

Just as Scottish industrialists assisted Alfred Nobel in the development of dynamite at Ardeer, so James George Weir, son of James Galloway Weir, helped Juan de la Cierva develop his autogiro, invented by him in 1920. De la Cierva was a Spanish civil engineer and aeronautical engineer who moved to England in 1920 and, with Weir's support, started the Cierva Autogiro Company, under whose patents G. & J. Weir began to manufacture his aircraft in 1936. Cierva was killed in an air crash at Croydon Aerodrome the same year but Weir's carried on.

Developments in helicopters started in late 1937 with the first test flight of the Weir W-5 on 7 June 1938 in Dalrymple, Ayrshire. Designed by R. A. Pullin, it was flown by his son and was the first flight of a British-made helicopter.

It was followed by a two-seat machine in 1951. The Cierva Skeeter W14 was used by both the RAF and the Royal Navy. By the outbreak of the Second World War, Weir's had a major stake in Cierva but the war saw developments in other priority areas. Helicopter developments had to wait but in 1943 the virtually defunct Weir aircraft division became the Cierva Autogiro Company to develop helicopters for the Air Ministry, mostly at Eastleigh.

Rolls-Royce of Hillington

Before we leave aviation we should mention another of Scotland's success stories, Rolls-Royce, which started producing aircraft engines in 1940, making a huge contribution to the war effort. The Hillington plant in Glasgow was producing 400 Merlin aero engines a week by 1943, many of them destined for Spitfires and Hurricanes. In one month production reached 1,650 and overall during the war years they produced 23,600 engines, which was 14 per cent of worldwide output – an astonishing statistic.

The Merlin engine was an icon of British design and engineering and made a major contribution to the war effort. The first production version of the Merlin, originally the PV-13, was in 1936 although it first ran in 1933. It was originally used in the Supermarine Spitfire, the Fairey Battle and the Hawker Hurricane. While it also powered the Avro Lancaster, it was in the Spitfire that it made its name, first flying in 1936. Its early use helped its development up to the war, when it proved its reliability.

Tobacco Manufacturing

To generations of studying Glaswegians, the Mitchell Library was and is a friendly face and a place of learning and support. Before the expansion of the Glasgow universities and colleges, the Mitchell might be the port of call when no space could be found in the home to study. More recently the library is again busy, not just for lending but for family research, internet access or to pore over its extensive collection of newspaper and family history archives. 'The Mitchell' is still the largest municipal reference library in Europe.

It's strange that on the many times that I passed that bust on the way to the front door for a smoke, I did not reflect on the name Mitchell and his legacy, built on an empire dedicated to cigarette manufacturing. Strange too that the Mitchell must have been one of the only buildings in Glasgow in which smoking was not allowed.

Stephen Mitchell is probably one of the best known of a few Scottish tobacco merchants who were to expand their businesses, moving from the low-tech manufacture of pipe tobacco to highly mechanised cigarette manufacturing using modern machinery. Their companies were eventually to be consumed by growing conglomerates and, like other manufacturing enterprises, be lost to Scotland.

Mitchell's other legacy was, of course, the establishment of a cigarette manufacturing industry which combined with W. D. & H. O. Wills and others in 1901 to become the Imperial Tobacco Company.

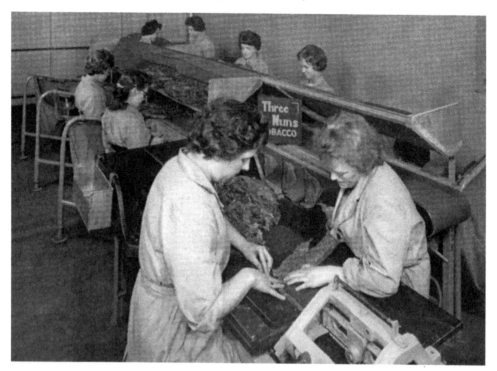

Producing Three Nuns, a popular J. & F. Bells/Mitchell & Sons brand.

Stephen Mitchell represented a tradition of tobacco trading and manufacturing in Scotland which had started with the 'Tobacco Lords' of the eighteenth century who made fortunes in the trade between the New World and Great Britain and who are still remembered in thoroughfares in Glasgow's Merchant City such as Virginia, Glassford, Jamaica, Dunlop and Buchanan streets.

While the Tobacco Lords were busy trading in the commodity, others were buying it and converting it to a range of products including snuff, cigars and 'shag' for pipe smoking. In terms of domestic Scottish production, Mitchell's was probably one of the largest and best known names in Scottish tobacco and he and others like him established the cigarette manufacturing industry, which was to become a substantial employer in Scotland, particularly in Glasgow.

Imperial Tobacco came about as a vehicle to thwart the acquisitive interests of the American Tobacco Company (ATC), which had entered Great Britain with the ostentatious purchase of Ogden's and made it known that they were in the market for other companies.

Thirteen companies amalgamated while continuing to manufacture under their own names. Among these were Scottish companies Stephen Mitchell & Son, F. & J. Smith (Glasgow Mixture) and D. & J. Macdonald. They were then joined by J. & F. Bell (Three Nuns) in 1904.

In 1981, Imperial Tobacco pursued reorganisation as a result of a decline in the demand for tobacco products. Centralisation, rationalisation and efficiency were

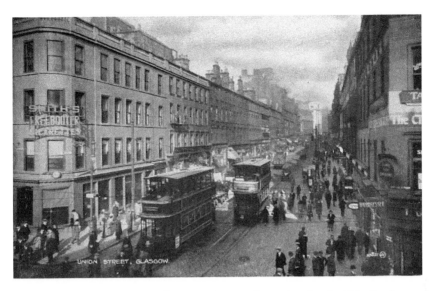

Looking up Union Street with a prominent advert sign for Smith's Freebooter Cigarettes. Finlay and John Smith founded their company in 1858 and were based in George Street in Glasgow, with a factory in nearby Albion Street.

called for and they closed four factories, including the Wills cigarette factories in Glasgow and the Player's cigarette factory in Stirling, in 1983. Rises in cigarette duty was also cited as a reason.

The Wills factory had been based in Alexandra Parade and although it was designed pre-war in an art deco style, the factory opened in 1953. At its closure in 1982 it was employing 600 people manufacturing the Embassy and Lambert & Butler brands. It is now a business centre. A second factory, for cigars, was opened in 1963 and closed in 1990.

At the time of closure, Wills' Scottish factories between them were making the astonishing figure of 160,000,000 cigarettes a week.

The acquisition and subsequent use of Scottish brand names is a common feature in the death of manufacturing industry. In many cases, this is not asset stripping but the natural conclusion when the value of a brand is contained in the name and little else, not the means of production. While small producers continued, it is clear that mergers and acquisitions in the tobacco industry with their resultant economies of scale as well as the promotions and distribution networks they could afford were beyond the reach of smaller companies who had not been part of the mergers and takeovers in the early part of the twentieth century. The absence of cigarette manufacturing may be considered to be no loss at the moment but where it was the mainstay of an area it was felt deeply. Lost too were the other inputs to cigarette manufacturing, including paper for the cigarettes and for packets as well as for inserts such as cards and coupons.

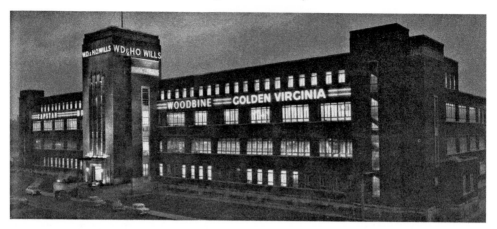

Wills Tobacco Factory, Alexandra Parade.

Walter MacFarlane and the Saracen Ironworks

As the empire expanded and the colonies throughout the world grew and settled, they looked towards machinery, fittings and fixings as well as comforts and reminders from home. They also celebrated the establishment of their new homes and cities with statues and municipal ornamentation. They particularly wanted cast iron and where else would they get it but from their homelands? If there were foundries in the colonies then they were small or primitive. That would change but in the meantime orders were placed with British foundries. One of the most productive and celebrated was the Saracen Foundry in Possilpark, Glasgow.

Walter MacFarlane was born in Clachan of Campsie, north of Glasgow, in 1817. His first employment that we know about was with a jeweller, William Russell, in the Trongate in 1830. It is recorded that he furthered himself with evening classes in design. During this period he met his future wife Margaret, who was the daughter of his employer.

Walter was a good friend of Margaret's brother Thomas and in 1851 went into partnership with him and another friend, James Marshall. They took over a disused brass foundry in Saracen Lane in the Gallowgate. By 1861 they were employing 120 people.

By this time they had outgrown these premises and relocated to expanded premises in Washington Street, in Anderston. Their premises were designed by the architect James Boucher, who went on to form an association with the firm.

They weren't here very long, however, as a decision was made to move to a greenfield site. You can imagine from the firms where Walter worked that central Glasgow was a hive of industrial activity, much of it supporting the nearby Clyde. Washington Street in Anderston was such a place, full of workshops but also full of tenement buildings. The pressure on space must have been immense and you can possibly imagine the difficulties there may have been in casting large pieces in such cramped areas.

The final site for the Saracen Foundry was to be in the grounds of Possil House, near Maryhill. This was named Possilpark by MacFarlane and in 1872 there was established one of the largest and greatest of Glasgow's and Scotland's industrial sites. I particularly remember the tower, which was a Glasgow landmark but has been demolished. The new factory occupied twenty-four acres and employed 1,200 people.

The foundry continued in operation into the early twentieth century, but eventually saw a decline in the industry and demand for such ornamental cast ironwork. Much of the product of the foundry was going overseas. But the days of empire were drawing to a close. In the colonies, foundries were being established and Scottish iron was not needed. Although there was still a call for some standard traditional products such as the classic red telephone box, tastes were changing and new materials were being developed. Iron was being replaced by steel. Electricity was replacing gas. Ceramic was replacing cast iron plumbing.

Walter MacFarlane and the Saracen Foundry may have gone but he has left us with solid reminders of Glasgow's style and enterprise throughout the world. In Brazil and Australia, in India, and at home in Scotland there are lasting reminders of his work. These are seen in staircases, banisters, bandstands, fountains and lamp standards, all illuminating the skill of the Glasgow iron worker.

Twelve and a Tanner a Bottle – The Whisky Industry and Glasgow

There are many Scotch whisky companies that I could use as an example of the enterprising spirit of the Glaswegian. I was brought up in Anderston in the 1950s and 1960s and was surrounded by the bustle of the distilling industry. There were the bonded warehouses of Buchanan's Black and White, and that of Arbuckle Smith in Cheapside Street. There were grain companies and mills, all supplying the distilleries, breweries and flour mills.

Once again, being on the river, Glasgow was historically important as the hub of the industry, certainly from the west coast and islands, like Islay, from where the puffers would arrive with their cargos of malt whisky to be stored in the whisky bonds or to go for fillings for blended whisky.

There were also many cooperages, for example at Anderston Cross, Cathedral Street and in Maryhill Road, supplying the casks to the industry, as well as the stables and drays taking a constant supply of casks to the dock and to the goods yards as well as the pubs throughout the city.

I remember Wm Teacher's particularly well as I would be sent to their public house across the road, where there was an off-license. There were two peculiarities about Wm Teacher's whisky. As far as I know, it was the only whisky company which had a chain of eighteen 'tied' public houses which Teacher called 'Dram shops'. This became very common with brewers but not so with distillers. The other peculiarity was why I was sent to the pub. It sold their own brand of malt vinegar in just the same shape and size of bottle as their whisky.

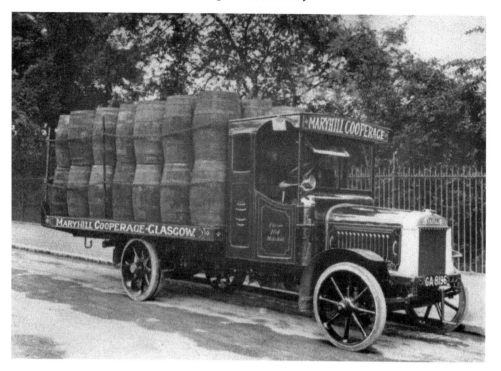

Agnew's Cooperage, Maryhill.

William Teacher, who lived between 1811 and 1876, worked in a grocers shop in Anderston, where Thomas Lipton was later to open his first shop. In 1834 he married into the family and began to expand the business into wine and spirits shops. His 'dram shops' were said to be run tightly, with anyone overdoing it being ejected. I don't particularly remember that happening to me but I do remember Teacher's bars being extremely clean, as many others were too. And he was also very far ahead of his time as he barred smoking in his public houses as well as discouraging rounds and loud talk. Apparently, he thought too that Glasgow wives would prefer their men to go to reputable establishments where they wouldn't come home stinking of drink and fags. Nice idea. It's finally taking effect.

Teacher's eventually became involved in blending and bottling their own whisky, Highland Cream, which was and is still very popular today. They built the Ardmore distillery in 1898. (William & Adam Teacher) Ardmore is still in operation, operated by Beam Inc., and still supplying the malt whisky 'fillings' for Teacher's Highland Cream. One very creative thing which was done was the maturation of whisky in oak casks on the way to Australia. This saved warehousing costs.

As a footnote, you will see the addition to the Teacher's wrapping paper here. The addition of 12/6 was probably made in 1920 as on 19 April the price of whisky was put up from ten shillings and sixpence to twelve shillings and sixpence. It caused uproar and this song was written by and sung by Will Fyffe. It was also sung to me by my father.

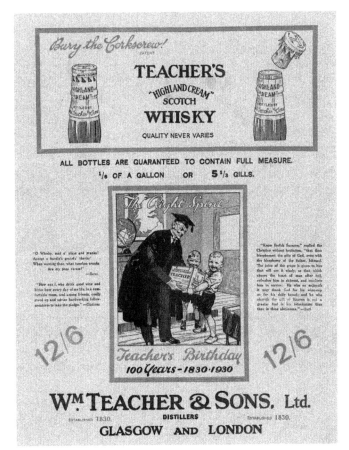

William Teacher. This wrapper also says 'Bury the Corkscrew'. This is because Wm Teacher's used the first ever replaceable cork. This was invented by the nephew of Adam Teacher, William Manera Bergius. It wasn't till 1926 that the screw cap was introduced by White Horse Distillers.

'Twelve and a Tanner a Bottle'

It's twelve and a tanner a bottle
That's what it's costin' today
Twelve and a tanner a bottle
Man it tak's a' your pleasure away

Afore ye can hae a wee drappie
You have to spend a' that you've got
How can a fella be happy
When happiness costs such a lot?

The whisky industry continues to be a major source of employment and economic prosperity. The Edrington Group, based in Great Western Road, is a direct descendant of the Clyde Cooperage Company and the distilling company Robertson & Baxter and they own Highland Distillers. Their brands include The Famous Grouse, The Macallan and Highland Park. Clyde Cooperage still exists as part of Edrington, supplying casks to the industry.

It's one of Glasgow's success stories and it is a company that Glasgow should be proud of as it reflects the benevolent nature of the city and its philanthropists. The Edrington Group is owned by the Edrington Trust, which was set up by Elspeth, Agnes and Ethel Robertson, who donated shares left by their grandfather, who founded the business, to the trust. The purpose of the trust was to ensure the continuance and profitability of the companies and to extend the support they give to charities. The Edrington Trust is a major supporter of Scottish charities. These include organisations involved in helping young offenders and for those with alcohol problems.

Most of the industry has moved away from the inner city but the Strathclyde Distillery, established in 1927 in the Gorbals, has outlasted some of the high rise flats which were built around it. The distillery is now part of Pernod Ricard and supplies grain whisky for blends.

And at Shieldhall is the world's largest Scotch whisky plant. From its opening in 1979 until 2011 the plant, owned by Diageo, produced 400 million cases of whisky, with the last of that figure being a case of Buchanan's Deluxe whisky off to Brazil. From here they send out Bell's Original, VAT 69, Johnnie Walker, and J&B. These and Buchanan's Black and White don't leave anymore in casks on the familiar dray from Washington Street in Anderston, but on container lorries off to the docks to cover the globe.

Finally, in a vote of confidence in the future prosperity of Glasgow, a new distillery is planned for the Queen's Dock between the Riverside Museum and the new Hydro concert hall. The small batch malt whisky distillery will include a visitor centre.

Other Historic Industries

It is obviously impossible to cover every industry in this book. I was recently asked about Billy Connolly, our favourite Glasgow comic and raconteur. 'Didn't he work in the shipyards?' I was asked. My response was that, 'Everyone worked in shipbuilding and everyone was a comic.' That's the spirit of Glasgow. Everyone's a comedian and at one time you couldn't say which industries were not connected to shipbuilding.

Dick's Bridgeton factory produced 'Balata Belting', drive belts for machinery. Shank's of Barrhead provided the sanitary ware that went into the great liners. Weir's made pumps, Mechan's built lifeboats. Furniture and cabinet makers fitted out the ships and the Finnieston Crane lifted aboard the engines and funnels made by any number of Glasgow companies.

But there were other industries too, including breweries, food manufacturers, potteries and glassworks, all contributing to the wealth and wellbeing of Glasgow.

As Glasgow's heavy industries began to disappear, it was recognised and indeed, the coming unemployment and depression of the 1930s was anticipated. A measure planned to alleviate this was the building of industrial estates in 'Special Areas'. The first industrial estate in Scotland, Hillington, was opened by the Queen in 1938 and immediately came into its own, with the Rolls-Royce factory building Merlin engines for the Spitfire and Hurricane.

Other industrial estates were to open, with Queenslie being very familiar to those travelling from Glasgow to Edinburgh. Opened in the 1950s, its workforce was to come mainly from the new Easterhouse housing 'scheme'. The largest employer was Olivetti's typewriter factory, employing 900.

Following the war, government incentives persuaded American companies to come to Britain and set up in custom-made factories. European companies like Olivetti saw it as a way of expanding in America and the British Commonwealth. The late 1950s and 1960s were a boom time for light engineering and electronics.

However, the boom time was soon gone. I worked in electronics at the time, in Lanarkshire, and one by one, the companies went or reduced. These included EMI (record players), Hoover in Cambuslang (vacuum cleaners) and Sunbeam (irons, shavers and other domestic products). My own employer, Pye Telecommunications, in Airdrie, also went. Pye manufactured telephones and radio equipment, including the Pye Cambridge radio, famous in police cars and fire engines, for example.

In fact, the problems previously facing heavy engineering were now facing light engineering. As Japan, Korea and other eastern companies built up their own industries, they were faster and more clever at developing new electronics. Our first transistor radios were tinny, cheap Japanese products. That was soon to change as they improved their products and seriously took on manufacturing in the West.

I moved from Pye to Barr & Stroud in Anniesland, one of whose less secret products were binoculars. These were the same binoculars used in the World Wars and which featured in many a black and white war movie. However, you can now once again buy Barr & Stroud binoculars but these are imported from China. Barr & Stroud is now part of Thales and still continues to manufacture periscopes and other equipment in Linthouse, near Govan.

While Glasgow has lost a great deal of its traditional and more modern industries, it is nevertheless thriving and has a great future. While there are worries that many of the new jobs are low-paid ones in call centres or in the service sectors, nevertheless, many of the developing jobs in optoelectronics, biotechnology, media and software combine with more traditional fields of education, engineering, textiles and food manufacture to produce a mixed economy. If Glasgow can continue to re-invest in future technologies and its people, but keep an eye of the competition from abroad, then it has a bright future. 'People make Glasgow' is the new marketing motto for Glasgow. I personally think that the Glasgow city authorities have done an amazing job through the years in putting citizens at the centre of Glasgow life.

The Development of the City

Water and Hygiene

When I was a boy in Anderston in the early 1960s, it was a bustling commercial and residential area of the city. Around Anderston there were 'brokies', or bits of land, big and small, whole blocks sometimes, which had been cleared and never built on.

These and the backyards were our playgrounds. To one of these, all of the children in the area were summoned one day by whistles and shouts. In clearing away concrete, a mechanical digger had uncovered an old well. With the different approach at that time to health and safety, two dozen young people of varying ages crushed round the gaping hole, which was about six feet wide. A few of us threw stones down without hearing a splash or the sound of them hitting the bottom. We thought it was bottomless, but obviously not as it was filled in the next day. This had been a great event, even in the busy timetable of a young Glasgow lad in the summer holidays. Progress could not stop for the well, which was in the way of the preparations for the approaches to the Kingston Bridge, across which would be carried the new M8 motorway.

It was an event, for where else would city boys have seen a well except in storybooks? For in the 1950s every schoolgirl and boy knew that our drinking water came from Loch Katrine by way of the Mugdoch Reservoir at Milngavie.

Looking down that well gave us an inkling of how Glaswegians at one time would have obtained their water. For Glasgow in 1800, the source of water was either the Clyde, the Molendinar and Camlachie burns, or a small number of private and public wells. As the city expanded dramatically, these wells became polluted and with the slow speed of extraction by bucket, long queues formed.

The first known solution to the problem was the work of William Harley, a private individual and entrepreneur who built a reservoir at the top of West Nile Street, collecting water from springs on Blythswood Hill. His water carts travelled throughout the city, providing stoups (pails) of water at one halfpenny. Hardy is also supposed to have given the name to Bath Street, as this was where he had a small swimming pool and hot and cold baths.

However, this was never going to be enough and the city magistrates took action. The Glasgow Water Company's Act provided for the extraction of water from the Clyde to reservoirs at Dalmarnock, from where it would be piped to Sydney Street

Glasgow's last public well – the Lady Well off Duke Street.

for distribution. The great James Watt and Thomas Telford were consultants on this project.

A second bill was enacted in 1808, allowing the Cranstonhill Company to pump water to the west of the city from Anderston Quay. These two companies competed until, in 1838, an Act of Parliament allowed the amalgamation of their two companies at Dalmarnock.

This also provided for the installation of filter beds and the construction of the pumping engines 'Samson' and 'Goliath' to take the water from the river. By the time the Glasgow Corporation took responsibility for the works in 1856, around 12 million gallons of water per day were being taken.

Around the same time, the Gorbals Gravitation Water Company started providing water. As this turned out to be purer than the water on the north side, there was a lot of competition, with most water used on the south side coming from the new company.

By this time the need for a properly regulated supply was becoming evident. Street wells were polluted from ground water and even though there were filter beds, these could not cope with the muck when the river was low.

There was a short-lived project to enable the taking of water from Loch Lubnaig but by this time the Corporation had taken the decision to wade into the water supply problem.

J. F. Bateman was asked to report on the best supply of water for the city and the Loch Katrine dream was born. At first it failed because of resistance and scaremongering. One eminent chemist said that the effect of soft water on Glasgow's lead pipes would make it dangerous. This was true and eventually led to the entire system being changed over time, with the removal of both lead pipes and tanks. The Admiralty objected to

taking the water as it would otherwise have flown down the River Teith to the Forth. This would cause problems in navigation for the Royal Navy!

The Bill was finally passed in May 1855, and the works completed in 1859 and opened by Queen Victoria. This was a relatively short time for what was then the greatest system of aqueducts since Roman times and one of Scotland's great engineering projects. The new scheme ensured that Glasgow had the cleanest water supply of any city in the world at that time.

Instrumental in pushing through the project was Lord Provost Duncan Stewart. Born in Glasgow in 1810, he was a contemporary of John Blackie, who had also been a Lord Provost and who was responsible for the City Improvement Act of 1866.

Duncan had begun his working time in Govanhill, in a counting house of Mr Dixon, acquiring his knowledge of business and finance. When his father died, Duncan took on his responsibilities of iron and coal master at Omoa on the Cleland estate, property of the Stair family. He was responsible for reconstructing the works and in addition became involved in mining an extensive field of ironstone. These ventures made him extremely rich.

In 1843, like many of the prosperous men of the day, he took his place in local politics, becoming within one year a river baillie. In 1845 he became a magistrate and Lord Provost in 1851, to some extent as a reward for his leadership as a magistrate during the civil unrest in 1848 in which rioting had threatened the population. Duncan Stewart made the issue of water supply his own and in the face of opposition carried it out steadfastly.

But it wasn't just the water supply which had been in a bad state. The city had grown out from the High Street, along the Clyde, but in a haphazard, uncontrolled fashion. Large houses were added to, split up and forced into narrow vennels which apparently over-ran with filth. Inadequate tenements with proper facilities were thrown up and simply contributed to overcrowding and ill-health.

Now it is time to address the issue of filth and of 'slums'. I can't have personal memories of Glasgow before the 1950s. But I do of Anderston then. I have very strong memories of the buildings: the tenements, the factories, the whisky bonds, the warehouses, the workshops, the pubs, and the shops. I knew many of the people who lived there. I grew up with them and know that irrespective of 'slum clearances', there remains a strong community spirit.

My memories of the area are at odds with the description of 'slums'. Most of the people I knew had inside toilets. We had a bathroom, as did many others. On the other hand, most of us lived in overcrowded conditions, with all that entailed in terms of sleeping arrangements and space to live, wash, do homework and simply survive.

Many of the people I knew were first- or second-generation incomers from the Highlands, from Ireland and from Ayrshire. I have often wondered why those people, who were normally proud of their surroundings and of their health and wellbeing, and who were very socially aware, would not take less care of their surroundings than in their homelands. Well, I don't believe it was the case.

While there were notorious slums in the Gorbals and elsewhere, in fact many of the buildings which were demolished in Anderston could not be called slums. If you

were to look at the famous Thomas Annan photographs taken between 1868 and 1871 on behalf of the City Improvement Trust, you will see that these black and white photographs record the narrow streets and vennels of Glasgow. However, the photographs don't actually record very much filth and rubbish. In fact, the vennels are surprisingly clean and free of 'ordure of man and beast' as one commentator recorded.

I am not an apologist for slums but you know, the fact is that many slums were a myth. Glaswegians will still talk proudly of making sure that whoever's turn it was 'to do the stairs' did their duty and that the front step was kept washed. To this day, people will say how shopkeepers would sweep the street in front of their shops. Whitewash and Cardinal Red polish were mainstays of the local drysalter, like our local store, Gilfeather's at the corner of Anthony Street. Here we would be sent for the same as well as fly sprays, paraffin for heaters, tins for workies' tea, two-ended baby bottles as well as canes and wee nets for catching 'baggie minnows'. Common, too, was the sight of carpets hanging over the washing lines in the back greens being beaten with carpet beaters, also bought from Gilfeather's along with washing boards which would also be in demand by the local skiffle group.

There were certainly slums and certainly poverty, malnutrition and early death. If you were to look at the reports of poverty and slums in Glasgow, I think that you would find that many of these were from single sources which were repeated until believed. I'm afraid that journalistic standards back then also gravitated to the sensationalist. Unfortunately, if you took a camera to areas in Glasgow now, you

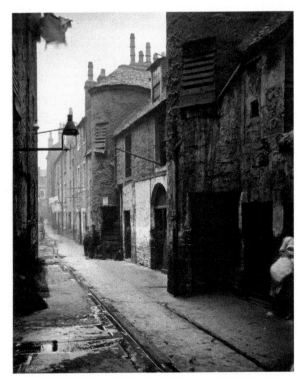

139 Saltmarket: Thomas Annan's view of poor living conditions in the narrow lanes of Glasgow. Annan was commissioned by the City Improvement Trust to document the city's slums, which were scheduled for demolition and reconstruction by an Act of Parliament in 1866. In fact, the photograph shows no litter or ordure whatsoever. Given that it was his job to record living conditions, it is improbable that this vennel was cleaned up for the photographer.

could replicate the conditions selectively and show that things haven't changed, which, of course, they have.

The photograph on p.75 shows that Glasgow in 1868 retained a medieval look and it would be inevitable that the quick change from a mainly rural market town to one of the world's largest commercial and industrial cities was going to cause some pain. After all, it hadn't been done before and it is clear in hindsight that there wasn't the infrastructure there to house the incoming workers. Neither was there the depth and quality of management needed. Basically, housing was a purely commercial enterprise and there were those around who would build low-quality housing with the barest, if any, amenities. On the other hand, there was also a lack of foresight. Consider that many of those arriving to work in the mills and the factories, and in service, would be single people or young couples. The flats which were built may have been totally adequate for their needs at that time but families expanded, as they did in a time before medical birth control. Religion and culture would also play a large part in the growth of the family.

The population expansion in Glasgow was a product of the industrial growth in and around the city. Glasgow also became a magnet for the dispossessed. While the Irish had been coming to Scotland before 1848, a series of blights affected the crop in Ireland and led to a period of sustained starvation and emigration. In 1841 the census showed that the Irish population in Scotland was 126,000. In 1851 it was over 207,000. This was around 7 per cent of the total population of just under 3 million. This did not include children born in Scotland of Irish parents. In fact, the Irish population was underestimated.

The Irish boats disembarked in Glasgow or other ports on the west coast and these areas became the first Irish communities in Scotland before they dispersed to those areas where they could work and where they would be accepted. In Wigtownshire and Kirkudbrightshire the Irish population was already substantial by 1840. There were large Irish populations in Dundee, where they worked in the linen and jute mills. They worked in the new Turkey red dyeworks in towns along the River Leven. Coatbridge, becoming a huge industrial town, had a 36 per cent Irish population in 1851. But the largest influx of all was to Glasgow. Around 30 per cent of all Irish settled there.

Daniel Defoe, the author of *Robinson Crusoe*, visited Glasgow in 1707 and had declared it, 'The cleanest and beautifullest, and best built city in Britain, London excepted.' By 1807 all this had changed. While there continued to be fine new developments, building in the city was generally uncontrolled, oblivious to sanitary engineering and was outstripping the ability to feed and water the fast-growing population.

The huge industrial expansion in Glasgow, aided and abetted by harsh conditions in the countryside, not only attracted Irish but also people from the West Highlands and from Lanarkshire and Ayrshire. In 1750 the population was 32,000, rising to 200,000 by 1830 and on its way to a half million by 1870.

This growing population was housed in poorly designed and hastily constructed buildings, which became squalid and overcrowded. This put pressure on the supply of drinking water and foodstuffs. Watercourses and wells became polluted. The city was choking in the thick smog from the vast factories, mills, workshops and foundries.

In these circumstances disease was rampant and infant mortality high. The period also saw rises in crime, drunkenness and juvenile delinquency. It was a situation which, if left to continue, would probably see the city in economic decline and social disaster. This was a time for radical action. One of those who saw the problems and the likely outcomes was John Blackie Jr. A publisher by trade, he went on to enable huge changes in the city, becoming a respected Lord Provost and churchman.

It was as a politician that John Blackie made his largest and longest lasting contribution to life in Glasgow. He was elected onto Glasgow Town Council in 1857, becoming Lord Provost in 1863. His major work in this time was the 1866 City Improvement Act, which was a major programme to improve life in the squalid poorer areas of the city.

The 1866 Act gave Glasgow Town Council powers to set up a City Improvement Trust. This was to purchase slum property, demolish it and to widen and re-align narrow city centre streets. The Act was also responsible for a new Cleansing Department. The areas targeted for slum clearance were mainly round about Glasgow Cross. The idea was to demolish the outdated buildings of the time, widen roads and then encourage private builders to build on the cleared areas. Restrictions were imposed, however, such as limiting the buildings to four storeys. There was to be only one single apartment in each level, the remainder to be two or three apartments.

However, building on the cleared land was very slow, caused partly by the collapse of the City of Glasgow Bank and partly by a recession at the time. At one time the Improvement Trust had to cease demolishing properties and found itself to be Glasgow's biggest slum landlord. It wasn't till the 1890s that building got going again and by the 1890s the Trust had built thirty-four tenements containing 1,200 homes. For example, Howard Street was built with sixteen single-room houses and thirty-two two-room apartments. By 1913, the Corporation, which took over responsibility for housing from the Trust, had built 2,199 tenement houses in the city.

The construction of single- and double-room apartments for whole families may seem very mean to us today and perhaps reflects the standards of what was being replaced.

Blackie was also involved with James Watson in doing something about the overcrowding and squalor in the common lodging houses then in Glasgow. They intended to provide cheap, clean and healthy lodgings. The Association for the Erection of Model Lodging Houses was formed. To begin with, three buildings were provided: two for males with 423 beds, and one for females with 200 beds. The Association was dissolved in 1877, with the Corporation of Glasgow taking over responsibility and continuing to build more 'models'.

As a boy in Anderston, I was aware of several of these 'models', one being in Pitt Street. In fact, if I came home looking scruffy my parents would refer to me as 'a Pitt Street modeller'. I remember delivering milk to at least two of them and they were not nice places. In the People's Palace in Glasgow Green there is a mock-up of one of the hutches in a model lodging house. This shows what it looked like but does not give any hint of the smell of the building or its inhabitants and the dangers contained

therein. The idea that these cramped kennels were an answer to the overcrowding and squalor then in Glasgow seems preposterous now but it indicates how bad conditions actually were.

After all his good works, it seems that the good citizens of Glasgow didn't take too kindly to the extra taxes to pay for all the improvements during the time of Blackie's tenure as he lost his seat at the next election. He did, however, receive a nice vote of thanks from the council at the end of his term.

It appears that John's municipal work on top of his business and Church affairs got the better of him and he had an attack of pleurisy in 1873 from which he died, being accorded a full civic funeral. After his death his two brothers, Walter and Robert, succeeded him in the business, his father dying a year after John Jr.

While many other business people were objecting to taxes raised to fund improvements and moving out of the smog and dirt to the west end or doon the water, John Blackie showed his commitment to improving the lot of the ordinary Glasgow citizen and for that he deserves recognition.

While there is very little known about the kind of buildings occupied in medieval times, it is highly likely that these would be of the wattle and daub type, single- or double-storey. As these would have been built without any planning framework and without consideration of future growth of the city, they were built cheek by jowl and naturally came with all of the unsanitary conditions that that entailed, leading to disease. Many of these existed into the nineteenth century.

Prior to the sixth century, the town had grown around two centres: St Mungo's Monastery on the Molendinar and the commercial city based around what is now the bottom of the Saltmarket. By 1285 there was a wooden bridge over the Clyde, supplementing the existing ford. In the fourteenth century, the burgh expanded along the Gallowgate and the Trongate in a ribbon fashion and was always a small village or town throughout the medieval period, with a population of around 1,500.

In the 1652 great fire, eighty of these closely built vennels, a third of the town, were destroyed. The candlemakers, who were blamed, were forced to work outside of the town. Their area became the Candleriggs. Again, in 1677, another fire, apparently arson, brought more destruction and the town council decided they had to do something. This was the first move to bring about any town planning. They decreed that any future houses on the High Street were to be built 'head to foot and back to fore' of stone.

If you had been standing halfway up what is now Glasgow's High Street in 1350, just as the Black Death hit the town, you would have seen above you the imposing Glasgow Cathedral under construction and below you the mixed stone and wood houses leading down to the river. Away to the west and to the east, you would be able to see the rigs or furrows cultivated by the residents for their own use, and for selling. You might see cottages stretching up towards Garnethill and Cowcaddens and the occasional big house. People may be travelling on foot, horseback or in carts. The population would be around 1,500 at this time.

Glasgow as a Modern City

It was around 1770 that the town began to be formally planned by James Barrie, Glasgow's first 'surveyor and measurer'. His plans formed the basis for future building as the town expanded along the main streets, the back areas of which had been rigs, narrow fields, from medieval times. The developments followed these to form what now includes Jamaica Street and Queen Street. In 1772, the new grid system started above Ingram Street. The grid was further extended westwards by James Craig, who was responsible for the original plans for Blythswood Square and the surrounding area.

Later on, the Police Act of 1800 determined that any property owners with buildings or spaces fronting streets, squares or public places should ensure at their own expense that the grounds in front of these properties be paved with flat stones. The pavements were not to be more than twelve feet wide in streets sixty feet wide and eight feet in streets forty to fifty feet wide.

As trade and industry grew, the city of Glasgow continued its designed move, following the river downstream as the foundries, factories, workshops and shipyards grew on the banks.

In time, the existing villages and estates were consumed to become wards of the city. My own Anderston was one of those independent villages. The lands had been given to the Bishop of Glasgow by King James II of Scotland in 1450, which was remembered by the still existing Bishop Street, where I went to school. Named after James Anderson of Stobcross House, it changed from farm lands to weaving cottages, bleaching and dyeing greens and then to become a major cotton centre. In the process it swallowed up the estates of Lancefield and Hydepark. As the river was deepened and enlarged, it was to become an area of warehousing, whisky bonds and factories. It was to remain much the same into the 1960s.

It was John Orr who took over the area in 1735 and who was instrumental in moving the area towards weaving and dyeing. Finnieston, a small village west of Anderston, was named after the Orr family tutor, Revd John Finnie. This was the home of the Verreville pottery and an early producer of fine crystal.

Beyond that was where some of the very few Roman remains were found on what was supposed might have been a small fort on Over Newton, now known as Yorkhill, where once stood the mansion of Robert Fulton Alexander, a Glasgow merchant. Again these lands have disappeared, becoming Yorkhill basin, the Children's Hospital and the area through which now runs the Clydeside Expressway.

In the north the same formula applied, with the Blythswood estate disappearing to be replaced with James Craig's planned square and elegant surroundings.

However, as we have already seen, the abilities of the authorities to deal with inadequate housing had been almost outstripped by immigration. Those arriving from Ireland, the west of Scotland and further afield found themselves living in ancient buildings, shoddily built tenements or in 'made-down houses'. The latter were buildings, for example in Anderston, which had been built for the middle classes. These were sub-divided and became overcrowded. In fact, this system has continued

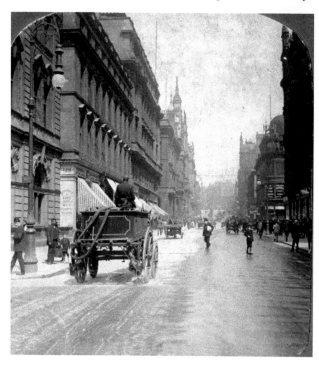

Water cart in Buchanan Street.

ever since. Such converted buildings can be seen in areas like Hillhead. At least today we have Houses in Multiple Occupation licensing. This is now national but licensing was first introduced in Glasgow following the death of two students in 1999, in a Woodlands flat that had no working smoke detectors and metal bars covering the windows.

The Corporation of Glasgow were well aware of the overcrowding problems. Historical interpretation might suggest that Glasgow local government had shown little interest in housing matters, but that is far from the case. Ever since it inadvertently found it was the largest slum landlord in Glasgow, it was attempting to do something about it even before the 'slum clearances' of the 1960s. The problem was that wars and other events got in the way. We have seen that it was the collapse of the City of Glasgow Bank as well as recession that left the city with so many poor buildings.

Naturally, there was no house building during the First World War. Following the war, rather than returning to a 'Land fit for heroes', the soldiers instead returned to unemployment and the dole.

However, Glasgow took the brave initiative to build and they did this with a vision that our people would live in a garden city environment which had been piloted in England by the likes of Joseph Rowntree in Bourneville, and in Welwyn Garden City. Based on the ideas of Sir Ebenezer Howard and Raymond Unwin, houses would be airy, light and with gardens large enough for vegetable plots. The idea was that such areas would be self-contained, with their own facilities such as shops and offices. I can verify all of this as I grew up in Knightswood, in a semi-detached house which had been built between the wars.

In 1919 government legislation made it compulsory for local authorities to plan housing schemes and gave funding to do it. With this funding, Glasgow took this movement to heart and in Mosspark created the first garden suburb, with two-thirds of the population housed in cottage-type buildings.

In Knightswood was created one of Britain's largest such garden areas. From 1923, the city's Direct Labour squad built 6,714 houses. At the same time, they catered for almost all denominations and eight churches were built along with shopping centres, a nine-hole golf course, tennis courts and football pitches. Even a cricket pitch was provided. It was also a 'dry' area, that is with no public houses. It is still generally the case.

While Nitshill was mainly flats, it too followed the same ideals. In this instance the provision also included hot water for domestic use and central heating provided from a central boiler house. I know that because my uncle managed the one in Nitshill.

Even as these garden suburbs were being created, they were becoming too expensive and by 1926 the standard had to be lowered. The differences in density and quality of build can be seen clearly between Knightswood and Upper Knightswood. Again, it was external influences which were preventing the building of the houses 'for heroes'. The depression of the time, not relieved until the Second World War, stopped most social housing being built.

Of course, this was exactly the time housing was needed. Those 'slum' areas which were left, including most of the Gorbals and parts of Anderston, Springburn, Bridgeton, Townhead, Cowcaddens and Kinning Park, had to be dealt with. But with the lack of funds to build, deprivation and the dole brought misery and violence which erupted in the streets, again not to be relieved until it was stopped by Percy Sillitoe's police and the Second World War.

Hermitage Avenue, Knightswood. This is a postcard sent by a lodger to her mother during the Second World War – presumably she was on war work.

It is this inter-war period which created the myth of Glasgow slums. However, in the totality of what was and is Glasgow, the Gorbals and these other areas could not be said to sum up the city. When you take into account the ever expanding city, areas including Kelvingrove, Hillhead and Queen's Park, there were plenty of fine and adequate buildings. When you then include the expanded burghs, taking into account Anniesland, Cathcart, Langside and so on, you would find that in fact, there were very few areas which would be called slums. Even the 85,000 people in the Gorbals and Hutchesontown areas could not be called to account for being slum dwellers. They were living in desperate conditions, but making the best of it as the city prepared for rebuilding.

The Bruce Plan

In the modernising of Glasgow, there have been mistakes and challenges along the way. There is no doubt that on an international stage, Glasgow is well on the road to being considered a modern European city, attractive to live in and attractive to visit.

One of the mistakes made was in building new tenements under 1930 and 1935 housing acts. These new tenements were in areas such as Blackhill, Possil, Braidfauld and Temple. There were also some in Anderston and my great aunt lived in one in the Calton. I remember these well as being dark and dismal. Made of a grey reconstituted stone, they were much cheaper to build than traditional buildings using brick or stone. They had all the drawbacks of the tenements, including open closes and small back courts or drying greens. They were notorious in that, with low rents, they were seen as a dumping ground for antisocial tenants, for crime and drug dealing. No doubt they would often have been better than the crumbling tenements that people had left to make way for the high-rise flats, but not always.

Glasgow in the 1940s, 1950s and 1960s was not an attractive place to live but plans were afoot to do something about it. While the Glasgow Garden Festival was credited as a real starting point in the mind of the Glaswegian, the plans were already underway. Maybe the Glaswegian didn't really have a full understanding of what was planned but when they woke up, the sparks began to fly.

Had Robert Bruce's 'First Planning Report to the Highways and Planning Committee of the Corporation of Glasgow' in 1945 been fully implemented then you would hardly have been able to recognise the city. At the centre of the recommendations in the report were radical and alarming proposals to demolish large section of the city centre. Thirty-nine Comprehensive Development Areas (CDAs) were identified. People in areas like Govan, Anderston and Townhead would be moved from their houses and in their place, multi-storey and lower-levels buildings would be built, with areas being identified for commercial and industrial use. Among the things going were to be the Glasgow School of Art and the City Chambers. Also going were the Central Station and the Glasgow Art Galleries.

As Glaswegians will know, the above didn't happen but a great deal of what he wanted did happen. The city succumbed to car madness. A motorway was built through the city and St Enoch's station was demolished along with great swathes

of decent properties. Bruce wanted a new 'healthy and beautiful city'. How the destruction of the Art School would have achieved this is anyone's guess. He also thought that the City Chambers were outdated.

The main thrust of Bruce's plan was to redevelop the city within its existing boundaries, building up as there was actually very little space. However, there was an alternative report produced by the Government in 1949, the Clyde Valley Regional Plan. This advocated overspill as a policy and in particular the movement of citizens to the new towns of East Kilbride, Cumbernauld and further afield. This was seen by Glasgow councilors as a means whereby the strong Labour support within the city could be dispersed and diminished. However, parts of both recommendations were accepted and redevelopment started, leading to two decades of intensive building in and around the city.

It was a period of intensive activity. While streams of lorries carried rubble out of town to landfill, work started on the new towns and 'schemes'. These included Castlemilk, Drumchapel, Easterhouse, Pollock, Springburn's Red Road flats and a multitude of other multi-storey flats. Glasgow acquired more high-rise buildings than any other city in Europe and also became the biggest landlord.

There is absolutely no doubt that inadequate housing had to go. We were part of it. My family was moved in 1964 from North Street in Anderston to leafy Knightswood. My cousins from McIntyre Street went to a very early Easterhouse. Mrs Boyle from the next landing went to East Kilbride when it was one street, or looked it. We visited her once. Granny Durning went to Easterhouse from Brigton.

Yet we still maintained the identity and the friends for many years and some still do. People from Anderston living in other parts of the city regularly get together. You will now hear the refrain 'He's an Anderston Man' like a badge of honour and David McLaughlin asked me if I had my USA car sticker. USA? I ventured. 'Aye – used to stay in Anderston!'

One major thing which was done was the demolition of Glasgow's 'slum' housing and for the residents to be rehoused in new towns or in the new housing schemes on the outskirts of the city. Some say that these were to become the new slums!

Prefabricated bungalows: 'Down in the jungle living in a tent – better than a prefab – nae rent!'

Glaswegians will be familiar with the M8 and the Kingston Bridge as well as the M74. I would certainly take exception to the fact that we were moved from our slum tenement to make way for the Kingston Bridge. For our building was far from being a slum and was equal to many of the buildings still standing and since renovated in Anderston and Partick. We even had an inside toilet and a bath! Oor hoose certainly wasn't big enough for a family with four boys and the move was our chance for a new start, away from the smog of the inner city.

Still, the M8 was built and we were moved. While the building of the motorway through Anderston, Cowcaddens, Kingston, Tradeston and Govan did mean the removal of many slum houses, it also meant the removal of many fine buildings, particularly at Charing Cross, including the Grand Hotel and the whole east side of my own North Street, including the famous Wooden Hut and The Office pubs. Charing Cross railway station was moved to a new location.

What is not realised is that the M8 through these areas and the M74 in the south and east were only parts of what was to be an inner ring road; this road was to go through many of the 'leafy' parts of Glasgow. There was such an outcry that the rest of the Inner Ring Road Initiative was shelved. This included a motorway through Maryhill and north to Balloch! It has taken forty years for the completion of the link from the M8 to the M74. While not the exact route suggested by Bruce, the link is now there.

When it came to railways, Bruce was obviously a 'brutalist' with no sense of heritage. Glaswegians will know that in the 1960s we lost St Enoch and Buchanan Street Station to cuts and the developers. Bruce wanted to get rid of all four stations

Charing Cross with the Grand Hotel in the background.

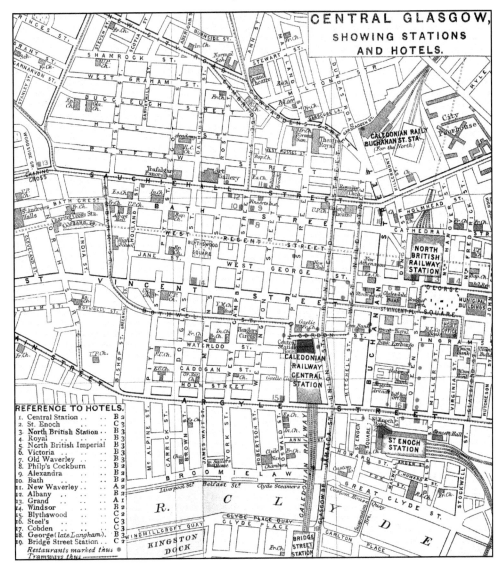

Map of central Glasgow showing the railway stations and hotels.

including Central and Queen Street stations and replace all with a Glasgow North and a Glasgow South Station. It just wouldn't have been the same.

One major change was the redevelopment of the Underground. Now we have 'The Clockwork Orange'. The smells of the tunnel are still there, if not the leather, wood and electric smells of the cars. The trains are now more modern-looking and in the way of the Glaswegian they developed the very apt nickname reflecting the look of the train as well as the film of that name starring Malcolm McDowell and Michael Bates.

'Aye Ready' – The Glasgow Fire Service

I can't remember how we first got to know about it, but it was just at the beginning. The shouts went round that there was a fire in Cheapside Street. Now fires were quite common in the centre of Glasgow in the 1950s and 1960s, common enough for us to look forward to them in a warped sort of way. We had seen the St Patrick's Girls School on fire as well as the famous St Andrew's Halls; the horrible James Watt Street Fire; the Theatre Royal in Hope Street; and sundry others including the ever-constant chimney and chip-pan fires, common on a Friday night.

We went to see what was happening and at that stage, as the first of the fire engines were arriving, we could wander down Cheapside Street and Warroch Street to get a better view. To begin with, the fire was within the warehouse, which turned out to be a whisky bond owned by Arbuckle, Smith & Co. There was not much to see, just the plumes of dark smoke, the smell of burning, the fire bells and the firemen running around, attaching hoses, just ignoring all those people who were in the way. In those days you could get very close to a fire and we all did that day, but very soon we had to move away where we lined up along Stobcross Street, even as a tea van arrived beside us to make sure the firemen were fed as they battled the growing fire.

The fire progressed and fire vehicles arrived in convoys. We went home for our tea but we were anxious to get out again. And when we did, the fire was getting bigger. We waited for hours as it grew and the flames got higher. We looked down Cheapside Street, where there was a lot of activity. A fire engine had made its way down the street and we could see it with its ladders extended high above the blaze, with the hose having little impact on the flames below, which were shooting ever higher and higher.

There was a rumble and all of a sudden the fireman on the ladder wasn't there. A wall had come down and all we could see were clouds of dust and flames. The wall had completely engulfed the fire engine and the men in and around it. Except for the sound of burning and sudden gasps, there was complete silence. The memory of the night of 28 March 1960 has stayed with me ever since. I had just turned ten.

We had to go to bed eventually but before we did, not that we could sleep, we went up to our flat roof where we could see the fire. I remember seeing flames higher than the church steeple nearby. My Auntie Polly in Nitshill said that they could see the flames from there, which must have been a good ten miles away.

I still remember the smell of whisky burning during the fire, which raged for three days, killing fourteen firemen and five men of the Glasgow Salvage Corps. Forty machines and 450 firemen attended the fire – it was the biggest peace-time fire in Glasgow's history. My mother had been a firewoman during the war and she knew a number of the men who were killed that day and night. Shops immediately set up funds for the families. I remember a sweetie jar outside a shop in Stobcross Street and woe betide anyone who might have tried to steal it! A memorial to the men killed is now in the Glasgow Necropolis, where a remembrance ceremony is held each 28 March.

While the fire had a marked effect on the way and where whisky was stored in Scotland, it took a long time for effective fire prevention and fighting measures to

be introduced. This was not before more disasters, even in the same year, and only a couple of streets away: the James Watt Street Fire was to claim twenty-two people in 1968.

Again, the fire was in a former whisky warehouse converted to house Julius and Samuel Stern's upholstery business. A glassware company occupied the basement. Glasgow at some time acquired the title of 'Tinderbox city', probably given by the media. The prominence of fires in the city was often put down to the architecture of the mostly Victorian buildings with their extensive use of wood. Within the Stern buildings, the floors were wooden, the stairs were wooden and it was filled with inflammable materials.

While it may nevertheless have been survivable, a day after the fire I saw the reason why it had not been. It had been a whisky bond and for security, the windows on all three levels were barred. Firemen and onlookers could only watch as those inside futilely tried to bend iron bars to escape. As the onlookers were beaten back by the heat and smoke, the screams of the trapped died. Only four people escaped from the fire: three workers and a lorry driver.

It was surely a disgrace that the windows were barred but it probably never occurred to anyone to remove them. The resultant enquiry blamed the barred windows, locked fire escapes and the negligence of the Stern brothers, one of whom, Julius, had died in the fire.

If any fire had prompted change then the James Watt Street Fire did. A number of bodies began to take action. Besides official reports, the Fire Brigades Union, the Scottish Trades Union Congress and others produced reports, probably addressing the obvious but asking for legislation on such things as allowing the fire brigade to get involved in fire prevention, removing barred windows, and a condition that staff be informed if buildings were refused a fire permit.

The reports probably came out too late to have prevented a near identical event in Fordneuk Street in Bridgeton the following year when a fire engulfed another upholstery warehouse. Fortunately no-one was killed.

The Cheapside Street and James Watt Street fires were to be the largest till that time and heavily influenced the development of the fire service. There were to be many more, smaller, fires, many of course attributed to smoking at home, often under the influence, and cumulatively keeping Glasgow high in the fire death statistics. Our folk song hero Matt McGinn was a casualty of the same thing.

While the long fight for fire and health and safety laws have prevented many an outbreak and saved many lives, very little can be done if the laws are flouted or not understood.

It wasn't just fires that were to call out the tenders. The Clarkston explosion of October 1971 was caused when a build-up of leaking mains gas ignited, blowing the local shopping centre to bits. The blast killed twenty-one people, mostly shop workers and shoppers as well as bus passengers on the way past the shops. The accidental gas main fracture was put down to corrosion and stress on the pipe. A monument to the dead marks the spot. It wasn't to be the only time that a gas explosion was to rip apart lives and livelihoods.

The most recent explosion was that at Stockline Plastics in Maryhill Road, when nine staff were killed and thirty-three injured in a gas blast in May 2004. Lord Gill presided over the fatal accident enquiry, which he called an 'avoidable disaster'. The enquiry found that metal pipes carrying liquefied petroleum gas (LPG) had been buried in 1969 and forgotten about. When the corroding pipes finally failed the resulting build-up ignited, destroying the building in seconds. The pipe would have cost £405 to replace.

Lord Gill found serious weaknesses in the health and safety regime at the factory as well as deficiencies in the Health and Safety Executive's understanding of the dangers.

Coping with all of this and with an exemplary record was the Strathclyde Fire Service, whose reputation in Glasgow has always been high. So much so that a Glasgow Firefighter's Heritage Trail has just opened, marking where the fire heroes have lost their lives saving people and property. Twelve memorial plaques have been placed around the city. The trail will also follow sites of former fire stations and other major events where citizens of the city were killed. One of these plaques commemorates another major fire in which seven firemen lost their lives, in a warehouse fire in Kilbirnie Street in August 1972.

While we have concentrated so far on the most recent fires, Glasgow had its very own Great Fire in 1652, fourteen years before London's. The candlemakers of the burgh were blamed for causing a number of big blazes in Glasgow. Eighty vennels (lanes) were destroyed and 1,000 families were burned out of their homes by a fire that consumed a third of the town. For this reason they were forced to move outside of the centre of the town to what we now know as Candleriggs.

The 1652 fire had been preceded in 1647 by an outbreak of the plague which caused many deaths and sent the university to Irvine to avoid it. The fire started in the High Street, in the house of James Hamilton. At that time the houses would have been mostly wooden, with thatched roofs; lighting would have been by animal oil lamps or candles. The combination was a potent mix of flammable materials just needing a spark to set it off. The fire spread out from the High Street, down the Saltmarket and along the Trongate and Gallowgate, reaching the Brigat (Bridgegate) before burning out. During the fire, churches were opened to house and feed those burned out and temporary accommodation was built. The cost of the disaster was assessed at £100,000 sterling with only £1,000, a token sum, coming from the government of the time.

Some good time after the fire, the Council sent representatives to Edinburgh to see their fire engine, an 'ingyne for slockening of fyre'. The result was that five years after the fire, Glasgow had its very first fire engine and fire station. Their firefighting equipment included buckets for water and long poles for pulling down burning thatch.

Following a case of arson in 1677, carried out by a disgruntled apprentice at his master's premises at the corner of the Saltmarket and Trongate, 1,309 houses were destroyed. It was time not just to put out fires but to prevent them happening, and this started with a council law that all new or restored houses were to be built of stone from 'heid to foot, bak and foir'. This was the start of the city of Glasgow becoming the handsome stone-built city so praised by Defoe and others. Defoe, author of

Robinson Crusoe as well as being a government spy, also wrote *A Tour thro the whole Island of Great Britain between 1724 and 1727*:

> Glasgow is, indeed, a very fine city; the four principal streets are the fairest for breadth, and the finest built that I have ever seen in one city together. The houses are all of stone, and generally equal and uniform in height, as well as in front; the lower story generally stands on vast square dorick columns, not round pillars, and arches between give passage into the shops, adding to the strength as well as beauty of the building; in a word, 'tis the cleanest and beautifullest, and best built city in Britain, London excepted.

Around about this time Glasgow brought another machine from London and ten years later, in 1744, appointed Robert Craig as a full-time firefighter. He was later given twenty-four firefighters, who were issued with stout leather helmets bearing the city coat of arms. The fire service was born.

Throughout Britain, from around 1770, in order to protect their investments, companies had begun to take out fire insurance with companies which had their own firefighters. The buildings so insured were identified by fire marks, which were metal plaques fixed to the sides of buildings so that the private brigades could identify them, presumably if the fire wasn't yet obvious.

With the coming of the new municipal brigades the idea fell out of use, in Glasgow around 1787, although the plaques remained on the buildings for many years. Even in the 1950s, before such things were collectable, my father pointed one out to me in Jamaica Street. One such insurance company was the Sun Fire & Life, whose building, designed by William Leiper, is now a Category A listed building at the corner of West George Street and Renfield Street.

Glasgow of course, while a borough, was only one of the municipalities growing around the Clyde, all with their own firefighting requirements. Govan became a police burgh in 1864 and a fire brigade was part of the responsibility. It was based in the town hall in Albert Street (now Orkney Street). The fire service served the Burgh of Govan until 1912, when it became part of the Glasgow Fire Brigade.

Partick also had its own force, based in a 1907 fire station which housed horse-drawn fire engines. The fire station received a direct hit during a bombing raid in 1941. A young messenger, Neil Leitch, was twice severely injured when he was sent for assistance during an air raid. He died from his injuries. He was gazetted by King George VI for his bravery and the city commemorated him with a Celtic cross in Dalbeth Cemetery.

Kinning Park, Govan, Hillhead and Partick burghs were to be subsumed into Glasgow over time and where they had fire brigades, these became part of the Glasgow brigade. In 1891, the brigades that had been under control of the police became independent, although still under the control of the city.

The fire at a wholesale pharmacist, W. & R. Hatrick, in Renfield Street was to be the site of the first loss of life in the service. While the fire was under control, an explosion brought down the building and killed four firemen.

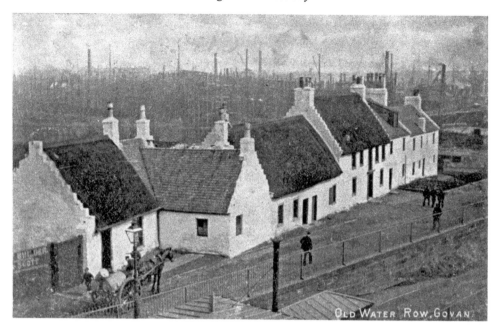

Water Row, Govan, a historic lane leading down to the Clyde from the heart of Govan to an ancient crossing point. Here too was the ferry wharf.

By 1829 there were forty-eight firemen with around six engines which would be pulled by the firemen to fires. The water was taken from large water butts pulled to the fire for horses. The fire engines were to be called 'the butts' well into the twentieth century and my mother, who was in the fire service as a young woman, referred to them as such.

With the coming of the Second World War, a coordinated approach to the provision of fire cover was needed. To supplement the work of local brigades, the Auxiliary Fire Service (AFS) was set up. This is an opportunity for me to tell you about the role of women in the fire services. The AFS was the first time that women took an active part in the fire service. My mother was one of a small number of women who joined the AFS and received the same training as men. I have pictures of her jumping from the roof of Bryant & May's match factory in Maryhill, and being trained in using the fire pump. While they did not actually fight fires they were in attendance and carried out dispatch duties and the other routine activities of firemen such as driving fire engines and checking lines and hydrants. My mother had the option to join the Auxiliary Territorial Service (ATS) or another service but chose the AFS.

The establishment of an integrated approach to fighting fires was hampered by the incompatibility of equipment such as hydrant valves and hoses. Standardisation was to come with the establishment of the National Fire Service (NFS), which joined the local brigades with the AFS in 1941.

Following the war, the Fire Services Act of 1947 dissolved the NFS and put the fire brigades back under local authority control, although there were far fewer than before. This left the Glasgow fire service with a range of different vehicles but over

Firewoman Prendergast - one of the first women to be taken on to train as firewomen with the Auxiliary Fire Service.

time, the purchase of modern equipment was to make it a modern fire service, fighting fires of every description.

One vital piece of equipment was the fireboat. The MV *St Mungo* was berthed in Yorkhill, at the Glasgow Marine Fire Station. She was a replacement for two previous steam fireboats. Fire on the busy river and in the dockside warehouses and factories was always a danger and the boat, which I visited as a very young boy with my mother, was an invaluable assistance in controlling ship fires. It also had an important role in pumping water at the Cheapside Street Fire in 1960. The boat was commissioned in 1959 and on the formation of the Strathclyde Fire Brigade in 1975 it was decommissioned and later sold on to Offshore Workboats Ltd. There was little need for it on the Clyde. The ships had gone, as had the warehouses, and access for fire engines had become much better.

One innovation which improved access to tall buildings was the unique 'Scoosher', which was a hydraulic boom holding an infra-red detector, a fire hose and a spike which could break windows to allow pumping into buildings. Another innovation was the foam tenders designed by the fire service. Covering a fire with foam excluded oxygen and extinguished the fire.

Not all innovations were a success though. Around 1834, the Superintendant, Mr Robertson, designed and built *Clyde*, a three-ton engine which needed thirty-two men to pull and operate it and was consequently late for fires. The need for more mobility was obvious though and the first horse-drawn vehicles were garaged in the new fire station in College Street in 1870. The glorious Central Station was opened in Ingram Street in 1900 and received its first fire engine from the Wolseley Tool & Motor

Company in 1905. It was the start of a motorised brigade for the city. By the way, it is said that the magnificent marble halls of the engine house were made from left-over marble from the nearby City Chambers.

The 1975 amalgamation to form the Strathclyde Fire & Rescue Service encompassed parts of Central Area Fire Brigade, the Glasgow Fire Service, the Lanarkshire Fire Brigade and others, creating Scotland's largest brigade, covering an area of over 5,000 square miles, including two major and three minor airports as well as numerous factories, whisky bonds, oil installations, public and historic buildings as well as numerous tenement and high-rise buildings.

As with many other businesses and occupations, there has been an ever-growing need for specialist firefighting services. Recent history has shown that the oil industry has its own challenges, as do the airports, factories and roads. While the cities still experience dramatic fires, they are very much safer now. Fire prevention and emergency evacuation has improved.

The decision was taken by the Scottish Parliament to bring the collective skills of all brigades together into one service. As a consequence, the Scottish Fire and Rescue Service, with headquarters in Perth, was established in May 2013. In 1829 the Glasgow superintendent had forty-eight firemen. In 2013, the Scottish Fire and Rescue Service had 9,000 fire fighters and support staff.

Before we leave the fire service, there are a couple of interesting wee points. The first one is about Wallace the fire dug. Wallace was a stray that followed a fire engine back to the station in 1894, where it was adopted by the crews. It ran alongside the engines as they went to fires. One visitor made a special pair of rubber boots for him on noticing that his paws were sore from his efforts. It is not thought that he used them as he seems to have gone bare-pawed. On his death in 1902, Wallace was stuffed and put on display along with the boots. While probably not in the same league as Edinburgh's Greyfriars Bobby, nevertheless Wallace is Glasgow's very own heroic doggie.

You might remember that the records of the Cheapside Street Fire showed that five members of the Salvage Corps were also killed at the fire. I remember the Salvage Corps well but its role has probably been forgotten by many. Its engines were stationed in a fire house at the corner of George Street and Albion Street and I would pass them on my way to school on the bus. I remember my mother explaining their role.

Just as insurance companies had set up their own fire brigades, with the growth of municipal fire services, the private brigades were required less. The insurance companies began to concentrate on saving the goods once the fire fighters had got the fire under control. Glasgow Salvage Corps was raised in 1873 and disbanded in 1984. There were two others, London and Liverpool, disbanded about the same time.

The origins of the Salvage Corps were in 1857, with the amalgamation of the Glasgow Insurance Committee and the Glasgow Salvage Committee to become the Glasgow Rate & Salvage Committee, eventually to become the Salvage Corps.

The original role was to assist the fire service in salvage work but it also undertook inspections of properties, power stations, gasworks, railway yards and other works. I hadn't realised that they were the early providers of fire prevention advice and

Citizen Firefighter. In front of the
Grand Central hotel stands this
memorial to all firefighters, past
and present, of Strathclyde Fire and
Rescue. I am particularly proud of this
as my mother was a firewoman in the
National Fire Service, a predecessor to
the SFR.

that, having been set up by the insurance companies, they had the power to change
insurance rates. They would issue fire prevention advice and, if this was not followed,
had the power to fix higher rates if they thought that there was a fire risk.

The corps in all three cities were closed down by the insurance companies on the
basis that they were not now cost effective and that their duties had been taken over
by the fire services under the 1947 Fire Services Act.

The Glasgow Police

By the end of the 1700s the growth of Glasgow was firmly established. It had reached
a critical mass where growth supported growth. With this growth came overcrowding,
riches for some and poverty for others; mansions and town houses for a few and
tenements. The streets were clogged with people, horses and carts. From 1780, the
population had risen from 48,000 to 200,000 in 1830. It had quadrupled in fifty
years.

With poverty for some and wealth for others came crime. The crime was diverse,
ranging from petty theft and burglary to body snatching. The body snatching, by
'resurrectionists', was a result of the need for corpses for the schools of anatomy,
with some of them not being too particular about where the bodies had come from.
The practice of taking fresh corpses from graves led to the use of mortsafes, which
were heavy stone or iron structures or slabs designed to prevent the digging up of

newly buried bodies. In addition, watch committees were set up to keep an eye on graveyards. It is said that Glasgow had the first of these, with a membership of around 2,000.

Early punishments were cruel and even humorous. One involved the perpetrator's ears being pinned to the door of the Tolbooth (lug pinning). However, it attracted so many sightseers, including schoolchildren plunking school and weavers leaving their work, that it was abandoned. I would like to think that the real reason was that it was because the poor criminal had ripped his ears apart trying to escape the dung and rotten vegetables being thrown at him. Again, this is one of Glasgow's mythical stories which probably helps the new ghost tours in the Merchant City. Surely no one would make it up?

What was certainly true was the use in Glasgow of the 'branks' or scold's bridle. When I was very young my father, from Bridgeton, would take us to the People's Palace in Glasgow Green, where a frightening range of primitive crime prevention instruments was on show. There was a wheeled stretcher for carting drunks to the jail but it was the branks that I remember so well. And I strongly remember how it might fit round the head of our primary schoolteacher, Mrs Hooligan (honest, although it may have been Houlihan).

The branks was a wrought-iron cage which would fit round the head, with a protrusion which fitted into the mouth, keeping the tongue down. The whole cage would then be locked.

Well before the formalisation of the police forces in Scotland, law was upheld by the Kirk Sessions. Primarily for transgression against Church rules such as breaking the Sabbath or taking the Lord's name in vain, the punishments seemed to have been meted out arbitrarily, and often against women who were felt to be above themselves. The use of the branks was one such torture, particularly if the person wearing it was placed in a public space for the same kind of treatment as the person with their lug pinned to the door.

It may have been because of the Auld Alliance, the traditional Scottish contact with France, that the word 'police' may have come to Scotland. It was only known in Europe, particularly France, up till that point. However, the use of the word seems to have had a different meaning to begin with. At the accession of George I in 1714, a Commission of Police was set up to make 'recommendations for the exercise of Crown patronage in the Kirk and collect information concerning papists, making proposals on reducing the Highlands to tranquility, maintaining the poor and repairing the highways, and disposal of the coarse wool money'.

It wasn't until 1779 that the Burgh of Glasgow met to 'consider the expediency of appointing a fit person to be inspector of the Police of the City of Glasgow'. By this time there were citizen constables, possibly a development on the 'watchers' already mentioned. The Burgh considered that they couldn't give close attention to the activities of these police and needed someone to preside over them. James Buchanan was appointed and he established an eight-person force. It seems that lack of finance led to the collapse of the force in 1781. The city had tried unsuccessfully to get its Police Act on the statute book, which would have provided the funds for the force

to continue. In 1790 the force ran out of money and the city went back to a citizen watch.

In June ten years later, in 1800, the city, this time successfully, petitioned the government to pass the Glasgow Police Act, which established the City of Glasgow Police, the first in the country. It predated Robert Peel's London Metropolitan Police, the 'Bobbies', by twenty-nine years although the city had had watchmen since 1663. The Glasgow Police also introduced the concept of preventive policing well before Peel.

A city merchant, John Stenhouse, was appointed as the first Master of Police. He appointed three sergeants and six constables who had specific territories to cover, carrying a lantern and stave. The beat policeman had been established, supported by sixty-eight watchmen.

The Police Board set up under the act also encompassed firefighting, lighting, cleansing, controlling taverns and dram shops, and paving. To this effect, the Act determined that any property owners with buildings or spaces fronting streets, squares or public places should ensure, at their own expense, that the grounds in front of these properties be paved with flat stones. The pavements were not to be more than 12 feet wide in streets 60 feet wide and 8 feet in streets 40 to 50 feet wide. This probably followed the lead of the 'Plainstanes', the first Glasgow pavement laid out for the Tobacco Lords in the Trongate. However, they were the only ones allowed to use it, ordinary citizens and even ladies being required to use the street with its mud and ordure.

In 1819, the city's first detective or 'Criminal Officer' was Peter McKinlay, who had previously been a police lieutenant. With a deputy two years later, the detective force was established. The first woman employed in actual police work was Miss Emily Miller, who was taken on in 1915. She was actually classed as a 'statement taker' in cases of sexual crime.

Of course, just as the Glasgow Fire Brigade was expanded by the inclusion of forces from other areas, the same was true of the police. In 1912 the Glasgow force merged with the Govan and Partick forces. Gorbals, Anderston and Calton had already been included in 1846 with the Municipal and Extension Act. At this time the force was divided into four divisions, A, B, C and D; that is, Central, Western, Eastern and Southern.

The enthusiasm that encouraged thousand of young men to sign up to fight in the First World War similarly infected those in the police force. Three hundred Glasgow officers enlisted, with the result that the force had to take on 400 temporary constables. Because of the continuing depletion the Chief Constable ordered police officers not to enlist. Of the 750 policemen who had enlisted before this, 112 were killed with thirty-three reported missing in action.

As we saw earlier, the aftermath of the Great War was stagnation, depression, and rising unemployment everywhere, but in those manufacturing areas dedicated to building the engines of war, it was most keenly felt. Glasgow and the west of Scotland suffered badly. It was most certainly not the fit land for heroes to live in, in the words of Lloyd George, the Prime Minister of the post-war coalition government elected in 1918.

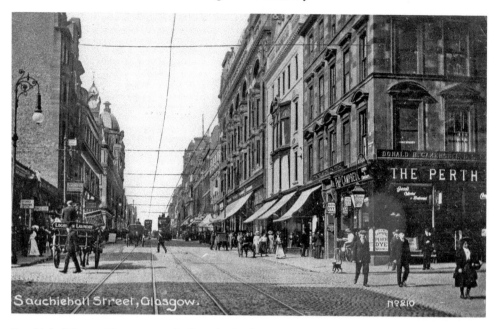

Sauchiehall Street. You can see the laundry baskets on the cart on the left marked 'Lochburn Laundry'. This is on its way to Maryhill, to Lochburn Home, run by the Glasgow Magdalene Institution for the Reformation of Penitent Females. The home closed in 1958 following an inquiry into the ill-treatment of inmates. Glasgow brought-up Peter Mullan made a film about Ireland's Magdalene institutions.

While he did much for social reform, embarked on with enthusiasm in Glasgow, nevertheless he could not reduce the effects of the reduction in manufacturing and trade, affecting many industries, including shipbuilding, engineering and fishing. Unemployment in the 1920s rose to 10 per cent and was to continue as such until the Second World War.

In 1921, events in Ireland and an event in Glasgow would bring the Irish War of Independence to our front door. The war, between the Irish Republican Army and the British Government, was fought between 1919 and 1921. While there had been riots and fights between Catholic and Protestant in the later days of the previous century, the ongoing conflict in Ireland was to cross the water to Glasgow and go down in history as 'The smashing of the van'.

In May 1921, a police wagon carrying Frank J. Carty of the Sligo Brigade of the IRA and escorting police officers was ambushed by a group of armed IRA supporters on its way from the courthouse to Duke Street Prison on the High Street.

A gun battle erupted and within minutes it had claimed the lives of Inspector Robert Johnson and Detective Sergeant Stirton. The subsequent dragnet caused rioting throughout the city, particularly with the arrest of a priest, Father Patrick McRory. In the event, the attack was thwarted, with Carty being transferred back to Ireland, where he was released.

Those who were arrested in the dragnet were released following a clever defence of the case. Most of the perpetrators were able to claim alibi. No-one was found guilty

1 *St Mungo as the Patron Saint of Art and Music* at the north entrance of Kelvingrove Art Gallery and Museum. The statue was sculpted by George Frampton and unveiled in 1900. (Author)

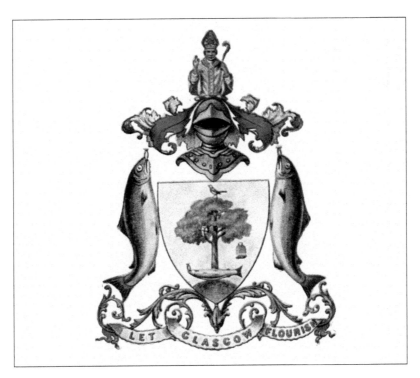

2 The Glasgow Coat of Arms: There's the tree that never grew/ There's the fish that never swam/ There's the bird that never flew/ There's the bell that never rang.

3 An iconic image in Glasgow: the original label for Paterson's Camp Coffee. Paterson was another Glasgow Grocer most famous for his chicory essence. The soldier on the label is Major General Sir Hector MacDonald; MacDonald was hero-worshipped in Scotland for his campaigns in Egypt and in South Africa during the Boer Wars. The more recent labels have the Indian servant as an equal colleague, sitting with MacDonald enjoying a cup of chicory coffee.

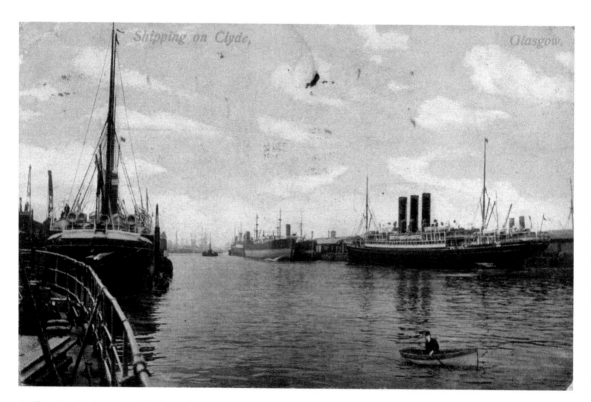

4 Shipping in the River Clyde in about 1905, including the Anchor Line's SS *Columbia* of 1902 (on the right). (J&C McCutcheon Collection)

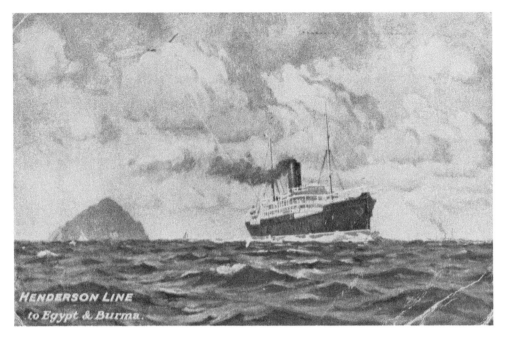

5 Paddy Henderson's Burma Line to Egypt and Burma, passing Ailsa Craig *c.* 1938.

6 Speirs Wharf at Port Dundas. Speirs Wharf was originally the offices of the Forth & Clyde Navigation Co. and the City of Glasgow Grain Mills and Stores, built for John Currie & Co. in 1851. The buildings were converted in 1989 into 150 loft-style residential apartments, a private leisure centre, and nineteen commercial units. (Author)

7 Hillhead Subway Station.

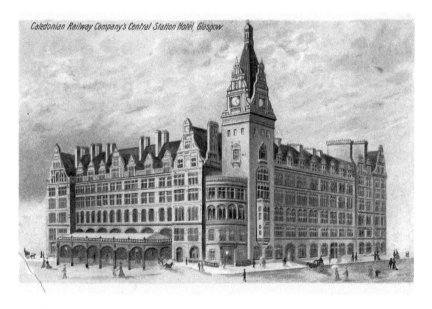

8 Glasgow Central Station and Hotel.

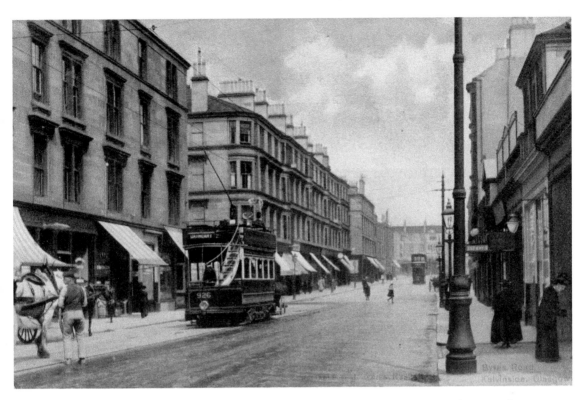

9 Glasgow tram No. 926 heading along Byres Road, Kelvinside, towards Cathcart in about 1906. The Hillhead subway station can be seen to the right of the picture. (J&C McCutcheon Collection)

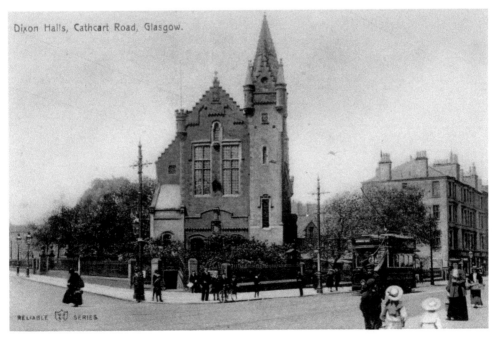

10 The tram in this 1906 image is heading down Cathcart Road, past the Dixon Halls. This Scottish baronial building was built in 1879 as Crosshill and Govanhill Burgh Hall and was renamed when the two burghs were annexed by Glasgow in 1891. (J&C McCutcheon Collection)

11 John Brown & Son, Manufacturers. John Brown's weaving mill was in French Street in Bridgeton. They advertised themselves as making Madras muslin and harness muslin. The factory in French Street cost £8,300 to build in 1899. French Street was originally Papillion Street, named after the Frenchman who introduced Turkey red dye to Glasgow.

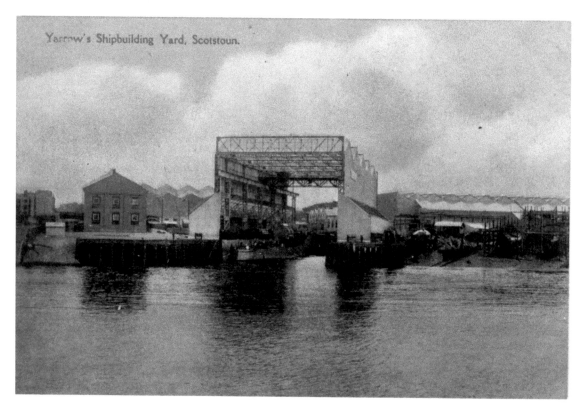

12 The gantry at Yarrow's Shipbuilding Yard in Scotstoun. In total, about 400 ships were built by Yarrow on the Clyde. (J&C McCutcheon Collection)

13 A remnant of the shipbuilding age. The Titan Crane was built in 1907 at the John Brown Shipyard. It is now a visitor centre and a Category A listed building. It hosts a shipbuilding museum. (Author)

14 No. 73755, *Longmoor*. Built at North British Locomotives, Springburn, it was the thousandth freight locomotive ferried to Europe since D-day. (Utrecht Railway Museum)

15 Walter MacFarlane sewage gas vent on Holburn Street, Aberdeen. If you take a walk through Macquarie Place in Sydney, Australia, you will come across a canopy for a fountain. Although the fountain has been removed, the canopy is a link between Glasgow and Australia and between this new century and the end of the nineteenth century. For this canopy came from Walter MacFarlane's Saracen Foundry in Possilpark, Glasgow, one of eight ordered for Sydney in 1870. (Author)

16 The Stewart Memorial Fountain. 'To commemorate the public services of Robert Stewart of Murdostoun Lord Provost of the City of Glasgow from November 1851 till November 1854 and to whose unwearied exertions the citizens are mainly indebted for the abundant water supply from Loch Katrine This fountain was erected 1872'. (Author)

17 Gallowgate.

Old Thatch Cottages, Scotstounhill.

18 Cottages in Scotstounhill. Until the 1860s, Scotstoun was the site of the Oswald family estate, Scotstoun House. With the expansion of shipbuilding yards west along the Clyde, the estate was gradually broken up and sold for housing. (J&C McCutcheon Collection)

19 Another view of Scotstoun, showing the wide, tree-lined streets of this garden suburb development. (J&C McCutcheon Collection)

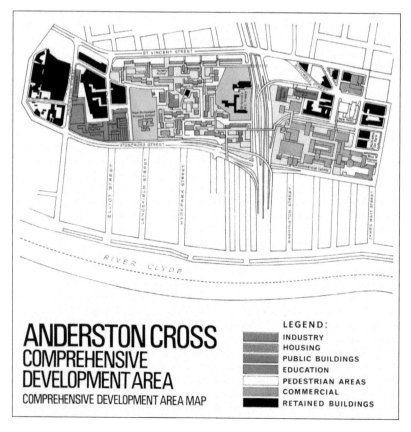

20 Anderston Cross Comprehensive Development Area.

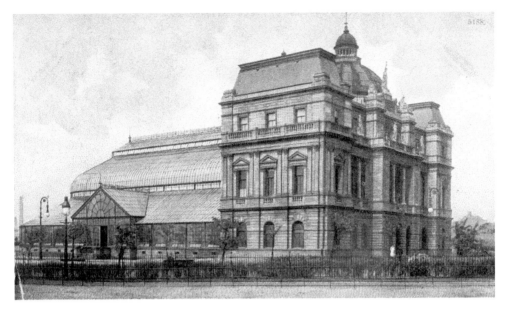

21 The People's Palace, still a marvellous museum dedicated to Glasgow history.

22 The former
Glasgow Mechanics'
Institute, Bath Street.
(Author)

23 A statue of William Thomson, Lord Kelvin, in Kelvingrove Park. (Author)

24 Lex Mclean. 'I spent six years in my first school – the happiest days of my life. Then they took me out of there and put me in a boy's school. It was a school for backward boys. However I didn't mind in the least for just across the road was a school for forward girls!'

25 Jimmy Logan's Metropole at George's Cross. St George's Cooperative department store is on the right.

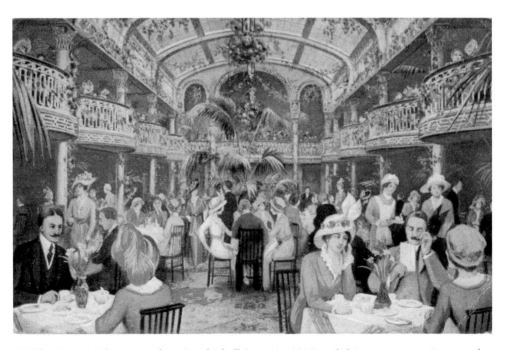

26 The Picture Salon opened on Sauchiehall Street in 1913 and this two-storey winter garden and tearoom, with a glazed roof and exotic plants, was built above it. The cinema here did not last long, closing in 1923. Although remnants of the winter garden still exist, there are plans to convert the building into a boutique hotel. (J&C McCutcheon Collection)

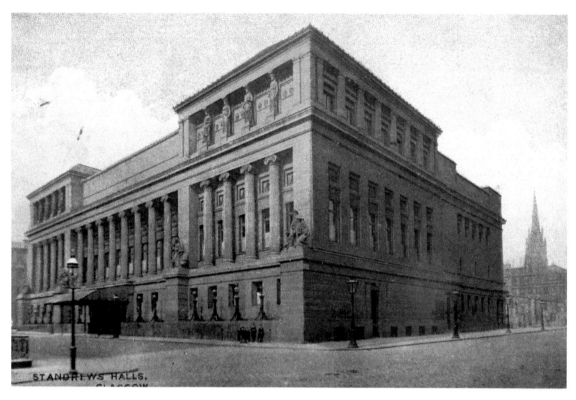

STANDREWS HALLS.

27 St Andrew's Halls, Charing Cross. The halls, opened in 1877, were designed by architect James Sellars and opened in 1877 to meet the demand for a large hall in the West End. They feature a large group sculpted by John Mossman as well as lamp standards produced by Macfarlane's Saracen Foundry. The building was almost completely destroyed by fire in 1962. The façade was saved and incorporated into an extension to Mitchell Library.

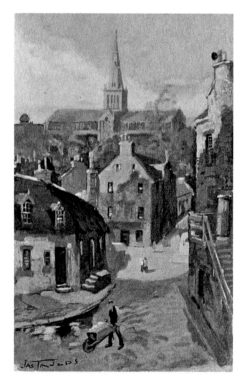

28 Glasgow Cathedral from the Drygait.

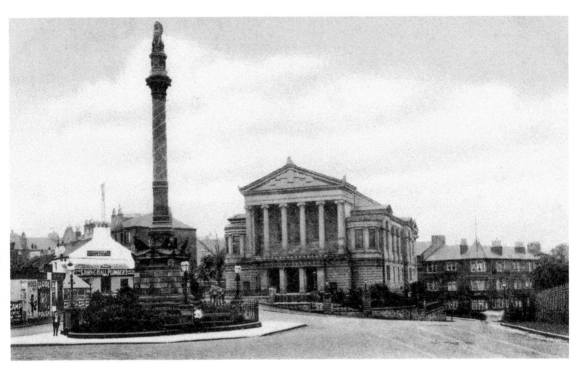

29 Monument to the Battle of Langside, Battlefield Place, Langside. Langside may be quiet and leafy now but a battle was fought here on 13 May 1568. In 1568, Mary, Queen of Scots had been held captive in Loch Leven Castle. She managed a famous escape and headed to Hamilton country and Dumbarton Castle, from where she hoped to restore her place on the throne.

30 The Hielenman's Umbrella in 1970, with one of Glasgow's first 'Indian' restaurants, the Lahore, on the right. (Dag Nilsen)

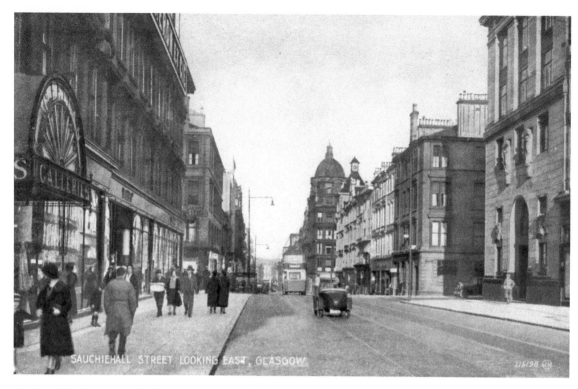

31 Sauchiehall Street with the McLellan Galleries on the left, with an entrance leading through Trerons' frontage.

32 *Miss Cecile Walton* by E. A. Walton. Walton trained at the Kunstakademie in Düsseldorf and the Glasgow School of Art. He was a close friend of Joseph Crawhall.

of the deaths. Perhaps there was not a great deal of pressure to do so as the British Government was negotiating a ceasefire in Ireland, which was to come in to place in July 1921.

This decade was also a period of militancy and fear of revolution that was to result in the General Strike in 1926. The actions of the police at that time were to colour attitudes later on.

While the police force had hitherto been mostly a local force supplemented by citizen watchers, it was to be remembered in future for its actions during the 'Battle of George Square', with images of police brutality appearing in American and Empire newspapers.

The 1920s were a bad time for Glasgow. While gangs had existed in the previous century, the mass unemployment after the First World War would allow a culture of street gangs, mostly of young men with little else to do. While there were gangs in other cities, Glasgow gained a reputation for the number and violence of the gangs, mainly in the east end of the city.

They were essentially territorial and often sectarian. Such things are often seen as a slight on the city's character and while no-one should condone the associated violence, nevertheless the phenomenon of young men forming gangs and carrying knives is not new and was well portrayed by Shakespeare. Unfortunately it still continues, although not as badly as in the 1930s, when it was at its peak.

The gangs may just have been seen as a feature of unemployment but some were also sectarian. My father was born in Bridgeton and lived there during the 1930s. He was in a very good position to tell me the truth about the gangs without any

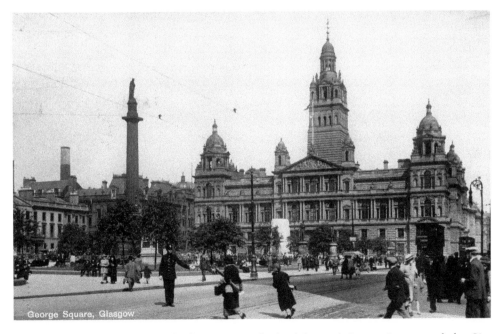

George Square, Glasgow

A Glasgow policeman on traffic duty against the backdrop of George Square and the City Chambers. Percy Sillitoe's tartan caps have not yet been introduced.

exaggeration. While many of the gangs were simply groups of feral youths pretending toughness and had existed from the late 1800s, the Billy Boys and the Norman Conks were in a different league altogether.

Glasgow gang tradition has it that Bridgeton was a Protestant enclave. The truth is that the area was of a mixed religious background with a very Roman Catholic population, being one of the areas along the upper Clyde in which they settled from the early days of the Irish Famines. In fact, it had more Catholic voters than almost any other Parliamentary constituency, second only to Liverpool. It also had a substantial Jewish population.

Out of this mix came William Fullerton, from Franklin Street. Billy Fullerton, with his anti-Catholic gang, the Billy Boys, was to bring violence to the streets of Glasgow, particularly with the gang warfare between them and the Norman Conks, a Catholic gang based in Norman Street, also in Bridgeton.

I will come back to this when we explore sectarianism, but for the moment back to the police, who were tasked with dealing with the gangs, who were said to be able to operate with impunity, terrorising and running protection rackets. The truth was nothing of the sort. Just like now, the media were overstating the issues. Those in the worst areas, including the Churches, did not recognise the stories going about and knew that it was the nature of the area, the unemployment and the lack of amenities, which were at the root cause of the problems, issues which would come back to haunt city planners.

The city fathers did not agree and petitioned Parliament for laws to allow for flogging. Another advisor suggested a form of Foreign Legion as the answer. Very interestingly, the then-Chief Constable, Andrew Donnan Smith, saw it very differently, saying that the city already had powers to deal with the gangs and what they needed was guidance rather than punishment. It was certainly a quandary as the Billy Boys and others were causing concern. Other gangs were a much lesser problem and were generally well known about and kept under control.

Unfortunately, an understanding of the nature of the gangs came to an end with the death in service of Smith, who was replaced by Percy Sillitoe. Percy Sillitoe, Glasgow's most famous Chief Constable, came with the kind of background the Glasgow councillors obviously liked.

Percy Sillitoe was an extraordinary man. He is credited with modernising the Glasgow police force, and with putting a stop to the gangs of the 1930s. He came from Sheffield, where he had already established a reputation for getting the better of the gangs there.

His guiding principle was never to show the gangs that you were afraid of them. He recruited burly Highlanders, who were encouraged to get in about the gangs and show them that they would meet violence with violence. One of these was Archie McDonald, a Glasgow police sergeant and wrestler who hailed from Skye. Sillitoe placed him and Hebridean Donald Campbell at the forefront in a special squad and gave them permission to get waded in. The new squad was relentless in pursuit of the gangs, with great success. The end came when Billy Fullerton was caught in the middle of his gang carrying a child. He was jailed for ten months for being drunk in charge of an infant. Sillitoe then confiscated the sum of £600 from his account. The gang,

without a leader, went into decline, spurred on by the coming of the Second World War, when employment was rising and young men were entering the military.

When Fullerton was released, Fascism was on the rise and he found favour with Oswald Moseley's Blackshirts, forming a gang of 200 bully boys. When Mosley was interned, this too fell apart. Fullerton went into the Royal Navy, where he served with distinction. But he wasn't finished with right-wing thinking as, when he was demobbed, he went on to form a short-lived branch of the Ku Klux Klan in Glasgow. Fullerton died in poverty but was given a huge send off, with 1,000 people following his funeral cortège to Riddrie cemetery.

While gang-fighting of that scale was finished, sectarianism was not and we will come back to both. Meanwhile, Sillitoe continued to fight violent crime and, being required to cut costs, knew that the only way to do this was to modernise the force. His most memorable innovation was what has come to be known as the Sillitoe Tartan. He believed that the policeman's helmet was out of date and impractical for modern-day policing. Based on the tartan band on the military Glengarry cap, he introduced a black and white band. This feature was then adopted by the police forces of Australia and New Zealand and many others.

Sillitoe was also the first to introduce radio cars, based on New York's force, and by 1936 twenty-nine police radio cars were deployed. He also introduced a forensic laboratory and started fingerprint recording, which hitherto had to be sent to London. He also promoted the use of women in the force in other than support roles. He was

Sillitoe is also remembered for the introduction of the Gilbert Mackenzie Trench-designed police box to Glasgow. This is a Glasgow box. These were painted red while two historic boxes in Glasgow city centre are now blue, presumably because of the influence of Dr Who's Tardis. On the bottom left is a St Andrew's Ambulance first aid kit. The lady is contacting police control using a telephone system which was contained behind a hatch.

also against stagnation, pensioning off older officers with a new thirty-year contract, allowing fresh blood to enter the force. He also recruited civilians in non-policing roles.

Sillitoe's innovations were to lay the foundations for the development of the Glasgow police force. Unfortunately, he was also to face enemies from within for corruption on the Glasgow Corporation was endemic. Sillitoe's men were to ferret out the corrupt councillors and officials. The Home Office was so concerned that they threatened to dismiss the council and take over its responsibilities.

In 1975, as part of local government reorganisation, the City of Glasgow Police and several other forces combined to form Strathclyde Police. But along the way, strangely enough, besides dealing with riots and criminals within the council, the police were to fight quite ordinary crime, although some of the murders were more than just normal.

Within my own lifetime, I can remember the manhunt for Peter Manuel in the 1950s. Manuel was born to Scottish parents in New York but returned to Scotland in 1932. At sixteen he began a criminal career but ended up serving nine years in Peterhead Prison for rape and sexual assaults. He also served further prison terms but in 1956 his career as a serial killer began with the murder and rape of seventeen-year-old Anne Kneilands in East Kilbride. He was to continue his spree, killing nine people, including three each of two families. He was finally caught after spending banknotes taken from one of his victims.

Manuel was convicted and sentenced to be hanged at Barlinnie Prison on 11 June 1958. He was the third last criminal to be executed in Scotland. The last was Henry Burnett, who was hanged at Craiginches prison in 1963. The last at Barlinnie Prison was Tony Miller, who was hanged in December 1960.

It took a more recent murder, in Anderston, Glasgow, to bring to light another serial killer. Peter Tobin was known to have been around Anderston in the 1970s and this is where he returned under the assumed name of Pat McLaughlin as a church handyman at St Patrick's Roman Catholic Church. It was a devastating time for the congregation, and for myself, as I had attended there as a young lad, where I was also an altar boy.

In 2006 at St Patrick's, he raped and murdered a Polish student who was working as a cleaner at the church to fund her studies. She was attacked by Tobin in the garage of the church house and hidden under the floor of the church. Tobin was tracked down to London, where he was arrested and taken back to Glasgow to stand trial. He was sentenced to life imprisonment.

When Tobin's previous movements were investigated, it was announced that he had already served a fourteen-year sentence for the rape and assault of two fourteen-year-old girls. They were left for dead in a gas-filled room but survived. Tobin went on the run, hiding out with the Jesus Fellowship, a religious sect in Coventry. He was captured in Brighton. On release in 2004, he returned to his home town, Paisley, but skipped supervision in 2005, at which time an arrest warrant was issued.

Following his sentence, Tobin's history was tracked and as a result the police found the remains of both fifteen-year-old Vicky Hamilton from Bathgate and Dinah McNicol, an eighteen-year-old schoolgirl from Essex. Tobin had left Bathgate for

Margate soon after Vicky's disappearance after she was last seen waiting for a bus. Dinah disappeared following a music festival, when she was seen to be hitchhiking home and in a car with a male driver.

Tobin was found guilty on all of these charges and sentenced to life and is serving it in Saughton Prison, Edinburgh. Following his sentencing, the Glasgow police started Operation Anagram to work out how many victims there were, as he had boasted of killing forty-eight. The operation has been wound down but there remains the suggestion from some that he is also Glasgow's other serial killer, Bible John, as the murders have some striking similarities and were carried out in an area familiar to Tobin in the 1960s and 1970s.

Bible John was the nickname of the killer who stalked young women at the Glasgow Barrowland Ballroom between 1968 and 1969.

The first inklings of his killing spree came when the naked body of nurse Patricia Docker was found in a Glasgow lane. The police were wrong-footed as she had told her parents that she was going to the Majestic Ballroom, whereas, in fact, she had gone there but moved on to the Over-25s night at the Barrowland.

In August 1969, a second body, that of Jemima McDonald, thirty-two, was also found, in an old tenement in MacKeith Street. She had been raped and beaten to death. Jemima had also been seeing leaving the Barrowland with a tall, fair-haired, slim young man.

In October of the same year, twenty-nine-year-old Helen Puttock was murdered in a similar fashion by a 'well-spoken man who quoted from the Bible'. This information came from Helen's sister Jean, who had been with her that night but had left the taxi at Knightswood while her sister travelled to her death in Scotstoun, to Early Street, where her body was found in the garden behind her flat.

Bible John, if one such person exists, has never been caught. Although there are some similarities to Peter Tobin, some say that the murders may have been committed by different people.

I suspect that recounting the crime in Glasgow would fill many books. Well, actually it has, by people like Jack House in his book *Square Mile of Murder*. In fact, the books about crime in Glasgow are numerous and, sadly enough, there is not enough room for them to be described here.

Before we leave the Glasgow Police, I should really more than mention the Glasgow Police Pipe Band, which has been around since the Burgh of Govan Police Pipe Band was formed in 1883, followed by the City of Glasgow Police Pipe Band in 1912, to be followed by the Strathclyde Police Pipe Band in 1975. The Glasgow Police Pipe Band has accumulated no less than twenty wins at the World Pipe Band Championships at Glasgow Green. The competition is a major event in the piping calendar, with bands from all over the world competing. In 1987, the first overseas band, Canadian, took the prize and it has travelled abroad a number of times since then. It is a sight to behold as the massed bands of all competing bands close the show.

So too is the Glasgow Police Museum in Bell Street, run by volunteer ex-members of the police force. It tells the story of the force from its early days from the Glasgow Police Act and before, up to the present day. It displays a wealth of artifacts and photographs.

Education in Glasgow – 'If I Had Had Your Chances'

Oor wee school's the best wee school
the best wee school in Glesga
The only thing that's wrang wi it
is the baldy-heided maister
He goes tae the pub on a Setterday night
he goes tae church on Sunday
And prays tae God tae gie him strength
tae belt the weans on Monday

The Beginnings of Scottish Education

Education is a modern concept, particularly for children of the working class. When education was provided, it was from the Church where, naturally, the study of the faith and adoption of the religious culture would have been an integral part of the ethos.

The Christian Church brought a need for an appreciation of Latin as well as doctrine. This was provided to a small elite by the new monasteries. This developed over time into the provision of grammar and choir schools attached to cathedrals in burghs.

One of the earliest was the Choir School of Glasgow Cathedral, around 1124. It was also the oldest school in Scotland. As the Glasgow Grammar School, it was controlled by the Church of its day until coming under local authority control in 1872. This was the origin of the High School of Glasgow. With the re-organisation of Glasgow schools along comprehensive lines, the Glasgow High School was headed for closure but following the intervention of former pupils, the school became independent and private in 1976. It has since moved from its home in Elmbank Street to Old Anniesland, site of its playing fields. Among its alumni are British Prime Ministers Sir Henry Campbell-Bannerman and Andrew Bonar Law.

The first Act related to education was from James IV's Parliament of Scotland in 1496, which commanded that those who administered the Scottish legal system should receive schooling. All barons and substantial freeholders were to put their eldest sons and heirs

Primary School, Bridgeton, around 1920.

into the local grammar school from eight or nine in order to perfect their Latin. They would then spend the next three years learning art and law. All of this was to enable the proper understanding of the law, 'for the benefit of justice throughout the realm'.

The expansion of education in Glasgow was a direct result of the Scottish Reformation of 1560. Choir schools had disappeared and government legislation provided for the expansion and funding of parish schools. Funded schools were provided, normally overseen by the Kirk, as churches and the new Protestant religion had now become titled. Where the Kirk couldn't support schools, this would be provided by parents, the burgh and others. The curriculum might include Latin, French and catechism. Further legislative changes would cement the provision of schools in every parish, certainly in the Lowlands.

By 1817, in the *Statistical Tables Relative to the City of Glasgow and Other Matters*, it was recorded that there were 144 schools within the 'Royalty of Glasgow'. Of the total of 16,709 pupils, 10,283 of these were in fee-paying places and 6,516 in free schools. This possibly included Sunday Schools.

Free schools were provided by many bodies and often funded by philanthropists and local businesses. One of the earliest of these was George Hutcheson of Lambhill, a Glasgow lawyer and banker, whose will in 1639 provided for a city hospital for the aged and infirm as well as founding a school. The hospital building started in 1641, with Thomas Hutcheson providing additional funding to educate twelve 'indigent orphanes'. Schooling of these began in the hospital building in the Trongate in 1648. Hutcheson's Grammar School still continues, but as a private independent school in Pollokshields.

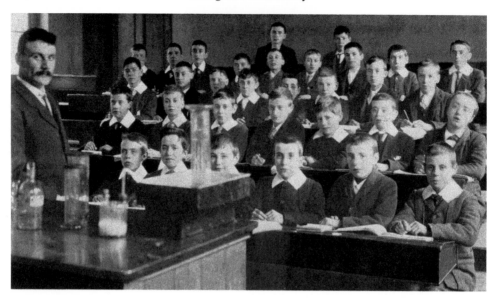

Second year science class, Glasgow 1901, St Mungo's Academy.

So, there was a growing provision of schools of all shapes and sizes, none of these compulsory by law. The disruption of 1843, when 450 ministers of the established Church broke away to form the Free Church of Scotland had implications, not just for the Church and its congregations, but for much of Scottish life including schools, which suffered from closure and fragmentation.

The solution was the Education (Scotland) Act of 1872, which provided for the compulsory education of all children between the ages of five and thirteen. At this time, the general provision of schooling was taken out of the hands of free and religious schools and school boards appointed. If you look on the sides of many of the older school buildings, or indeed those converted to other uses, you will see the name of the school and the School Board which built it.

In 1901, the school leaving age was raised to fourteen, to fifteen in 1947 by the incoming Labour government, and in a divisive move, this was further increased to sixteen in 1973. Another contentious issue for many years was the 'Qualy' or Qualifying Examination. At the end of primary education, pupils would take the Qualy, which decided whether they would enter Junior or Senior Secondary education. Junior Secondary schools provided a three-year course in mostly technical and basic skills before the pupils left for apprenticeships or other jobs. The Senior Secondary school, on the other hand, was a five to six-year education which provided the Senior Leaving Certificate (Highers). A combination of these Higher subjects would provide university entrance.

This form of selection at an early age was, of course, nonsense as it took no account whatsoever of the late development of children, who, because they were seen by others as failures, might see themselves as failures. They would then be denied the opportunity for skills and personal development open to others.

These schools, coming as they did from a Protestant background and the mainstream in civic life, were effectively Presbyterian schools and as a result ignored the needs of

Alexander's Public School, Duke Street.

the Roman Catholic population, which was growing substantially through movement of populations from the west of Scotland, the islands in the west and from Ireland. This was corrected by the 1918 Education (Scotland) Act when Catholic and Episcopalian schools were brought into state funding as denominational schools.

Before this, there was little for the growing Irish population, developing as it was in the major centres of population and work such as Glasgow, Coatbridge and Dundee. Contrary to urban myth, the Irish were keen on education and from the 1600s a system of 'hedge schools' had emerged where children were mostly educated outdoors in subjects including Irish language, English, Latin and maths.

With emigration to Britain, this desire for education continued and was provided by free schools or the Church. The Church adopted the principles of the Lancastrian model, designed by Londoner Joseph Lancaster. Essentially, this system was based on children learning and then being rewarded for passing this on to others. Nowadays, it is called peer learning. His ideas were taken up substantially throughout the world, and particularly by the Catholic Church.

In Glasgow, as the population continued to grow, churches were needed. The school was often built first and used as a church on Sunday. In modern times, this was exactly the model when Corpus Christi school and then church was built in Knightswood in the early 1970s.

The Catholic Schools Society was formed in Glasgow in 1817 to promote the education of the Irish immigrant children. There were a number of industrialists who were concerned about the welfare of their workers. They formed a committee under

City Public Junior Secondary class in the early 1960s.

the chairmanship of the famous Glasgow merchant Kirkman Finlay MP, not himself a Catholic. His view was that, 'The manufacturers of this country could never have gone on without the emigration from Ireland, or the assistance of the Irish weavers; and having them would they retain them in an ignorant and debased state?'

The Society began to erect the first Glasgow Catholic schools, two in the Gorbals, one in Bridgeton and one in Anderston. By 1841, a schools inspector had reported that the Catholic schools were further on than non-Catholic schools in helping their pupils learn to read and write as well as do arithmetic. By the Education Act of 1918, when Catholic schools were brought under local authority management, the Catholic school system had developed considerably, assisted by the various religious teaching orders like the Marist Brothers, who were and are dedicated to teaching.

The system of education remained generally unchanged for many years. There were 'junior' and 'senior' secondaries. There were privately funded schools and there were also 'selective' schools which were allowed to choose their own pupils. This was normally on the basis of examination or the Qualy. Hillhead High School and St Mungo's Academy were two such schools.

The major changes in Scottish education started in 1962 with the introduction of the Scottish Certificate of Education Ordinary (O) and Higher (H) grades, the latter becoming the basic entry requirements for entry to university, the Civil Service and technical jobs.

But the biggest change was the national change to comprehensive education in 1972, when selection was abolished and comprehensive schools for specific areas

were introduced. While some selective schools like Glasgow High became private, others like St Mungo's became comprehensive. The idea was that education was becoming too focused on the attainments of those who could best afford it. The new schools were intended to provide a standard, broad curriculum to all. State funded schools were perceived to be able to provide the resources needed to achieve this wide curriculum, particularly in technical subjects.

The comprehensive system remains the mainstay of Glasgow education. Glasgow now has 138 primary and thirty secondary schools as well as forty-four schools offering additional support, and 110 nurseries. Moves towards specialist schools, sixth form or technology colleges for school pupils have generally found few supporters in Scotland. However, there are three specialist schools: the Glasgow Gaelic School, whose campus is in the former Woodside Secondary School buildings in Berkeley Street, caters for children from three to eighteen with all subjects being taught entirely in Gaelic; Knightswood Secondary hosts the National Centre for Excellence for Dance and Musical Theatre; and in Bellahouston Academy is based the Glasgow School of Sport.

Glasgow education has certainly responded to the need to promote cultural and sporting activities in schools. On the other hand, over the years, a need for change has been seen, away from narrow specialisms to a wider focus and improvement in learning of basic skills. This has resulted in a major review which has produced a new curriculum in Scotland, Curriculum for Excellence, which is said to meet the needs of the modern pupil. It has met with much resistance from teachers and time will tell if the results are worth the changes.

Further Education

Glasgow would still be no more than a small town were it not for the growth of industry. Many Scottish county towns and burghs grew and then reduced as industries came and went or social conditions changed. Even now, the towns of the Borders have been greatly reduced as the woollen industry has collapsed. Aberdeen lost its granite industry but rose again with oil. Bathgate lost its car manufacturing and Paisley its thread mills. Glasgow grew and survives because of trade, industry and particularly manufacturing and, until the 1960s and 1970s, adapted to changing markets and world conditions. It is again thriving through investment in new technologies.

None of this would have been possible to the extent it has if not for further education, although in truth, in the early days the term further education would have been unrecognisable to many. So too would the term 'vocational education'.

We might think it strange now but in the seventeenth-century those pioneers of iron and steelmaking, engineering and manufacturing were proud of their creations and were happy to share them in factory tours and lectures. There were also vast numbers of young people keen to take on new learning. Engineering and science was then like our present information and computer technologies. It was a young person's world and they wanted to be the pioneers, like Bill Gates of Microsoft or Steve Jobs of Apple. Science was becoming practical and they wanted in on the act.

We weren't yet at the stage where sullen and reluctant apprentices would be sent off to day release. Young people wanted to learn the skills of science. The industrial revolution created a need for mainly young men to learn more than just the practical aspects of their trades. The mechanics institutes provided lectures by well-known experts in their fields. They were also a place where these young students could 'network' with like-minded learners who would generally attend in the evenings after their day's work was done.

In Scotland, a general education was always seen as important so it would be no surprise that as well as leading the world in engineering, it would also lead the way in technical education.

The Andersonian – Birthplace of Further Education

The Andersonian Institution was founded by John Anderson MA, FRS, who studied at Glasgow University and was a professor of both Oriental Languages and Natural Philosophy there around 1750. During his tenure in the latter position, he thought that the study of physics, or physical science, the modern names for natural philosophy, would be useful for 'mechanics', those in industry and the sciences who were not able to follow an academic course. 'Mechanic' then meant more than people who fixed cars.

He organised classes in natural philosophy as well as setting up a museum of scientific artefacts. After his death he bequeathed his property for the setting up of 'Anderson's University'. In 1828 it became Anderson's Institution and it changed its name again in 1877, to Anderson's College. The Andersonian existed from 1796 to 1887, first in John Street and then, after 1828, to George Street.

The original concept was for faculties in Arts, Law, Medicine and Theology as well as an elementary academy. It was a sizeable undertaking, starting with lectures in natural philosophy and chemistry delivered by Dr Thomas Garnett. This was followed by a professor of Mathematics and Geography. When Dr Garnett went off to become the first professor of the Royal Institution in London, he was succeeded by George Birkbeck. Birkbeck taught Dr Garnett's classes but also gave free lectures on the physical sciences.

Birkbeck was a Yorkshireman who trained as a doctor in Edinburgh before taking up his post at Anderson's. He seems to have been an eminently practical man as he realised when his students showed a great interest in his experimental apparatus that they would benefit from his lectures on the 'Mechanical arts'.

These classes were held well after Birkbeck went off to London and led to the formation of the Mechanic's Institute. Birkbeck was instrumental in setting up the London Mechanic's Institute and the concept was thereafter copied worldwide. His London institute was to become the Birkbeck Literary and Scientific Institution; it was eventually renamed Birkbeck College and became part of the University of London in 1920.

Meanwhile, the Andersonian, with a depleted Mechanics faculty, went on to expand with professorships in art, geology, modern languages, English and logic. The Chair of Applied Mechanics was created in 1868. The Chair in Technical Chemistry was founded by James (Paraffin) Young in 1870, a Glaswegian who started the huge shale oil industry in West Lothian.

The medical school at Anderson's opened in 1800 when Dr John Burns lectured on anatomy and surgery. Botany, midwifery and medical practice were added. With the further addition of medical jurisprudence, ophthalmology and surgery, the school achieved a strong reputation for providing medical training for accessible fees.

The Glasgow and West of Scotland Technical College – Beginnings of a New University

By 1877, a range of colleges and institutions had been opened, some through specific endowments. That year, a number of these amalgamated to form the Glasgow and West of Scotland Technical College. These included Anderson's College; the College of Science and Arts; the Young Chair of Technical Chemistry; Allan Glen's Institution; and Atkinson's Institution.

In 1912, this became the Royal College of Science and Technology, which in turn became Strathclyde University when it merged with the Scottish College of Commerce. This was part of the Robinns Report, which recommended that all colleges of advanced technology should be given university status. The new university's first intake was to be around 217,000 in 1973.

Strathclyde University is actually Glasgow's second university by age as it can trace its lineage back to the 1796 Andersonian Institute. The university's campus is still based around the Royal College building. It took over the Jordanhill Teacher Training College in 1993 but in 1912 this closed, with the centering of all schools on the John Anderson Campus. This was all possible because of the Bruce plan, which had designated Townhead as a Comprehensive Development Area, and as the buildings were cleared, including my own birthplace, the Glasgow Royal Maternity Hospital (or Rottenrow), the area, with great foresight, was zoned for educational purposes as even then it was anticipated that the Royal College would grow into a university.

Other Educational Institutions

John Anderson's legacy was to provide 'useful learning' for all and this specifically included women, who were rarely provided for. In fact, women's education was often to be taken on by other women who saw the inequality.

A prominent woman who was important in the development of women's education was Isabella Elder. Isabella was the wife of prominent Glasgow shipbuilder and engineer John Elder, who we saw in the chapter on shipbuilding. Isabella funded the Queen Margaret College for Ladies in North Park House, beside Glasgow's Botanic Gardens, in 1883. The college was set up by the Association for the Higher Education of Women as a reaction to women not being able to study at university. Many of the women in the institution were prominent in Glasgow society. The college was named for Queen and Saint Margaret of Scotland.

With the entry into the University of Glasgow of women students, the college merged with the university in 1892, although the women's buildings continued in use up to 1934, when they were sold to BBC Scotland. Queen Margaret continues to make her presence felt in the form of the Queen Margaret Students' Union and the Queen Margaret Halls of Residence.

Isabella's munificence didn't stop there. She endowed a school of medicine within the Queen Margaret College in 1890. She enabled the Elder School of Naval Architecture at the university in 1883 and provided funds for lectures at the Glasgow and West of Scotland Technical College.

It was in Govan that John Elder owned the shipyard that was to become Fairfields and which Isabella ran for some time following the early death of her husband. And it was Govan which received a huge share of their legacy. Isabella provided funds for Elder Park, to which Govanites could visit to repair their health in the otherwise industrial burgh. She opened a school of home economics run by Miss Martha Gordon as well as employing a district nurse to visit homes and give classes in hygiene and care of children. She also gave the Elder Park Library.

The Elders were not the only benefactors of education in Glasgow. While industrialists have received rather a bad reputation, in fact many of them, like the Elders, were possibly more concerned about the need for education than their workers.

Stow College in the Cowcaddens remembers David Stow, a philanthropist who founded an infant school in the Drygait in 1828 and a juvenile school in the Saltmarket in 1831. Stow was the first to recognise that professional teaching and outdoor play areas were essential for learning. His Normal Training Seminary was the first purpose-built teacher training college in Great Britain. Stow College was the first purpose built technical college or 'trades school', built in 1934 to ensure the continuation of mainly engineering skills, in the same year that the *Queen Mary* was launched.

Further education colleges in Glasgow offer a wide range of qualifications although the Higher National Certificate and Diplomas are the mainstay, offering qualifications which are recognised by employers in Scotland. In many cases, modern Scottish universities also recognise these as providing an articulation allowing students to enter universities at an advanced level. Unfortunately, this is not as widespread as it should be and some of the older universities are less than enthusiastic about offering places to HNC and HND students.

With the decline in traditional industries, there has been less of a need to provide the wide range of technical skills that they did previously. Some colleges adapted to changing circumstances, sometimes slowly. Stow College, for example, offers a Music Business course. Part of the learning is managing the three record labels that the college owns. I know this as I had a part in approving the course. It is a fine example of a truly industry based approach which other colleges could usefully use. It is very easy to see a building being the centre of learning whereas most vocational leaning actually happens in the workplace. Saying that, Stow College and others are now offering ranges of flexible computer-based courses.

Over the past few years, the college structure has been under the microscope and many of the existing colleges have merged: Glasgow Nautical College, Glasgow Metropolitan

College and Central College merged in 2010 to form the City of Glasgow College. The City of Glasgow College currently has around 32,000 students from around 135 different countries. Stow College merged in 2013 with John Wheatley College and North Glasgow College to form Glasgow Kelvin College. Glasgow Clyde College has been formed from the previous Anniesland, Cardonald and Langside Colleges.

Glasgow University

We have seen how the birth of technical education was to arrive at the birth of Strathclyde University, which was to be Glasgow's second after Glasgow University. It would be far from the truth to say that Glasgow, the original 'Uni', was not vocational for that is not the case in the way that it has developed.

Glasgow University on Gilmorehill and throughout the West End is actually on a new build site, having its origins in 1452, in the original burgh of Glasgow. It was built at the behest of King James II, who allowed Bishop William Turnbull to add a university to Glasgow Cathedral. Bearing in mind that this was a Roman Catholic cathedral, it was confirmed in a Papal Bull from Pope Nicholas V.

Glasgow University is, then, the second oldest university in Scotland after St Andrews. It is also the fourth oldest in the English-speaking world.

Classes at the new university started within the chapter house of the Cathedral and were subsequently held in the Pedagogium or 'Auld Pedagogy' in nearby Rottenrow. Pedagogy comes from the Greek for teaching.

In 1563, Mary Queen of Scots, following the 1560 Reformation, gave the University thirteen acres of ground previously belonging to the Dominican order of Black Friars on High Street. Here, using remnants of the friary, including the chapel, the university became established and it was to remain in the area until the buildings were demolished in 1870, making way for the City of Glasgow Union Railway College Goods Yards, when the university moved to Gilmorehill in 1870. However, in making the move the university did take with it remnants of the old buildings, including parts of the façade which were incorporated into Pearce Lodge, a gatehouse to Gilmorehill. Sir William Pearce was a shipping magnate and one of the original founders of Fairfields shipyards, who funded the preservation and move.

The Gilmorehill building was designed by Sir George Gilbert Scott. It is the second-largest example of a Gothic Revival building in Great Britain after the Palace of Westminster. The university, with the purchase of many Victorian buildings, now straddles most of Hillhead.

At its foundation, the university had faculties of divinity, medicine and law. Over time it was to develop or acquire faculties in arts, business and social science, veterinary practice, engineering and others.

The university is now among the top in world rankings and derives a great deal of its funding from research grants and again is among the top performers in the field.

We have already said that John Anderson provided vocational education for both men and women who were unable to study at the University. As you might expect

Glasgow University from Dumbarton Road.

for the time, there was some opposition from his colleagues; however, he was to go on and establish Anderson's College and ultimately Strathclyde University. While he championed those who couldn't get to university, the University was, over time, to make its mark in the practical development of Scottish industries, particularly in its departments of Chemistry, Natural Philosophy and Engineering.

This is well illustrated by some of those who were to graduate from or teach in the institution and who were to establish its place as one of Europe's great centres of learning.

My father was a physics teacher in Glasgow and it was from him that I learned so much about both the history of Glasgow and physics. He was the kind of teacher who could make a subject interesting and his knowledge was comprehensive. Perhaps that is why he admired Lord Kelvin, who is generally acknowledged as the father of modern physics. My father's degree certificate refers to 'Natural Philosophy', as physics used to be called. It was Kelvin who turned the very small 'nat phil' department at Glasgow University into a large and effective department teaching physics. It was an educational example to the rest of the world. He was also instrumental in turning inventions into practicalities, taking out about seventy patents.

Born William Thomson in Belfast in 1824, he was to move to Glasgow at an early age when his mathematician father took up a post at the university. He was well provided for and his father ensured an excellent start to his career with introductions allowing him to study at Peterhouse College, Cambridge, where he excelled in all subjects including sports. However, his main interests were in physics, particularly in the fields of thermodynamics and electricity.

Besides founding a laboratory at Glasgow University and being the first to teach physics in the lab, he was responsible for a wide range of innovations and inventions: he invented a tide predictor and, using this, produced a theory of revolution of the Earth's poles, this being confirmed with computers in the 1950s.

His work on the Atlantic cable was momentous. He theorised that the quality of the cable was fundamental to the success of electricity flow. He successfully designed recording equipment which could be used over the huge lengths of the cables.

He introduced the absolute scale of temperature, now measured in 'Kelvins'. He was a prodigious researcher and produced around 600 papers. He successfully introduced a range of nautical instruments including depth sounders, compasses, sextants and chronometers. His work has been extremely important to science and to Scotland and reflects why Scotland has been so successful in the application of scientific discovery. He was an entrepreneur who could see practical application in his work and through this contributed considerably to Britain's ability to defend itself through two wars.

James Watt is undoubtedly one of Glasgow's heroes, and there is a well-established myth that he invented the steam engine while strolling by the banks of the Clyde at Glasgow Green. First of all, he didn't invent the steam engine, and whether he did what he did while on Glasgow Green is probably a wee story.

Anyway, the truth is that he worked from 1756 as an instrument maker at the University, including building some of the instruments used by the famous Professor of Medicine, Joseph Black, discoverer of carbon dioxide.

By 1759 he had set up a partnership with James Craig to build optical instruments, at the same time working as a civil engineer on the widening of the Clyde and on the Forth & Clyde Canal. One of his projects for our well-known John Anderson at the University was the repair of a model of Thomas Newcomen's steam engine. The engine, which appeared around 1712, had been used primarily for lifting water from mines. The beam engine powered by Newcomen's engine was only cost-effective where coal was abundant as a lot of energy was required to heat the main cylinder, which was cooled as the steam condensed. Where mining was for other than coal, such as tin in Cornwall, the cost severely raised the overheads of production.

It was Watt who realised that a great deal of energy was wasted in cooling and reheating the cylinder. He devised a separate condenser, which vastly improved the efficiency of the engine. He also made other improvements such as doubling the action of the pistons using both up and down strokes for power. The royalties for use of their machine and improvements made Watt and his partner Matthew Boulton rich men. Glasgow University's engineering building is named after James Watt.

These are just two of the many teachers and students from the University now ranked in the highest in the world. Others include Adam Smith, economist and author of *The Wealth of Nations*; John Logie Baird, who pioneered television; R. D. Laing, the author of *Sanity, Madness and the Family*, who is noted for his work on mental illness; and John Grierson, the 'father' of the documentary, famous for *Drifters* and *The Night Mail*.

Glasgow University continues its growth with the planned redevelopment of Glasgow's Kelvin Hall. The changes will see the world-famous University Hunterian Museum installed in the building, making this area a destination for museum and art gallery visitors from home and abroad. The building will also incorporate the National

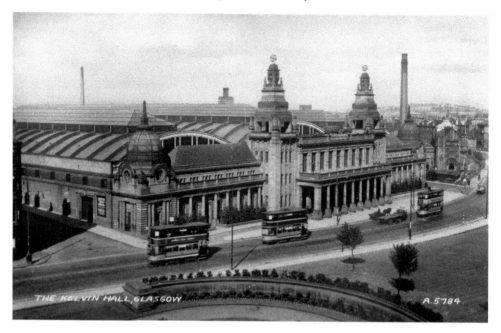

The Kelvin Hall, opposite the Kelvingrove Art Gallery and Museum, was designed to house large-scale exhibitions. During the Second World War it was used to produce barrage balloons.

Libraries of Scotland Scottish Screen and Sound Archives. The Royal Highland Fusiliers Museum will also be hosted there, as will contemporary and fine art galleries.

Strathclyde University

We have already mentioned that Glasgow's second university, Strathclyde, had been formed with the Royal College of Science and Technology and the Scottish College of Commerce at the core.

Professor John Anderson's 'place of useful learning', arguably the first truly 'open university' was established as Anderson's University in 1796. Among those attending it were James 'Paraffin' Young, inventor of the process for extracting oil from shale. The University developed quickly and with a need for a bigger building, the Glasgow and West of Scotland Technical College was born, with Edward VII laying the foundation stone in 1903.

Over the early years of the century it established its place in the provision of engineering and scientific study and research. I know that it was a good place to study, having been told so by my father, who attended there in the 1930s. He was to become a physics teacher and owed much of his return to education to the College.

In the 1960s it merged with the Scottish College of Commerce and in 1964 a Royal Charter was awarded, with the merged college becoming the University of Strathclyde.

Still the University grew, with its reputation growing as it did so, answering the call for more student places in engineering and science even as home industry was declining. In 1993, with the ending of separate teacher training colleges, Jordanhill College merged with the university's new School of Education, now in the refurbished Lord Hope Building.

Now with a single campus in the Townhead area, Strathclyde is Scotland's third largest university, hosting 29,000 full and part-time students.

The growth of Glasgow as a learning city continued with the opening of its third university, again formed from the amalgamation of existing institutions.

Glasgow Caledonian University

The Glasgow Cookery Book has been in our house for several decades even though my wife, the main cook, does not come from Glasgow. I was aware of how famous 'the Purple Book' is and that it has travelled the world with those emigrating. Several hundred thousand copies have been sold and a Centenary edition was published in 2009. It is a treasury of Scotland's favourites, including leek and potato soup, Dundee cake and shortbread. Thankfully, the recent edition has dropped dripping and sheep's heid broth!

With my inquisitive brain attuned to looking for subjects for my own book, I wondered idly who had written the *Glasgow Cook Book*, if indeed it had been one person. What I found was that it had been put together from lecturers' course notes but the person behind its publication was Ella Glaister. Ella was the principal of the West of Scotland College of Domestic Science which became known affectionately to Glasgow citizens as 'The Do (or Dough) School'.

The Do School came about in 1908 through the amalgamation of two institutions, the Glasgow School of Cookery and the West End School of Cookery. The College actually started off in 86 Bath Street, near to where Watt Brothers is now. Through appeal, the present building in Park Drive was planned and building started in 1913.

The College was for the training of teachers of domestic science as well as providing instruction in areas such as needlework and cookery to the general public and domestic servants. During both the wars the College was instrumental in helping the military and the civilian population cope with the demands of catering for large numbers, and of coping with rations and food shortages.

Following the First World War, Ministry of Labour courses were provided for war workers and for widows. These included cookery, laundry, dressmaking and housekeeping skills. The College also acted as a central training place for unemployed girls under the schemes of the Central Committee for Women's Training and Employment.

Clearly the creation of such an important and prestigious institution was a massive undertaking and would require strong leadership. At that time, I would also imagine that in a male-dominated world, considerable strength of character as well as management skills would be required to see the project through to completion, particularly as the First World War was on the way. While she was not in post to see the occupation of the new building, the person who saw the implementation of this great Scottish institution was Ella Glaister.

While she was Principal at the College from just 1908 to 1910, she was clearly a driving force. Ella was a Glaswegian and the eldest of six children of John Glaister and Mary Scott Clarke. John Glaister was an eminent physician who was Glasgow University's Regius Professor of Forensic Medicine and Public Health. Ironically, her parents were both to die within hours of one another in the Glasgow influenza epidemic in 1932.

4044/23 Domestic College of Science and Park Drive, Glasgow

Glasgow and West of Scotland College of Domestic Science, the 'Do' School, Park Drive. In 1975 the college was renamed The Queen's College, Glasgow, honouring its patron since 1944, Her Majesty Queen Elizabeth II.

The West of Scotland College of Domestic Science went from strength to strength. In the 1920s it began to focus on diet, establishing courses for nurses and prospective dieticians. This included subjects such as bacteriology, hygiene and biology, along with the more traditional cookery.

In 1960 it was decided that lower level courses would become the responsibility of the growing number of further education colleges, with training at a higher level being provided by the College. Courses now became available to male students. The College continued to widen its programme, introducing or taking over health and medical-related courses from other institutions. This included physiotherapy, orthoptics, radiography, chiropody and occupational therapy.

In 1993 the Queen's College merged with the Glasgow Polytechnic to form the new Glasgow Caledonian University. Glasgow Polytechnic had been formed in 1971 from the merger of the Glasgow College of Technology and the Glasgow College of Commerce.

The merger has formed a new campus in the town centre to the north of Buchanan Street bus station. It has around 18,000 students in three schools: Engineering and the Built Environment; Business and Society; and Health and Life Sciences.

The Glasgow School of Art

And finally, there is another great educational building in Glasgow, with its origins in the city's industrial heritage. As far back as 1835, the government recognised the need for a

better quality of product design. They set up the Government School of Design in Glasgow in January 1845. This was one of twenty similar institutions founded throughout the United Kingdom for the provision of training in design for industry. Originally based in Ingram Street, it moved to the McLellan Galleries in Sauchiehall Street in 1869.

The provision at the school was wide, including drawing, shading, modelling, and technical and architectural drawing. Students were expected to come up with designs for actual manufacture.

The institution was originally managed by the Board of Trade, and then by the Department of Science and Art, based in South Kensington, London. A Masters of Art could be gained over a flexible period of time and there was no restriction on entry.

The Schools of Design were intended to instil three principles: decoration is secondary to form; form is dictated by function and the materials used; design should derive from historical English and non-Western ornament.

> The true office of Ornament is the decoration of Utility. Ornament, therefore, ought always to be secondary to Utility ... True Ornament does not consist in the mere imitation of natural objects; but rather in the adaptation of their peculiar beauties of form or colour to decorative purposes controlled by the nature of the material to be decorated, the laws of art, and the necessities of manufacture.

In 1853 the school changed its name to incorporate that of a major benefactor, becoming the Glasgow School of Art and Haldane Academy. In 1891 that name was dropped and the Glasgow School of Art emerged in 1892, with its first diploma awards in 1901.

As it grew, it may have simply done so as another municipal building to match the fine architecture of Glasgow's city centre, where there was an expectation that new buildings would comply with the grid system, be tasteful and reflect the importance of Glasgow in the world. The theme may seem ostentatious to us now but it has left us with some of the best architecture in Western Europe.

In 1885, Devon-born Frances 'Fra' Henry Newberry took over as 'Headmaster' of the School of Art and his enterprise, open mindedness and creativity would become instrumental in fostering the 'Glasgow Style'. He also employed women and practising artists and therefore promoted vocational educational practices far ahead of many colleges. He also started an art club to allow students to diversify away from the given curriculum.

He also fostered the work of many respected Glasgow artists and we will come back to that later. For now, we can say that Fra was in a position to promote Charles Rennie Mackintosh as the designer of the new Glasgow School of Art. He also worked closely with Mackintosh during the building work. This was to make Glasgow School of Art an icon of world architecture, voted Great Britain's Best Building in 2009.

The Glasgow School of Art has three academic schools: Design, Fine Art and the Mackintosh School of Architecture. The School of Art has turned out the bulk of Scotland's prominent and artists. The School of Architecture has been recognised by the architectural profession as among the top ten in the world.

Among the alumni of Glasgow School of Art, we can include John Byrne, artist and playwright; Peter Capaldi, actor and director; Robbie Coltrane, actor; Jack Coia, architect; and Peter Howson, painter. The early graduates included Charles Rennie Mackintosh, Margaret MacDonald and Bessie McNicol. We will look at these later.

I prepared this edition of the book during the clear-up following the fire at the Glasgow School of Art. There are few Glaswegians throughout the world who would not have been horrified by the fire. The complete loss of the Mackintosh Library was tempered by the fact that there was no loss of life and that 90 per cent of the building was saved, along with 70 per cent of the contents. Given the scale of the fire and the potential for complete destruction, this survival has been attributed to the efficiency and dedication of the Scottish Fire and Rescue Service, which fought tirelessly to save the building and remove its contents. There were few watching who thought that the building could be saved, so it was with amazement and grateful thanks that we learned how much had been rescued.

The fire broke out on 24 May when gases from a canister of expanding foam were set alight by a hot projector. While in modern buildings this may not have caused such destruction, the design of the art school allowed the fire to spread from the basement studio, via ducts and voids, throughout the building.

There was some nonsense talked about leaving it in a ruined state as it could never be replicated, or that we didn't have the craftsmen to do so! The building will be replaced and I am in no doubt that the library will be an identical, but modern, tribute to the enterprise and skills alive in Scotland and I hope the opportunity is taken during the rebuilding for many more young people to learn those skills on site as the building is restored. I was also heartened by the amounts which have been offered to replace the building and I was delighted that, with many others, I was able to offer some art books to replace those destroyed in the fire.

Education and the World

I recently wrote a book called *Scotland's Lost Industries*, in which I described the extent to which we have lost so many jobs in manufacturing and engineering, such as in vehicles, shipbuilding and locomotives, carpets and paper. Behind all of this was the enterprise and particularly the commitment to vocational education. It is clear to me that without the commitment of industrialists and philanthropists we would not have had the economic success that we have had.

What I had not realised till I started to research this book was the extent to which that underpinning vocational education has become one of our greatest industries. In Glasgow alone, the colleges and universities welcome over 100,000 students, many of these from overseas, attracted by the prestige of our education. This brings enormous sums into Glasgow and the west of Scotland by way of employment, research and investment

In 2013 Glasgow is seen by student bodies as one of the best places to study and socialise. Having had a Glasgow education behind me I can't disagree, because part of that education was taking the chances offered to me by Glasgow Corporation in the 1970s to undertake further study at Langside College to get into university as a mature student.

Health and Wellbeing

Glasgow's reputation as a centre of medical advances is second to none.

In Glasgow's early days, medical treatment was provided by the Church and the only surviving relic of such a hospital is the Provand's Lordship, opposite Glasgow Cathedral. It was built by the Bishop of Glasgow, Andrew Muirhead, in 1471 as part of St Nicholas Hospital.

The original hospital was built by a previous Glasgow bishop, Andrew de Durisdere, more as an old folks' home as it housed 'a priest and twelve old men'. The existence of the Provand's Lordship probably owes its continuance to the fact that much of the hospital continued in use until the eighteenth-century.

Roland Blacadder was a sub-dean of Glasgow Cathedral. He also founded a hospital for the poor in the north of the town around 1525. This appears to have eventually become part of St Nicholas Hospital.

The Provand's Lordship continues in use as a museum, with the interior decoration and furniture gifted by Sir William Burrell.

In medieval towns, lepers were banished beyond the city walls. The same was true of Glasgow, where the Church-owned 'Lands of the Gorbals' housed those suffering from leprosy. Leprosy was then an incurable disease of the nerves and respiratory tracts, spread by contact, particularly nasal droplets.

A leper hospital was built in the Gorbals in the 1300s and was still operating around 1600. This was in Brigend, a bridge over the Clyde having existed since around 1285. This was around where the Citizens Theatre now stands. The hospital was dedicated to St Ninian and became St Ninian's Croft, being later incorporated into Hutchesontown.

Besides the above, there is very little evidence of the existence of hospitals at the time of the Black Death, a combination of plagues, when it reached Scotland in 1350. Plague is a deadly infectious disease, mostly transmitted by rodents and fleas, and by air contact. In the close-built houses in cramped towns and cities, outbreaks of the disease travelled quickly, bringing a swift death with bodies often covered in pustulating sores.

We can assume that there would have been medical provision of some sort when the plague struck Glasgow in 1646. By this time, being after the Reformation, there would have been none of the traditional Church treatment available. With each recurrence of the plague, Glasgow survived but with the population depleted.

It was the swift growth of Glasgow which was to bring constant threat of disease. The cramped, overcrowded conditions in which new arrivals were expected to live were perfect for transmission of infection. But hospitals for medical treatment alone seem to have been a novel concept, for the Town's Hospital, opened in 1740 on the banks of the Clyde, was also a poorhouse, a workhouse and a home for the aged and infirm, for orphans and an asylum. This was eventually to become a teaching hospital and from around this time hospitals began to develop as the city grew in all directions.

With Glasgow University's move to Gilmorehill in the 1870s, the Western Infirmary was built as a teaching hospital. The hospital has seen a steady growth since then, helped by my occasional visits for treatment. A fond memory of a tetanus jab in the bum still remains.

However, the Gartnavel General Hospital on the Great Western Road, once a mental asylum, has been redeveloped and some services presently supplied by the Western will be moved there in 2014, with the present site being redeveloped.

The Southern General Hospital was another former poorhouse, originally based in an old cavalry barracks in Eglinton Street. Run by the Govan Parish until 1912, when it was absorbed by Glasgow, it was run by Glasgow Corporation until the formation of the NHS in 1948. The Southern General's Institute of Neurological Sciences is where the Glasgow Coma Scale (GCS) was devised by Graham Teasdale and Bryan Jennet in 1974. The GCS is a scale which is used internationally to assess levels of consciousness after a head injury and is used also to monitor patients in intensive care.

Further south in Langside is Victoria Infirmary, which was originally a voluntary hospital. Voluntary hospitals existed before the NHS. They were entirely dependent on philanthropy, bequests and contributions. It is a credit to those able to give their wealth to society through funding hospitals. The Victoria started life in 1890 with eighty-four beds, had 260 by 1906 and 400 by 1927. The Victoria goes down in history as having the first British auxiliary hospital, Philipshill, built in 1929. It became an orthopaedic hospital and closed in 1992.

There should also be a mention for the war hospitals. As Britain prepared for war, there was no doubt that there would be casualties. To treat the injuries sustained in the coming conflict, a number of emergency hospitals were built round Glasgow. One of these was at Killearn, near Drymen. Being near to the Clyde and Clydebank, the hospital was used to treat seamen arriving from convoys and those injured in the Clydebank Blitz, as well as prisoners and war workers.

Killearn Hospital was associated with the Western General and had its own specialities, including orthopaedic and neurosurgical units. I visited a relative there many times in the 1950s and I can confirm the difficulties in getting there by public transport, which was one of the reasons for its closure in the 1970s. Strangely enough, the buildings are still there, abandoned, and give some idea of what a wartime temporary hospital looked like.

The Training of Medical Staff

We saw earlier how John Anderson established Anderson's Institution in 1726. By 1877 it was styled Anderson's College and in 1887 the College split. One fraction joined with other institutions to form the Glasgow and West of Scotland Technical College while the other became Anderson's College of Medicine. The college became part of Glasgow University in 1947. The Anderson College buildings are still where the college moved to in 1889, in Dumbarton Road beside the Western Infirmary. The buildings now house the University's International School.

The practice of medical education can be traced back to permission being given through a 1451 Papal Bull to Glasgow University. Education did not actually begin until a Professor of Medicine was appointed in 1714. The person credited with properly establishing the medical school was William Cullen, who was appointed to the chair in 1751.

Teaching was originally carried out in the Town's Hospital, opened in 1740 on the banks of the Clyde. This was also a poorhouse, a workhouse and a home for the aged and infirm, for orphans and an asylum.

From 1794, with the opening of the Glasgow Royal Infirmary at the door of the cathedral and close to the university, medical training flourished and Glasgow became the United Kingdom's principal centre for training. A particular influence on student numbers was the need for the provision of doctors during the French Wars. By 1810 there were 300 medical students.

In 1870, Glasgow University moved to Gilmorehill and a new teaching hospital was built in 1874. It had 150 beds in 1911, rising to 600 by 1911. It was originally a voluntary hospital, funded by donations and bequests, but became part of the National Health Service when it was introduced in 1948.

It is apparent that those involved in medical education at the Royal Infirmary took this badly. In 1876, they set up a competing organisation, the Glasgow Royal Infirmary School of Medicine. The Royal Infirmary allowed the training and matriculation of women students and during the period 1890-92, forty-three women trained alongside male students.

This school of medicine was eventually replaced by a new independent medical school, St Mungo's College of Medicine. Again, in 1947 St Mungo's was absorbed by the Glasgow University Faculty of Medicine.

The Glasgow University Faculty of Medicine was to produce great advances in many areas of medical practice but perhaps the greatest ever advance was born in Glasgow with Joseph Lister, professor of surgery at the University, who was a pioneer of antiseptics.

Based on a paper by Louis Pasteur, who suggested that chemical solutions could prevent infection of wounds, Lister experimented with the idea. Before this, infections were thought to be caused by exposure to 'bad air'. While hospitals might be aired, there was no appreciation that infections and viruses could be caused by contact. Often hand washing facilities were not available or used and there were no special protective clothing.

Lister discovered that using carbolic acid solution had a beneficial effect on the prevention of gangrene. He published an account in *The Lancet* of an injured

eleven-year old boy who had recovered after treatment. The boy's wound had been covered with lint dipped in carbolic acid.

Lister recorded the huge changes in the surgical wards at the Glasgow Royal Infirmary, in which the air was foul with the stink of suppurating wounds. Over two years this completely changed to the relative pleasant smell of antiseptic. Lister has quite rightly been called the father of antiseptic, whose work was to open the door to a better understanding and use of infection and hospital medical practice. You can see a statue of him in Kelvingrove Park. I was surprised to learn that Listerine mouthwash, still on sale, was named after him and sold from 1879.

Public health was to be a battleground which would bring out the best in the medical profession. In the new industrial days of Glasgow, life expectation was horribly low. Living conditions worsened as new immigrants crammed into shared rooms. The lack of wells along with the pollution from industry, chimneys and horses provided the ideal circumstances for the transmission of disease.

And it was in the right place for diseases like cholera to arrive from other countries. One such cholera epidemic in 1848 brought demands for change. The result was the building of the new water supply from Loch Katrine to Glasgow which was opened in 1859 by Queen Victoria. A new sewage system built between 1850 and 1875 also improved living conditions.

In 1863, Glasgow appointed a Medical Officer of Health, William Tennant Gairdner, who had already accepted the post of Professor of Medicine at Glasgow University in 1862. At the time, following the coming of fresh water to Glasgow, there was a continuing impetus to improve public health and Gairdner threw himself into it. Following Gairdner there were eight successive MOHs in Glasgow. All of these made a huge contribution to the health and wellbeing of the Glaswegian.

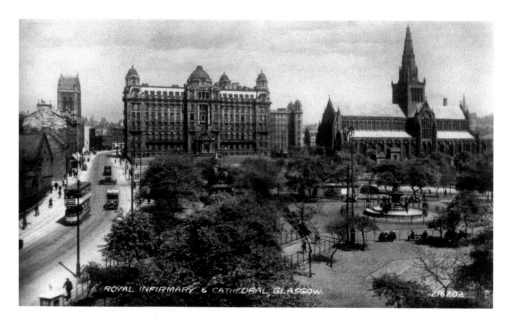

The Royal Infirmary and Cathedral.

Another advocate of public health at Glasgow University was John Glaister, father of Ella Glaister, whom we met earlier. It was he who introduced graduate degrees in Public Health and Forensic Medicine. He was famous for presenting evidence at the trial of Oscar Slater for murder in 1909. The 1960s television series *The Expert*, starring Marius Goring, was based on John Glaister. I remember it well.

One student on Glaister's new public health course was A. J. Cronin, author of the books on which *Doctor Finlay's Casebook* was based. Graduating in medicine in 1919, he went on later to complete the Diploma in Public Health, one of the important introductions of John Glaister. Many of A. J. Cronin's books are based on public health issues and it is generally accepted that *The Citadel* was a plea for a national health service. Interestingly, A. J. Cronin had worked together with Aneurin Bevan, responsible for introducing the NHS, at the Tredegar Cottage Hospital. It really is a small world. Ironically, John Glaister and his wife died in December 1932 as a result of the flu epidemic which was sweeping the country.

Even though conditions continued to improve, it wasn't to stop an outbreak of bubonic plague as late as 1900. A Glasgow docker was infected, probably by a rat on one of the ships he was working on. Luckily, the disease was diagnosed by a doctor at Belvidere Hospital. The outbreak was contained by quarantine, fumigation, and inoculation of all contacts. Of forty-eight cases diagnosed, there were sixteen deaths. It was recorded that the results would have been very much more severe if a rapid response had not swung into action.

Glasgow became practised in dealing with subsequent outbreaks of disease. There was a diphtheria outbreak in the 1930s and 1940s which claimed 100 children's lives between 1944 and 1945. But it was recorded that while immunisation was available at that time, not one of the dead children had been treated and the Corporation was criticised for not making more use of private practitioners.

Polio (or Poliomyelitis), also called infantile paralysis, was a scourge of young people of my age and I do remember many wearing the signature leg calipers. Polio is a viral disease which, in some cases, can lead to paralysis of the limb, and therefore the use of calipers to support the leg.

You can add to this outbreaks of smallpox and measles. Tuberculosis was dealt with by mass immunisation using the BCG injection which I received at primary school, where we were lined up outside the school office in fear of the pain and huge mark which might appear on our arms.

As I said at the beginning of this chapter, Glasgow's reputation for medical advances is second to none. So then, how come Glasgow has a dismal health profile? Scotland has the highest rate of death among young working-age men and women of any country in Western Europe. Cirrhosis of the liver is also among the highest.

While the Beatson West of Scotland is among the top hospitals in Europe for cancer care, a number of forms of cancer in Glasgow and the west of Scotland are among the highest in Europe.

There are the continuing challenges of alcohol, obesity, smoking and drug misuse but Glaswegians can be their own worst enemies in this respect. I am allowed to say that because I see myself somewhere in that group.

Music Hall, Theatre and Cinema

'The Roar of the Greasepaint, the Smell of the Crowd'

Glaswegians love to be entertained and the visit to the pantomime at Christmas was an essential part of the entertainment and a prelude to the holiday festivities. We would normally go with the school, maybe the altar boys and maybe the Cubs. We maybe managed three times if we were lucky.

I have vague memories of the pantomimes. I know that I saw *Peter Pan* and when Captain Hook appeared I know that I called out with the rest of them in panic, 'He's behind you!' I don't know if I saw it at the Alhambra or the Pavilion, or maybe the King's, but I do know that I was fascinated by it to the extent that I would wait at the Alhambra stage door and collect autographs, one being of a young Johnny Beattie, still going strong on BBC's *River City*. I do know that it was in the Alhambra that I saw Roy Rogers and his partner Dale Evans perform there, complete with his trusty 'Four-Legged Friend', Trigger. Roy Rogers was a famous American singer and film star. In 1954 he was on a promotional tour and stayed at Glasgow's Central Hotel. There is an apocryphal story that his horse Trigger shared the room with him but this is probably because he had booked one of the bridal suites!

It was also at The Alhambra that I saw Max Bygraves star in the famous *Five Past Eight Show* in 1963. His son Anthony was also in the show. It's strange how things stick in your mind but I have a very clear recollection of Max singing 'Whenever I Feel Afraid I Whistle a Happy Tune' – I still sing it.

The Alhambra, close to my home in Anderston and the theatre which I attended most frequently, was lost to new developments and falling audiences. It closed with a final show by Cilla Black in 1969. But not far from here was another, earlier theatre, in the village of Grahamston, which was almost completely obliterated to make way for Central Station. I have to say that, growing up in Anderston as I did, I had no knowledge of Grahamston even though I lived a few streets away, it being between my house in North Street and the Central Station.

Like Anderston, Finnieston, Blythswood, and Kinning Park, Grahamston had been a village, just outside what was then the western boundary of Glasgow. It was named after John Graham of Dougalston, an advocate who feued around six acres from the Blythswood Holm in 1709 and who modestly gave it his own name.

The Pavilion.

Grahamston lay in the square of land bounded roughly by Mitchell Street, Hope Street, Argyle Street and Gordon Street. In common with the other villages of Glasgow, it succumbed to the growth of industry and commerce. By the 1850s what had originally been fields and market gardens had been built upon and Grahamston had formally been absorbed into Glasgow.

The area included a church, woodyards, a sugar refinery, a gas holder and a brewery as well as tenements. The main street in this small area was Alston Street, named after Glasgow merchant John Alston. Besides private houses, Alston Street, over the time of its existence, hosted building contractors, a crystal chandelier maker and a theatre.

With the inexorable march of progress and Victorian endeavour, most of Grahamston was to disappear under the tracks and platforms of Glasgow Central Station. But out of that grew a myth, and nothing more, that some vestiges of Grahamston still exist in tunnels under the station, even to the extent that shops were left, still with articles on the counters as well as cobbled streets. Nonsense of course, as the area was completely cleared in order to put the massive foundations down into what is a gravel and sand sub-soil. A nice idea though, and one I often gave thought to when I explored the station when I was young, looking for the secret entrances. I never had the courage, though, to enter the massive network of service tunnels which do lie beneath the station. The cobbled street idea may have come from the fact that

the arches in Midland Street and Broomielaw below the southern end of the station have been used for storage and parking for many years and were in fact cobbled; some still are.

The magistrates of the town were God-fearing men who didn't relish the idea of a theatre within the town of Glasgow. Baillie John Miller, father in-law of James Alston, owned land at the Grahamston Brewery which at the time was outside the burgh boundary. This he sold to a group of theatre promoters, and the first Playhouse was born in Alston Street in April 1764. The theatre was built to a design of architect John Adam and featured a prominent statue of William Shakespeare.

The beginning of theatre in Glasgow was not without resistance from the advocates of the austere life. Two days before the theatre was to be opened, with famous actress George Anne Bellamy in attendance, there was a fire when a crowd broke into the building, setting light to the props and making off with what they could. However, Mrs Bellamy was made of stouter stuff and pulled out all the stops to make immediate repairs, continue with rehearsals, and open as planned with a musical concert, a comedy and a farce, James Townley's *High Life Below Stairs*.

However, the Church leaders couldn't let the subject drop and continued to rail against the 'deil's house'. In 1780, shortly after John Jackson took over the theatre, it was again attacked and a fire started, destroying the building, after which it was to become part of a granary before the whole street disappeared to allow the building of Glasgow Central Station.

Jackson was still in the business and bought land in Dunlop Street, on which was built the Theatre Royal in 1782. The theatre became extremely popular, featuring stars of the day such as Mrs Siddons and 'Master Betty'. Sarah Siddons was a Welsh-born tragedienne who made Lady Macbeth her own. Master Betty was a child actor born as William Henry West Betty in Shrewsbury in 1791.

These actors showed that Glasgow wasn't just a provincial stage but attracted the greatest players of the day to the theatres, which were growing in numbers despite the best resistance of the Church and the effect of fire-raising by their most ferocious followers.

In Queen Street, not a stone's throw from where Alston Street disappeared, arose the Theatre Royal, designed by David Hamilton and built by the Glasgow Corporation. From the Dunlop Street Theatre came John Jackson to manage this theatre, which was the first in Great Britain to boast gas lighting. Unfortunately, while the religious fanatics had no hand in it, the theatre burnt down in 1829. By this time the previous Theatre Royal had become the Caledonian, mostly used for 'lowbrow' entertainments like circus shows and as a music hall.

Glasgow architects and builders were highly respected for the beauty of their works. Glasgow, since the days of the Tobacco Lords, and even back to the building of the great cathedral, had been proud of its buildings. Their statues also reflected the wealth which was being generated. They were not backwards in promoting it and bearing in mind that most of the city magistrates were the wealth makers, it would not surprise you to know that they took pride in the ostentation and magnificence of their buildings.

Unfortunately, their appreciation of such things as fire prevention was minimal, not just in the public buildings but in their mills and factories. We will come back to that, but for the moment you won't be surprised to learn that the Dunlop Street theatre burned down in 1863 and was demolished in 1869 to be replaced with St Enoch's Station and Hotel.

In 1869, the Theatre Royal was to be reborn where it now stands, at the top of Hope Street in Cowcaddens, and is, by dint of others disappearing, the oldest theatre in Glasgow. This is where the celebrated partnership of Howard & Wyndham appeared. With chairman Michael Simons, they were to provide Glaswegians and Scots generally with many years of popular shows in many theatres, including one that they built: The King's Theatre.

There were to be other theatres and among these was the feared Glasgow Palace Empire. First appearing in Sauchiehall Street, 'The English Comic's Graveyard' was to move to Renfield Street. The 'Palace' was dropped and the Empire went on to host huge audiences watching stars of music, stage and screen including Jack Benny, Judy Garland and Bob Hope. In 1949 Danny Kaye, one of the biggest names in cinema, performed to sell-out audiences. He had already starred in *The Kid from Brooklyn* and was soon to go on to *Hans Christian Andersen* and *White Christmas* with Bing Crosby. A great favourite among his songs was 'The Ugly Duckling', which featured regularly on BBC radio. However, less favoured was Danny's rendition of 'I belong to Glasgow'. I suppose it was well meant and a tribute to both Will Fyffe and to Glasgow, but it was truly dreadful. You can still get it on YouTube. Perhaps I am being too critical, as Will Fyffe, Harry Lauder and others also parodied the Scot. It just seems daft to see Americans do it, in the way they portrayed the disappearing village in *Brigadoon*, and, of course, *Greyfriars Bobby*. Still, I suppose they have done a lot for tourism.

There was also the Pavilion, opened in 1904 as a music hall. Largely unchanged architecturally, it is a Category A listed building; it is designed in French Renaissance style and opened as the ambitiously titled Pavilion Theatre of Varieties.

It hosted many artists, including Harry Lauder and Charlie Chaplin. But the Glaswegian in the 1930s was sore in need of laughs, so the Pavilion reflected the demands by producing pantomime. And one comedian who made the Palladium his home was Lex McLean. Alexander McLean Cameron, (aka 'Sexy Lexy') was from Clydebank and is acknowledged as the last great Scottish music hall act; he was a huge draw at the Pavilion and many other theatres from the 1950s until the 1970s.

Lex was actually a Bankie Boy but had no hesitation in calling himself a Glaswegian. Glaswegians responded by taking him to their hearts and loving his humour. It was risqué but never smutty. The whole family could go and see 'Sexy Lexy'.

Lex was to succeed the great Tommy Morgan at the Pavilion with a summer season. Those whom he invited to his show were either famous, like George Formby, or would become famous by appearing in his shows. These included Andy Stewart, the Alexander Brothers and Jack and Tom. Another of these acts was the Harmonichords, a fresh faced group of Irish boys who went out to carve out success as The Bachelors with hits such as 'Charmaine' and 'Diane'.

Jimmy Logan's Metropole in Glasgow's George Cross had the opposite of the success of the Pavilion. I suppose you can call Jimmy one of my heroes. I was brought up in Glasgow, where Jimmy and his family were an institution just like Andy Stewart and the White Heather Club. I saw him in pantomime and variety shows at the Glasgow Alhambra. But unlike the White Heather Club, Jimmy Logan represented the true Glasgow and took Glasgow humour far and wide.

For me, while I liked and respected him in pantomime, I thought that one of his best ever performances was as a boss in *The Ship*, which involved the creation of a 67-foot-wide model of a ship inside Harland & Wolff's former engine shed in Govan during the Glasgow Year of Culture in 1990. This accommodated an audience of up to 1,200 and ended each night with the launching of the ship.

It had been Jimmy Logan's ambition to run his own theatre and he achieved it with an offer to buy the Metropole, becoming the owner of the renamed New Metropole in 1964, a venture into which he put his life savings.

While the first years were good for Jimmy and his fellow directors from the family, allowing them to invest in improvements, it became a struggle. The Corporation of Glasgow apparently failed to tell them that it was a listed building and refused planning permission for the re-development of an adjacent building owned by the company. The Corporation had its own plans for the redevelopment of St George's Cross and the theatre didn't appear to figure in them.

One of the events which helped the survival of the theatre was the rock musical *Hair*, which ran for ten months, playing to 200,000 people. I was one of them. However, the theatre suffered from the 1972 blackouts, a product of the Miners' Strike, and the resulting Three-Day Week, during which shows had to be cancelled. The theatre closed and never re-opened. In 1974 there was a fire caused by vandalism which virtually destroyed it. The bank finally took control and sold it to a developer. A block of flats now stands on the site.

In 1996, Jimmy was awarded an OBE for his 'Services to Scottish theatre' and an honorary Doctorate of Letters at Glasgow Caledonian University in 1994. He died in 2001, not long after having set up the Jimmy Logan Cancer Trust.

There were many other legends. We mentioned Tommy Morgan. Brought up in Lily Street in Bridgeton in 1898, Tommy was a draw from the 1930s to the 1950s although I am not sure if I saw him in panto, where he regularly appeared as the Dame. He preceded the likes of Billy Connolly with his pronounced (or badly pronounced) gallus Glasgow accent. Tommy was dear to Glaswegians, a man who had seen poverty as well as the mud of Flanders during the Great War. The bar at the Pavilion Theatre is named after him.

Another Glasgow favourite was Glen Daly, who succeeded Lex McLean at the Pavilion. I only saw Glen once, as far as I can remember, but it must have been memorable as I can remember what he sung. He was the 'star turn' at the St Patrick's, Anderston, school concert in the mid-1960s and I particularly remember him singing 'The Gypsy Rover'. He was just as much at home singing folk songs as he was singing both Scottish and Irish favourites of the time.

Glen Daly, whose name was actually Bartholomew Francis McCann McGovern Dick, was born in 1930. On leaving St Mary's School in the Calton, Glen worked in

the Clyde shipyards, just like his music hall and Pavilion chum Lex McLean. Glen started his career in Glasgow's Metropole but it was as a 'feed' to Lex that his career began to take off. At the Pavilion, his contemporaries were the up and coming artists Andy Stewart and The Alexander Brothers, Tom and Jack.

Besides making TV appearances on the White Heather Club, he toured extensively abroad, including Australia, Canada and the USA. In Blackpool he entertained Glasgow 'Fair Fortnight' holidaymakers, sharing the stage with Ken Dodd, The Bachelors and The Nolans. Glen was extremely comfortable with club singing and was a regular at Glasgow's Ashfield Club. *The Very Best of Glen Daly (Live at the Ashfield Club)* was a huge hit and he went on to make other successful albums, including *Legends of Scotland, Glasgow Night Out* and *Glen Daly 'Mr Glasgow'*.

If Lex McLean was a dedicated Rangers supporter then Glen Daly was Glasgow's exact opposite. How more Celtic can you get than to have a football fan club named after you, as they did with the Glen Daly Rothesay Celtic Supporters Club? Some people even believe, incorrectly, that Glen Daly wrote 'The Celtic Song', the anthem that he is most closely associated with and which he took into the UK charts in 1961. This, and his huge Irish Catholic following, has given him the name 'Mr Celtic'.

Glen became ill in the early 1980s and retired to Bute, where he passed away peacefully at his home. He is buried in Rothesay's Barone Cemetery.

For interest, 'The Celtic Song' was actually written by Mick (Garngad) McLaughlin and the rights sold to Glen Daly for £10. Mick Garngad also wrote many other Celtic anthems as well as being a local poet. 'The Celtic Song' was famously sung in an episode of the cult American series *Lost*.

Many of our Glasgow singers and comics came from underprivileged backgrounds and through enormous courage in front of discerning (in a Glasgow sense) crowds became huge stars. A fine example of these was Tommy Lorne.

Tommy Lorne was one of Scotland's great music hall performers and appeared regularly in Howard & Wyndham's pantomimes. Originally from Fleming Street in the Cowcaddens, son of Irish parents, the family settled in Kirkintilloch. Tommy was an intelligent boy and this intelligence took him with a bursary to St Aloysius College in Garnethill, following which he started a technical apprenticeship at the Blochairn works of the Steel Company of Scotland. However, it is clear that he had the stage bug. He said that he first appeared in Kirkintilloch on stage at the age of five and subsequently with the Port Dundas Court Juvenile Minstrels, singing and dancing.

He performed at talent shows and, as he became more well-known, teamed up with other artists. His longest lasting stint was as Wallace and Lorne, with Billy Wallace. They toured Scotland on the variety circuit, eventually appearing at Harry McKelvie's Royal Princess's Theatre in the Gorbals. This was a famous and lavish pantomime lasting up to twenty weeks. The Royal Princess was to go on to become The Citizens Theatre.

Lorne was Tommy's stage name as he was actually born Hugh Corcoran. There is a story that he actually wanted to be Tom E. Lorne but the printers made a mistake! Like most music hall performers before and since, he adopted his own dress, mannerisms and sayings, although his dress was a bit exaggerated. He wore an oversized Glengarry

bonnet, a kilt and jacket that were both too short, wore white make-up and talked in a high, squeaky stage voice!

And it is probably the sayings that stick most of all. Even though Tommy Lorne was before my time, I remember well the sayings still being used, and in fact used by other comedians. Whether 'Sausages are the boys' had anything to do with Lorne sausages I don't know, but the phrase coined by him is still on the go and I remember Jimmy Logan using it. The other one was 'Ah'll get ye!' and I can see my father saying his most famous: 'In the name of the wee man!' I always wondered who the 'wee man' was and whether it was the same wee man he was going to see about a dog. It is also said that the Lorne sausage is named after Tommy, or perhaps he was named after the sausage!

What I didn't know was the connection with Garngad (Little Ireland), where Tommy appeared many times in St Roch's Hall. Garngad was the home of my Irish Catholic grandparents and St Roch was their parish church. Tommy was a pal of one of the parish priests at that time, Father Edward Lawton. When Tommy caught pneumonia and died in 1935, his funeral service was conducted there by Father Lawton. 3,000 mourners were at what was the largest funeral ever in Garngad. It was attended by the great Harry Lauder, who retired the same year.

Tommy worked himself to death and drank too much for his own good. He also had contractual difficulties with A. Stewart Cruikshank, Managing Director of Howard & Wyndham. The pressure in his final 1934-35 season of doing two shows of *Cinderella* a day contributed to his entry to an Edinburgh nursing home with exhaustion. At forty-five, he contracted pneumonia and died at 11 Ainslie Place, Edinburgh, on 17 April 1935. Tommy was buried in his parents' lair at the Auld Aisle Cemetery, Kirkintilloch.

It may be that Tommy Lorne is responsible for the BBC being called 'Auntie'. No-one seems to know the reason why but Tommy Lorne produced a record for the BBC in 1922 called *Auntie Aggie of the BBC*. It was re-issued on an LP in 1972.

You would be hard put finding someone in Scotland, and even beyond, who has not heard of 'I belong to Glasgow'. That song, written, composed and sung by Will Fyffe, is surely as Glaswegian as Glasgow itself. Only slightly less known is the composer.

Will Fyffe loved Glasgow and was loved by Glaswegians. He certainly knew the working man. It might be said that if he was glorifying drink, he was reflecting the plight of many a Glaswegian, whose escape from poverty and a disintegrating city was the bottle.

I can't remember when I first heard about Will, but I do remember my father explaining 'Twelve and a Tanner a Bottle' to me, possibly when he was singing it, as he often did.

It was probably written in 1920 as on 19 April that year the price of whisky was put up from ten shillings and sixpence to twelve shillings and sixpence. It caused uproar and this song, written and sung by Will, was famous at the time.

Some of you will already be raising your hands in horror, as Will Fyffe did not actually belong to Glasgow but to Dundee, and from a more privileged background than that portrayed in some of his songs. His mother actually worked as a piano

I Belong to Glasgow.

Written. Composed and Sung by

Will Fyffe.

RECORDED ON: Regal-Zono. G5084—Will Fyffe

Will Fyffe, 'I belong to Glasgow': 'I belong to Glasgow, dear old Glasgow town/ But something's the matter with Glasgow/ For it's going round and round/ I'm only a common old working chap as anyone here can see/ But when I get a couple of drinks on a Saturday/ Glasgow belongs to me'.

teacher, and his father was a carpenter with an interest in entertainment. He was born in a tenement at 36 Broughty Ferry Road in Dundee in 1885.

While he was born a Dundonian, Glasgow was his adopted city and when he died tragically of a fall from a window after an operation in 1947, he was interred in the city's Lambhill Cemetery.

There is a story that in Glasgow, where he was hugely popular, the Empire Theatre ran a Will Fyffe competition. Disguised as himself, he came second singing 'I belong to Glasgow'. Will wrote the song, apparently after meeting a drunk in Glasgow's Central Station. Apparently he was going on about socialism and drink at the same time and when Will asked him if he belonged to Glasgow, he said that, 'At the moment, Glasgow belongs to me.'

These have been a few of the characters over the years who Glasgow has taken to its heart. There were many more and fondly remembered. And now we have a tribute to all of those actors and singers who graced the boards through the years in Glasgow. The Britannia Panopticon in Argyll Street has now re-opened and is undergoing refurbishment. Founded in 1857 in the Trongate, the theatre hosted famous early stars such as Dan Leno and Harry Lauder. It was the theatre where a sixteen-year-old Stan Laurel started his career.

Astonishingly, when it was closed, the theatre disappeared and was forgotten about until it was rediscovered around 1997, hidden behind a false ceiling. The theatre is a piece of living history and the last remaining music hall in the world.

The Glaswegian still loves to be entertained and you would travel far and wide to find such a range of family entertainment. Besides the traditional panto at the

King's and Pavilion, there is now the brand new SSE Hydro, showing major international acts.

But pride of place for the Glaswegian must be the Glasgow Concert Halls at the top of Buchanan Street, a very appropriate place in the centre of the city as we 'walk up Sauchie, down Buchie and alang Argyll'. Who needed a street map?

The Concert Hall was a long time coming. The St Andrew's Halls was the main venue for concerts up till its destruction in 1962. A temporary home for Glasgow music lovers was found in my own local cinema, the Gaiety. This had started out as the Tivoli Variety Theatre and was rebuilt in 1904 as the Gaiety Theatre, showing both cinema and variety until it was a full cinema in 1935. It closed in 1960, a victim of a declining local population and eventually another victim of the new M8 and approaches to the Kingston Bridge. In the meantime, it was to be the Glasgow Concert Hall. I was among the very first people to see the inside of it in full light as I had only ever seen it in the dark. My school and many others were taken to listen to Benjamin Britten's *A Young Person's Guide to the Orchestra*, with the Scottish National Orchestra conducted by the famous Scottish conductor Sir Alexander Gibson.

But you know it didn't start where I started, with my own experiences of pantomime. No doubt, as Glasgow was growing and as the Glasgow Fair developed, there would have been street entertainers such as the 'penny geggie', which was a travelling show, basically a tent or tents carried by cart or handcart and which would set up on village greens and certainly on the Green at the Glasgow Fair.

Another form of entertainment was the whistle-binkie. A whistle-binkie, by the way, was a musician or storyteller who played at penny weddings and other gatherings and who was dependent on the audience for payment. A penny wedding was one at which the guests would bring their own food and drink. Sir Walter Scot makes reference to it in the *Heart of Midlothian*: 'Doctor, my breath is growing as scant as a broken-winded piper's, when he has played for four-and-twenty hours at a penny wedding.'

But you know there was other music, and while it wasn't as popular as variety, orchestral, choral, ballet and jazz have also had their place. This 'highbrow' music could then, and maybe now, only be afforded by the better off. In an earlier chapter we learned that perhaps the first great name to appear was Frederic Chopin, who entertained an audience of Glasgow's elite in Glasgow's Merchants House. With the French Revolution in progress and with declining health and deserting pupils, he had been invited to Britain by Jane Stirling, a friend and possibly lover. He played to a number of audiences in London, Manchester and Edinburgh and arrived in Glasgow for a well-received concert on 27 September 1848. Jane was able to muster many of the Scottish elite to attend the concert.

I do know that at primary school efforts were made to introduce us to classical music by way of big loudspeakers that we were sent to collect from the school office. These were then plugged into a little socket on the wall and we were told to be completely silent while we listened to classical music. We had violin lessons and piano lessons at school and we were taken to concerts at the St Andrew's Halls.

And one of the favourites to appear in the St Andrew's Halls was Hugh Roberton's Orpheus Choir. The Glasgow Orpheus Choir had its roots in 1901, in the Toynbee House Choir in the Toynbee Men's Social Club at 25 Rottenrow. With seventeen-year-old Roberton as conductor, two hard years' work culminated in a concert at the East End Industrial Exhibition in 1903. There was a bit of a falling out and the choir left the club in 1906. With Hugh on the podium, the Glasgow Orpheus Choir played to a packed St Andrew's Hall in Glasgow, followed by London's Queen's Hall in 1908. A tour followed, which included Leeds, Liverpool, Birmingham, Sheffield, York, Manchester and Dublin.

Sir Hugh retired through ill health in 1951 and died at his home in Cathcart in October 1952. So much did they love Sir Hugh and consider the choir to be his, the Orpheus Choir decided to disband. Some of the choir members then formed the Glasgow Phoenix Choir, which is still going strong.

Besides being in at the start of the Orpheus, he was a composer and wrote 'All in the April Evening', a beautiful choral work. He put the words to 'Westering Home' and 'The Mingulay Boat Song' and translated 'Marie's Wedding' from the original Gaelic.

What care we tho' white the Minch is
What care we for wind and weather?
Let her go boys, every inch is
Wearing homeward to Mingulay!

The Citizens Theatre has always been the home of more serious drama. The Citizens Company was formed in 1943 by dramatists James Bridie and Paul Vincent Carroll and Tom Honeyman, director of the Glasgow Art Gallery and Museum. Based first at the Glasgow Athenaeum, it moved to its present site in 1945. This had been the Royal Princess's Theatre but now became the Citizens.

Glasgow theatre began a new era in the 1970s, and 1974 was a particularly great year. The Citizen gave us *The Cheviot, the Stag and the Black, Black Oil* by Tom McGrath's 7:84 company. The play revitalised Scottish theatre. McGrath called it a 'ceilidh play' which covers the exploitation of the Highlands and Islands and includes the clan system, the role of shooting estates and the oil industry and the fight against the landlords.

The Kinema

At the start of the twentieth century, Glasgow had more cinemas than any city outside of America. Another record was Green's Playhouse, which was opened in 1927 by entertainment entrepreneur George Green. With seating for 4,368, it was the largest cinema in Europe. In the 1950s it was still popular and it was where I saw both *Ben Hur* and *The Nun's Story*. Another comment on Glasgow education is that it was our primary school which took us to see these.

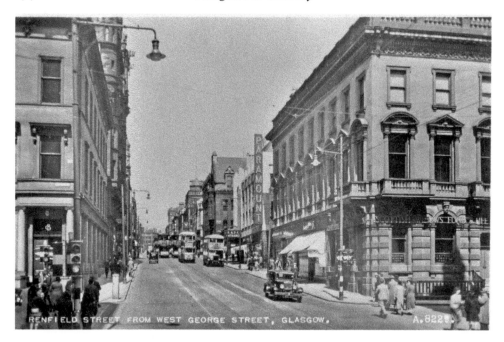

The Paramount, with Renfield Street on the right. This Art Deco building was to become the Odeon. It was a massive cinema, built in 1934 to seat 2,800. The building is presently being demolished, with the façade retained.

Cinema was popular throughout the wars years and into the 1960s, when audiences went into decline as more and more Glaswegians were able to afford television. My own Gaiety Cinema closed, to temporarily become the Glasgow Concert Hall. A few became bingo halls or disappeared in the 'clearances'. However, Green's Playhouse was to go out in a blaze of glory. It closed to cinema audiences in 1973 but re-opened the same year as the Apollo, or 'the Shed', and was to become famous as Scotland's venue for major rock concerts.

> The only thing that should happen to the Apollo is that it be torn down by rock fans brick by brick while a rock band play 'Scotland the Brave' at 50,000 watts, F*$% bingo long live rock! *Bob Geldof*

Artists who performed there include Alice Cooper, AC/DC, Status Quo, Diana Ross, Nazareth, Paul McCartney and The Stranglers. Pete Way of UFO said that the crowd in Glasgow dripped rock!

However, all good things come to an end. It was due for redevelopment by the time it became known as the 'Appalling' and closed in 1987 following a fire which rendered the building unsafe. How unusual! However, in another, more dubious record, the new UGC Cineworld Megaplex cinema built on the site boasts that it is the tallest cinema in Europe. It has also been recorded as the busiest cinema in Britain.

We should also mention the Coliseum Cinerama in Eglinton Street, which had a proud history but an ignominious end. Built in 1925, it had a long history of cinema and was Glasgow's first venue for a talking picture in 1929. In 1963 it was the home of Glasgow and Scotland's only Cinerama.

Cinerama is wide screen cinema, with images from three synchronised projectors beamed onto three curved screens. With a seven-track surround system, this produced an amazing effect which again drew the crowds. It was an attempt to compete with television but in the end it couldn't. Only a very small number were made and I know that at the Coliseum I saw *Ice Station Zebra* and *2001: A Space Odyssey*.

Interest in Cinerama waned and the cinema returned to normal films, closing in 1980. For a time it became another bingo hall until finally closing in 2006. In 2009 the building suffered a bad fire with most of the roof falling in. The building was finally demolished. The shame of this is that it was a beautiful building, designed by the famous theatre architect Frank Matcham and listed by Historic Scotland.

I am not one to be sniffy about bingo, or housey-housey as I knew it as a child. The curious growth of bingo has certainly helped preserve many cinemas and a fine example is the Vogue Bingo Club in Riddrie. It is one of the best preserved 1930s cinemas in Scotland and listed B by Historic Scotland. Designed by cinema architect James McKissick, it opened in 1938. The Vogue continued showing films until April 1968, since when it has been a successful bingo hall, most recently cared for and run by NB Leisure Ltd. Its basement contains cinema memorabilia including cinema seats and parts of the original projector.

The Glasgow Film Theatre. The GFT started life as the Cosmo.

The Glasgow Folk Singer

It was Billy Connolly who described those vocal interpreters of our Celtic heritage as civil servants 'putting on their Aran sweaters and becoming weekend folk singers'. How true, and I was one of them. It might surprise some to know that Billy Connolly himself was also a folk singer, once of the Humblebums, with the late, great Gerry Rafferty. We played on the same stage at the McLellan Galleries on his very first solo gig.

I am pleased I was involved in a little way with the folk revival of the 1960s, which was as much about anti-Polaris protests and about the Campaign for Nuclear Disarmament and socialism as it was about singing. I even had the duffle coat sporting a CND badge.

If we didn't sing on the same stage as the folk singers, we went to see them. If not in pubs, then in the Glasgow Folk Club, which used to be in Montrose Street. Among these was Matt McGinn, who had a similar background to, and whom I think knew, my father. Both of them came from the east end and went on to become secondary school teachers as a second career. Matt's output was prolific. In looking back at his songs and poems I was reminded that he had written 'The Ballad of John MacLean' and 'If it wisnae for the Union', and 'Three Nights and a Sunday (Double Time)', all of which endeared him to the Glasgow working classes. Most Glaswegians will also remember 'The Wee Red yo-yo' with great fondness.

If Glasgow was passionate about football, it was passionate about singing. If 'Wan singer wan song, round the living room into the wee sma hoors of Ne'er day' was not folk singing then what was? For that was where the songs of particular cultures could be sung. Next in line after 'I left my Heart in San Francisco' would be 'The Ould Orange Flute' or 'The Homes of Donegal'.

The singers of the folk revival would be the ones to take these songs to a wider audience, as well as become household names. Both duos, Roy and Alex McEwan and Robin Hall and Jimmy McGregor, were about the first Scots folk singers to appear on national television, on the *Tonight* programme with Cliff Michelmore. The latter's best known song of the time was 'Football Crazy': 'He's football crazy, he's football daft, and the football it has robbed him of the wee bit sense he had'? Very true. The gravelly voiced Scot, Fyffe Robertson, was a regular reporter on the same programme.

Matt McGinn.

Radio and Television – A New Media Era for Glasgow

Radio has developed substantially since the earliest days when the choice was the BBC Light or Third Programmes or Radio Luxembourg. Still, I wouldn't knock the Light Programme as I vividly remember it playing in the waiting room of my dentist in Corunna Street in Finnieston; here I would sit and watch the fish swimming around a big tank as I waited for treatment. Fish tanks were a feature of dentist's then. I suppose it was a calming influence, as was the Elizabethan Serenade on the radio.

The first radio service in Scotland was actually launched as Station 5SC by the BBC in 1923. It was based in Rex House, 202 Bath Street, in Glasgow. It eventually combined with other BBC stations to be part of the BBC Home Service, set up in 1939.

The Glasgow base subsequently moved to Blythswood Square, and then onto West George Street as the station expanded. In 1929 it was decided that BBC Scotland's headquarters should be in Edinburgh's Queen Street. It was here that BBC Radio Scotland became an entity in 1978. This remained the Edinburgh base until relocating to The Tun in April 2002, near to, and tied in with the creation of, the Holyrood Parliament.

By the early 1930s, radio was available to around 80 per cent of Scotland, broadcasting from Glasgow. It included news, plays like *Rob Roy*, the first radio play broadcast by the BBC, in the 1940s. An early success was the comedy show *The McFlannels*, starring Glasgow's own Molly Weir as Poison Ivy. In 1938 the first practice air-raid warning was broadcast and in September 1939, the service merged with the BBC Home Service for the duration of the war.

BBC Scotland is now docked on the land which last saw the Glasgow Garden Festival and previously harboured ships from throughout the world. It is now a popular radio station with a wide variety of programmes on radio and internet.

Pirates from Glasgow

While there was early television in the 1960s, there was precious little to entertain young people until the birth of pirate radio. I was one of those young lads who slipped away from school at lunchtime in order to make requests for records to be played on the new pirate station, Radio Scotland. Their head office was in Cranworth Street, just off the Byres Road.

The man behind all of this was 'Mr 242' himself, Tommy, or TV Shields. Tommy had previously been present at the birth of Scottish Television as Press and Publicity Manager, but saw the opportunities afforded by radio and was involved unsuccessfully in trying to establish land-based stations.

An unknown Simon Dee opened Radio Caroline on Easter Sunday 1964, and was then the very first pirate radio ship broadcasting. The monopoly on broadcasting held by Radio Luxembourg and the British Broadcasting Corporation had been broken and it was not long afterwards that Tommy took the plunge. Radio Scotland began broadcasting on Hogmanay 1965.

> Radio Scotland
> Playing just for you
> So beat the ban
> And join the clan
> On good old 242

Radio Scotland was a phenomenon and extremely popular. Jack McLaughlin's 'Ceilidh' provided us with a successful mix of traditional and modern as well as the wit from 'The Laird of Cowcaddens'. Contributions from Tony Meehan, Stuart Henry and Richard Park were what youth in Glasgow were waiting for.

Radio Scotland also had a magazine, *242*, which I bought regularly. Being a PR man, Tommy knew that marketing would be behind the success of the station. The magazine was popular and besides advertising it contained reports and photos from Radio Scotland's 'Clan Ball'. It had articles on the stars of the day. Featured in it were the likes of Chris McClure and The Section, Lulu and Adam Faith.

Although it quickly became a well-loved institution, it was an irritation to the BBC and the government were forced to do something about it. They could not do anything about the broadcasting as it was outside territorial waters. But they could do something about those trying to reach the boat.

The station closed on 14 August 1967, when the Marine Offences Act came into force. This effectively made it illegal to supply pirate ships from the mainland. This included staff, advertising and pre-recorded tapes. It effectively isolated all offshore operators. While Radio Caroline struggled on, pirate ships supplied from Great Britain ceased operation. Radio Scotland tried to be exempted on the basis that it reached parts of the country not served by the BBC. It failed.

Radio Scotland broadcast from *The Comet*, which was built at John Brown's as an Irish lightship before it began broadcasting. When the curtains finally came down it was towed to Methil while a buyer was found. When there were no takers it was towed to Holland for breaking up.

Tommy died not long after Radio Scotland was forced to abandon ship. It is said that he had been broken-hearted at the end of his dream. However, he was part of the pirate radio movement, which was instrumental in forcing the broadcasting authorities to examine their outdated approaches and find out what young people actually wanted. Not long after, the BBC introduced Radio One as well as *Top of The Pops*.

Tommy's legacy was also a platform for the development of a host of young broadcasters who went on to Scottish and national broadcasting jobs.

Among these were Paul Young, who went on to carve out a successful acting career. I saw him first at The Citizens in Roddy McMillan's *The Bevellers*. He is well known for his fishing series *Hooked on Scotland*. Richard Park continued in the media, going on to become a judge on *Fame Academy* via Radio Clyde and Radio One. There was also Jimmy Mack, Tony Allan, Tony Meehan and Bob Spencer. Jack McLaughlin, 'The Laird of Cowcaddens', was another name whose *Ceilidh* was outstanding. Jack continued in broadcasting and hosted STV's *Thingummyjig*, which continued his mix of traditional Scottish and modern.

This Wonderful World – The Exciting Days of Television

There are many Glaswegians of my age who will remember the famous, cultured voice of Michael O'Hallaran giving his daily lunchtime announcement: 'This is Scottish Television broadcasting from the Black Hill Transmitter of the Independent Broadcasting Authority.' That would precede the *One O'Clock Gang*, hosted by Larry Marshall. One of the first shows of its kind, the *Gang* was to showcase Scottish stars who till then were only on stage. Many of them took brilliantly to TV. There was Ricky Fulton and Jack Milroy (Francie and Josie – 'Hullawrer Darlin'), who did a regular classroom sketch. There was the trio of Charlie Sim, Moira Briody and Peggy O'Keefe and Johnnie Beattie. I once was in the TV audience and that might even have been during the appearance of Michael Holliday, the singer of 'The Runaway Train' and 'The Story of My Life'. Bill Tennent was one of the first ever newsreaders.

My other favourite programme was *This Wonderful World*, hosted by the great John Grierson and which was on just before we went to Scouts on a Friday night. I loved it. This programme, in black and white, featured short films and animations from throughout the world, and as far as I can remember, was the only one to do so until the concept was reintroduced by Bob Harris in *The Old Grey Whistle Test* in the 1970s. The programme was innovative and enjoyable and started me on a lifetime love of documentary.

I did not know at that time about the importance of John Grierson but he was instrumental in many ways in making documentaries an art form. He was responsible for the ground-breaking film of the Scottish fishing fleet, *Drifters*, and also *The Night Mail*, which had a script by W. H. Auden and a musical score by Benjamin Britten. He was instrumental in setting up the Post Office Film Unit as well the National Film Board of Canada. It is a credit to STV that they saw the potential for showing such experimental works as they did on *This Wonderful World*.

STV was created by Canadian Roy Thompson and took to the airways in 1957 when only 187,000 homes were equipped to receive the station. By the end of the first five years 937,000 homes were able to receive broadcasts within a potential audience of 3.25 million in an area covering 4/5ths of the Scottish population.

The One O'Clock Gang as bus drivers and conductors. Larry Marshall is on the far right, Moira Briody in the middle.

STV was to create a format which was loved by the Scottish population. Rather than follow any BBC format, its mission was to reflect:

> local preferences, lead, not follow in the process. It should air the views and meet the needs of as many minority groups as possible without sacrificing the legitimate interests of the non-vocal minority ... Since Scottish Television serves an area of intensive industrial, development where life for the great majority is an uneventful routine with little glamour or excitement in it, we believe our viewers have as great a need for laughter, gaiety and fantasy as they have for enlightenment and exhortation.

Worthy sentiments, and over the years STV have given us, without the budget of the BBC, a decent fare of programmes and established some household names. Besides Larry Marshall and his Gang, it introduced *Scotsport* with presenter Arthur Montford. In a programme which might not now meet local preferences was TV chef Eric Milligan in a cooking programme called *Keeping Your Man*! Roy Kinnear was Mr Fixit in a programme featuring a toy repair shop. We also met a young Paul Young in *Round-up*, which featured a schools quiz.

They were also adventurous in drama, producing plays and funding repertory theatre. The TV audience probably first saw Gordon Jackson, later of *Upstairs, Downstairs*, in *Dear Boss*, about a local newspaper. Geraldine McEwan appeared in *Double Image*.

Their plans for featuring serious music, as they called it, were disrupted and delayed by the fire at St Andrew's Hall, where they had filmed the last ever Last Night of the Proms with the Scottish National Orchestra.

STV is still alive and well, now based in brand-new buildings in the media park on Pacific Quay, next to BBC Scotland, with whom it competes for television audiences throughout Scotland.

'To Play for the Sake of Playing' – The Story of Sport in Glasgow

Football – 'The Scientific Game' (According to Michael Marra)

25 May 1967 was a nervous day in Glasgow. It was as if all of the years of Saturday afternoons and Wednesday nights standing in sunshine, rain, hail and snow had finally been found to be worth it. All of the years of playing in the school yard, the close or on 'the brokie' were found to be well justified. All of the frustration, anger, and joy had been aired. All of the heated discussions and debate in the pub, on the terrace or on the tram and bus had been heard. Football was at last recognised by the country as important and raised to a national celebration. All at once it wasn't just a manly spectator sport. Those with no prior knowledge, love, or involvement realised the importance to the country and to the family as well as to the club. Scotland and Europe held its breath. In Lisbon, that very evening, Celtic Football Club was about to play Internazionale in the final of the European Cup.

I was seventeen. I travelled homewards from Dalmarnock on a bus through a deathly quiet Argyle Street. A huge chunk of Glasgow had already rushed home to watch the game, one which I can't now describe in detail except that the tension that was felt throughout the city must have been the same as when Andy Murray played in the Wimbledon Tennis Final in 2013. But the scenes of jubilation when the final whistle blew were incredible and there were few, excepting the most partisan, who could deny Celtic the glory as Jock Stein's 'Lisbon Lions' arrived home to Glasgow in triumph to parade the cup in front of a jubilant crowd at Celtic Park. That famous victory showed that football in Scotland had come a long way since the first Glasgow teams had emerged in the late 1800s.

In 1424, in the reign of James I, the Scottish Parliament banned football, 'fut ball', which was probably as good a reason as any for people in Glasgow to take it up. Football seems to have been derived from more brutal and larger assemblies of young men in great numbers pursuing pigs' bladders or other such spheres from one side of a town to the other. This resulted in damage and riots which must have disturbed the peace considerably. Remnants of this primitive sport are to be found in Kirkwall's 'Ba Game', where a leather ball is indeed kicked, mostly by young men, from one end of the town to the other.

How football became limited to eleven players remains a mystery, except that one story says that English school teams had ten pupils, making eleven if you include the

teacher. It is well known that after the Football Association, the Scottish Football Association (SFA) was the second national football organisation and the Scottish Cup is the world's oldest national sporting trophy.

Glasgow has the honour of having hosted the world's oldest international football competition. Played in 1872, this was between Scotland and England and, strange as it may seem, it was played on the grounds of the West of Scotland Cricket Club in Hamilton Crescent. The game was a 0-0 draw.

Just as an aside, another interesting fact is that it was Glasgow's famous multinational grocer, Tommy Lipton, who started the Football World Cup in 1910. The Sir Thomas Lipton Trophy was played for on two occasions in Turin. It was said to be the first World Cup although there had been another competing claim in Turin in 1908. For Lipton's competition, the Football Association of England refused representation. Undaunted, the great Lipton invited West Auckland FC, a miners' club from County Durham, to play against some of the most prestigious teams from Europe.

The SFA, formed in 1873, is still the governing body of the game in Scotland and was for many years based above Kelvingrove Park in Park Gardens but is now housed in the rebuilt national stadium at Hampden Park. The Scottish Football Museum is also there.

While it is home to many international games as well as pop concerts, the stadium actually belongs to Queen's Park Football Club and that is where we examine the start of the modern 'round ball game'.

In July 1867, the minutes of a meeting began with: 'Tonight at half past eight o'clock a number of gentlemen met at No. 3 Eglinton Terrace for the purpose of forming a football club.' That was the beginning of Queen's Park Football Club, and of Scottish organised football.

Before that, football was mostly uncontrolled 'mob football', 'kickaboots', or limited to public schools and such institutions where rules would be specific to that institution.

Queen's Park was a highly successful club, attracting audiences of up to 10,000. Their success created some of Glasgow's football history as Glasgow and Scotland took to the 'gemme'. Their home ground took its name from Hampden Terrace, which overlooked their first ground, which they occupied for ten years beginning with a Scottish Cup match in 1873. It hosted the first Scottish Cup Final in 1874, with Queen's Park beating Clydesdale 2-0. The Scotland *v.* England match followed in 1878, with Scotland beating England 7-2.

In 1884, with continuing success, a new stadium was built at Crosshill with the Hampden name carried with it. This was later to become home to another famous club, Third Lanark, and renamed Cathkin Park.

Not only was Queen's Park innovative in forming a club, they also had ingenuity in the way in which they went about building the club for fans. Their original ground had the first ever turnstiles and presumably the first ever 'lift over', the unofficial method of allowing young lads in free if they could be 'hudgied' over the turnstiles. It happened to me. The world's first ever all-ticket match was the 1878 one played against England. And it was not only in the infrastructure that they were innovative.

They laid the foundations of modern team play, 'the scientific game', rather than the individual approaches there had been to that date. It was also decided that there motto would be *Ludere causa ludendi* – 'To play for the sake of playing'. That amateur status has been upheld till this day and makes the club unique in senior football.

They were also the instigators of the Scottish Football Association when they wrote to the early teams in 1873. There was a response from eight clubs: Clydesdale, Vale of Leven, Dumbreck, Third Lanark, Eastern, Granville and Kilmarnock. With Queen's Park, these formed the basis of the Scottish Football Association. A resolution was passed to set up an association based on the rules of the Football Association (FA) as well as to provide for an annual cup competition.

Following the formation of the SFA, most of the matches played would be 'friendlies', local cup matches or SFA Scottish Cup ties. In England, organised competitive leagues had started to form. The Football League started in 1888 and this included Scottish teams. With the professionalising of football in England, Scottish footballers had been attracted south for the large salaries. The English called these 'Scotch Professors' as many of them had university backgrounds. Naturally, as the universities were closely associated with the beginnings of Scottish football.

All of this started Scottish clubs thinking about a Scottish league. This time it would be Renton which took the initiative, writing an invitation to clubs to take part in discussions. The result was the inauguration of the Scottish League in 1890.

In 1998, a number of teams broke away from the SFL to form the Scottish Premier League (SPL). At the time of writing there has been a major change in this set-up with the SPL and SFL both being abolished and merged to form a new Scottish Professional Football League.

But back to Queen's Park, where, in 1900, a decision was taken to build a new stadium at Mount Florida. The new Hampden Park opened in 1903, becoming the world's largest stadium till it was overtaken by Maracanã in Rio de Janeiro in 1950. Again it was innovative, with a car park, a press box, crush barriers and a Tannoy system.

We can only look at a very few of those players and officials who made the game what it is and who are honoured in the Scottish Football Hall of Fame. The Hall of Fame is hosted by the Scottish Football Museum at Hampden Park. The Hall was started in 2004 but if it had started earlier, it would surely have included 'Toffee Bob', who played for Queen's Park.

Robert Smyth McColl is considered to be one of Scotland's greatest footballers. He played as a centre forward. Born in 1878, he joined Queen's Park in 1894 when he was sixteen, from Benmore, a defunct Mount Florida club. His first game was in a 2-1 win against Rangers in a Glasgow Merchant's Charity Cup match at Cathkin Park. Queen's Park went on to be beaten 2-1 by Celtic in the final.

According to the International Federation of Football History and Statistics, Robert McColl

was a scorer with a deadly shot, but also an exemplary team-mate and excellent at passing. He made his international début in Dundee on March 21, 1896, when he played against Wales without scoring, but he scored ten times during the next five

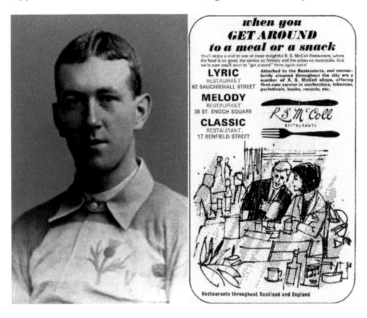

when you
GET AROUND
to a meal or a snack

You'll enjoy a visit to one of these delightful R. S. McColl Restaurants, where the food is so good, the service so friendly and the prices so reasonable. And we're sure you'll want to "get around" them again soon!

LYRIC
RESTAURANT
62 SAUCHIEHALL STREET

Attached to the Restaurants, and conveniently situated throughout the city are a number of R. S. McColl shops, offering first-rate service in confections, tobaccos, periodicals, books, records, etc.

MELODY
RESTAURANT
38 ST. ENOCH SQUARE

CLASSIC
RESTAURANT.
17 RENFIELD STREET

R S McColl
RESTAURANTS

Restaurants throughout Scotland and England

R. S. McColl
– Footballer and
entrepreneur.

full internationals. On April 14, 1900, he reached the Scottish Cup final with Queen's Park FC, but lost 3:4 to local rivals Celtic.

By the way, is it not a great thing that we have a federation to record such detail?

After eight years at Queen's Park he was tempted to join Newcastle United, although he was also attracted by Derby County, Blackburn and Liverpool. In 1905 he signed for Rangers, where he stayed until 1907 before returning to Queen's Park, where he stayed until 1910. During his time in football he gathered 13 caps for Scotland, playing centre-forward. In the game against England in 1900 he scored a hat trick, Scotland eventually winning 4-1 at Celtic Park. He retired from football at 32 but not before scoring nine goals in his last three games.

In 1901, possibly in wise preparation for retirement from football, he opened a sweetie shop in Albert Drive with his brother Tom. This company expanded rapidly to become an institution in Scotland, R. S. McColl. They opened a factory in North Woodside Road in 1916, at which time they had thirty branches. They also had a chain of restaurants with three very popular ones in Glasgow. In 1933 Cadbury Brothers took a controlling share in the business. Both brothers remained with the new company during its growth to 180 branches by 1935. They retired in 1946.

Queen's Park was instrumental in not only upholding the standards of the game but in promoting Scottish football. The club, as were many others at the time, was founded by 'gentlemen', which in many cases meant those from the professions of law, medicine, insurance, engineering and so on. Many of them, particularly in Queen's Park, valued the amateur status which allowed them to continue playing while carrying on with their professions.

In 1921, Queen's Park, with the realisation that university football teams were a fertile source of talent, launched the Queen's Park Shield, the most prestigious annual

prize in student football in Scotland. The shield is solid silver and contains the crests of the four ancient Scottish universities: Glasgow, Edinburgh, St Andrews and Aberdeen. The shield is still played for and is presently held by Stirling University.

We mentioned Third Lanark, who were another of Glasgow's early football clubs and one which I was taken to by my father, who used to chant a little ditty which went something like 'Renton are game and the Rangers the same, ditto the LRV ...' At least I think that's was it was, and LRV would refer to the Third Lanarkshire Rifle Volunteers, which was formed shortly after the 1872 Queen's Park game with England. Apparently a group of soldiers from the regiment had visited the match and the enthusiasm was such that they decided to create their own club.

The club started with a very appropriate nickname, the Redcoats, and at one time they were also called The Warriors, but the name that stuck was the 'Hi-Hi's.' Apparently a defender had belted the ball so hard that the crowd took up the chant: 'hi hi hi!' While their official title changed to Third Lanark AC in 1904, their nickname stuck but the club had to come down to earth.

In the same year that Celtic won the European Cup, Third Lanark met its end in a very similar way to more recent endings, with directorial misadventure and worse, taking away from faithful fans their right to Saturday afternoons of pride and passion (while ma stayed home and did the washin?).

My big brother told me that he had also been to see Third Lanark near the end and remembers Jocky Robertson, who at 5 feet 5 inches was reputed to be Scotland's smallest goalkeeper. Over twelve years, he kept the Cathkin Park crowd entertained with his acrobatic saves.

Third Lanark had won most domestic trophies over a glorious period of ninety-five years. And, like Queen's Park, they had made a major contribution to Scottish football. They were First Division champs in 1903/4 and won the Scottish Cup in 1889 and 1905. They were also winners of the Glasgow Cup and the Glasgow Charity Cup. While they were not always at the top of the tree, nevertheless they were a well respected club as well as a very well remembered one. It is so sad that one person can bring a whole organisation down. It is something that we have seen so often when 'businessmen' with other interests get involved in the running of football clubs and forget that their biggest stakeholders are actually their fans. It is no wonder that Queen's Park, with their commitment to amateur status, have lasted so well.

Most of the blame for the destruction of the club was laid at the door of Bill Hiddleston, who had briefly been a board member in the 1950s before being asked to resign. In 1962 he was back on the board and his involvement brought acrimony, dissent and disaster. George Young, the manager, and three directors immediately resigned in protest. Over the next couple of years, player dissatisfaction and resulting sales to other clubs brought the club down. By 1966/67, the lack of money for basic things like floodlighting and hot water showed that the end was in sight, as indeed it was when the liquidators were brought it.

I would probably have been taken to Firhill, to see Partick Thistle, as a very young boy. Firhill was a second choice for my father if Celtic were playing too far away from home. This was the case for many supporters as Partick has a special place in the hearts of many Glaswegians north of the river.

Let's start with the name, which as you may know is rather misleading as Partick Thistle are actually based in Maryhill, to where they had moved in 1908 following homes in various parts of the area, starting in Partick and including Meadowside and Kelvingrove.

The first Scottish Cup Final in 1874 obviously created fantastic interest in and enthusiasm for the new football game. Partick Thistle, or 'The Jags', was a result of this, being set up in 1876. While the Jags may not always have been at the top of the pile in terms of trophies, their very existence is a tribute to their management and the way that they have included their fans.

The Thistle website bemoans the fact that the very first goal scored at Firhill in 1909 was scored by a visiting team, Dumbarton Harp, and 'it is a shame that quite a number of goals scored since then have been by visiting teams as well!' A good sense of humour as well as patience is an essential requirement if you want to be a Thistle fan. One fan told me that he used to think the name was actually Partick Thistle Nil as the latter word appeared constantly. See what I mean?

While they have rarely had a full trophy cabinet, they nevertheless won the Scottish Cup in 1921, beating Rangers 1-0, and the Scottish League Cup in 1971. The latter was a famous event when Celtic was soundly beaten 4-1.

It is interesting that there was an early motion in 1903 to turn the club into a company: '*The Evening Times* reported that the important business of the evening – a proposal to form the club into a limited liability company – wasn't entertained by the members.' From 1921 to 1971 the team only had limited success but did appear in the finals of three League Cups and won the Glasgow Charity Cup on occasion.

We can see that the end of the 1800s was a boom time for Scottish football, possibly in the same way that ice hockey has come to the fore in recent years. From 1867 a number of clubs started and folded as they found or didn't find fans. Some lasted as long as playing in the first Scottish Cup. These included Clydesdale FC, Callender FC, Granville FC, Rovers Glasgow, and Blythswood FC. One of those who survived was Clyde FC, the 'Bully Wee', which was formed in 1877, playing at Barrowfield Park in Bridgeton before moving to their long-term park at Shawfield, south of the river. The reason for starting at Barrowfield may have been an early involvement in rowing. Some of the early clubs emerged from existing 'gentlemen's clubs' already involved in rowing, bowling or cricket. Football was just an extension of existing activities for some. By the way, a short-lived team called Albatross FC also played at Barrowfield. Their name might suggest why they were short-lived!

I well remember games at Shawfield in the 1950s. It was grim and I doubt whether there had been many improvements when, in the 1970s, their badly maintained home was sold from under them. When they were finally served with a notice to quit in 1986, they had to find another home. An interim measure led to five seasons of ground sharing with Partick Thistle followed by a couple of years at Douglas Park, Hamilton, while a new stadium was being built in Cumbernauld. It took a bit of time to arrive but Clyde FC have now settled into their new home in the new town of Cumbernauld. New age travelling footballers glad to have found a home.

Next out of the tunnel and playing together are the 'Old Firm', otherwise Celtic FC and Rangers FC, old and sometimes bitter rivals, often of a sectarian nature.

In the late 1880s there was a huge growth in football. It must have received enormous publicity for the number of clubs emerging or embracing football was huge. In the east end of Glasgow there was someone who saw this as a way to engage the young men of the area and form a club as a way to raise funds to alleviate poverty. The man who did this is revered in both the history of Glasgow Catholic football and education: Brother Walfrid, of the religious teaching order the Marist Brothers. He taught at Sacred Heart School in Bridgeton, where he became headmaster.

Celtic or 'The Bhoys' (and now 'The Hoops') was intended to reflect both Irish and Scottish roots and was formed from the mostly Irish Catholic population of the area. It still maintains the strongest cultural adherence to its background.

Celtic's first ever official game, in 1888 against Rangers, was described as a 'friendly encounter'. That would change, but in the meantime its first ever goal was scored by Neil McCallum in a game which Celtic won 5-2. McCallum was described as 'one of the trickiest and cleverest outside rights that the Vale has given to Scottish football'. He previously played for Vale of Leven and Renton FC and had periods with Blackburn Rovers. His grave has recently been re-discovered in Bonhill Churchyard in 'The Vale'.

Celtic made a good start to its collection of trophies. While they lost out to Third Lanark in the 1889 Scottish Cup Final, they picked up the North-Eastern Cup, one of a number of competitions which started with the great enthusiasm for football.

Their first Scottish Cup came when they defeated Queen's Park at a final in Ibrox in 1892. In the same year, Celtic's existing home, Celtic Park or Parkhead, or 'Paradise', was built on the site of a brickworks. It opened in 1892 with a game against Renton of the Vale of Leven.

In the following year, the pattern was set with Celtic winning their first Scottish League Championship. This pattern was to be repeated and along the way records were to be broken, including in 1937 when The Bhoys beat Aberdeen in the Scottish Cup Final, watched by an unbeaten record crowd of 146,433 at Hampden Park. I am glad to say that I was present at a second record when, in 1970, in front of 133,961, the largest crowd ever to watch a European club competition, Celtic beat Leeds United at Hampden Park. They went on to be defeated 2-1 in the final by Feyenoord after extra time, in Milan.

For people of my generation, the pinnacle of success must have come when Celtic won the European Cup with a team which all came from within 30 miles of Glasgow. An unbelievable statistic now.

Along the way the club produced heroes like Willie Maley, the first manager appointed in 1897, when the club became a limited company. There are too many to mention them all but a representative few would include Charlie Tully, a Belfast boy who signed for Celtic from Belfast Celtic in 1948 and went on to cult status when he was instrumental in the 3-1 defeat of Rangers. It is said that 'Tully Cocktails were sold in pubs and there was green Tully ice-cream'. Why not?

There was also manager Jock Stein, who led the 'Lisbon Lions' to victory in the European Cup; Jimmy 'Jinky' Johnston, who had hero status and after whom a junior team and football academy is now named; and Kenny Dalglish, who is Scotland's

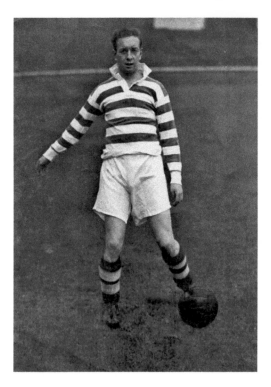

Charles Patrick 'Charlie' Tully, 1924 – 71. Charlie Tully was a Belfast lad who played for Belfast Celtic, scoring the winning goal in the 1947 Irish Cup Final. He signed for Celtic in June 1948 and in 11 years played a total of 319 matches for his team, scoring 47 goals.

most capped footballer and who went from Celtic to a glorious time at Liverpool FC before going into management, some of his time back with Celtic, now called 'The Hoops', although I don't remember that name in my youth. And by the way, *The Celtic View* is the oldest football magazine in the world.

The other half of the Old Firm is Rangers Football Club. It is said that the idea of forming a football team was discussed by Moses McNeil, his brother Peter, and friends William McBeath and Peter Campbell. They had been watching Queen's Park play and were enthused by the idea. They gathered enough players round them and their first game, played on the Green at Flesher's Haugh, was in 1872 against Callender.

It was Moses McNeil who suggested the name 'Rangers' after reading about it as the name of an English rugby team, Swindon Rangers.

By 1876 the team was formalized, with Moses McNeil called up to play against Wales. The Scottish League was formed and Rangers and Dumbarton shared top place after a 2-2 play off.

The very first Old Firm match came in the 'friendly' of 1888 related above when Rangers were beaten 5-2. Revenge, and their first Scottish Cup success, came in 1894 when they beat Celtic 3-1 in the final at Hampden Park.

In the very early days, Scottish teams could also play in the English FA Cup and Rangers very nearly won the 1887 title but were beaten by Aston Villa in the semi-final at Hampden Park.

Rangers are Scotland's most successful football club and this started early as they entered the twentieth century, having won the Scottish Cup in 1897 and 1898 and

every one of their league matches in 1899, becoming in that year a limited company under the chair of the board James Henderson and club manager William Wilton.

Under Wilton's stewardship the club had immense success in the early part of the century. Wilton died in a tragic boating accident at Gourock on the first day of his holiday in 1920. William Struth had been the club's trainer for six years and took over the reins, starting a career which lasted thirty-four years, a record, and which filled the trophy cabinets with silverware and made some legendary names, among them Willie Waddell, whose only team as a player was Rangers even though he joined at seventeen, retired at fifty-six and during his tenure won seventeen international caps, five league titles and four Scottish cups.

When he retired as a player from Rangers, he went on to captain Kilmarnock to their only League Championship win, in 1965. He was to return to Ibrox as manager in 1969 following the departure of David White but in the meantime he began to write on sports for the *Scottish Daily Express*.

In the second half of the 1960s, Rangers had been struggling to keep their trophy cabinet full. Celtic had been dominant in that time but in 1971, with the return of Waddell, Rangers won the Scottish League Cup. This was followed by the Cup Winner's Cup in 1972, in which they beat Dynamo Moscow 3-2 in Barcelona.

'Where were you when ...' is one of those President Kennedy moments when an incident so momentous makes us remember exactly what we were doing on such and such a date. I was working in a licensed grocers on the afternoon of Saturday, the day of an Old Firm match at Ibrox. Someone came into the busy shop and said that there had been a terrible accident at Ibrox and people had been killed. My immediate thoughts were of my family and friends, although it was highly unlikely that any of them would have been present. The state of violence and drunkenness at the Old Firm matches had made them no-go areas for many sensible people and eventually led to stopping the Old Firm New Year's day 'friendly' game for the same reason.

It was Saturday 2 January. There were 80,000 fans in the stadium. In the 90th minute of play, Celtic scored, putting them into a 1-0 lead. It looked like the game was over and Rangers fans started exiting the ground. But it wasn't over yet. In the final seconds, Colin Stein scored an equaliser for Rangers. On stairway 13, someone fell and like a domino effect, others followed, creating a crush which took the lives of sixty-six people and injured 200 others. Five schoolchildren came from the same town – Markinch in Fife.

As the fans were all heading in the same direction, there was no proof that any were heading back to the pitch, but the last goal must have caused at least some to hesitate and debate returning. We will return to the disaster but in the meantime let the record show that Willie Waddell is highly respected for his immediate role in supporting the fans and team members. He cancelled all training and arranged a rota of players and officials to visit the injured and relatives of the dead. He was also instrumental in converting Ibrox to an all-seater stadium to avoid this happening in the future.

We saw it all before with Third Lanark. Football should be about the game, and the fans that come to watch it, from both sets of supporters. Unfortunately, when the egos of little men get enmeshed with business and those little men forget the reason

for the game, disaster is waiting in the wings. That is what has happened to Rangers Football Club in recent years, leaving it in Scottish League One in 2013, the third level of Scottish football, rather than where it once was, competing with Celtic and other major teams for Scottish and international trophies in the Scottish Premiership.

The basic story is that the club got into cash difficulties around 2006 and struggled for a number of years before entering administration in 2012, owing Her Majesty's Revenue and Customs (HMRC) a great deal of money. HMRC refused to allow a Company Voluntary Arrangement (CVA) and the club was liquidated on 31 October 2012.

A CVA is a mechanism to allow payment over a fixed term and if the creditors agree then the company can continue trading. As the HMRC refused, a decision was taken to sell the company to Charles Green, the chief executive of the club.

And here is where there is a hot debate. Irrespective of the financial and management, is a football club the sum of its fans and players or is it simply an asset, or, in this case a liability?

The other members of the Scottish Premier League refused to recognise the new structure as being the same one that occupied a place in their league. In order to continue playing, Green gained membership of the Scottish Football League as well as the membership of the old company. The condition was that they should enter the league at the bottom, the Third Division.

There is absolutely no reason why football teams should last forever, particularly if they are limited companies and go into receivership. If the directors and managers lose the respect of the fans then there is little hope. However, when teams like Queen's Park are committed to playing the game for the sake of the game then there is more chance of a long-term fan base. The same is true, by the way, of Barcelona FC, which is actually owned by its fans and is a registered association rather than a private company. While it has had financial difficulties in the past few years, sports clubs in Scotland might learn from its structure. Its success on the field is legendary.

A recent sports commentator said that the loss of Rangers has done a great deal of harm to the Scottish Premier League and to Scottish football. As you can imagine there are opposite opinions, but I thought that the idea was about one of the most arrogant that I have heard, whether it would be applied to Rangers or to Celtic. It's as if the Scottish Football League was all the football that was on offer. In fact, thousands of Scottish people are involved in football at all levels, whether it be supporting, watching, managing or coaching. Scottish football has never been healthier, and has never played on such good grounds as it is now.

I have just visited the amazing Emirates Arena in Parkhead, where I met the football development officer who looks after the Jimmy Johnstone Football Academy. Here I learned that youth football is alive and kicking, and at the arena nine teams play and take part in coaching. This involves 130 players and between forty and fifty volunteers. The Jimmy Johnstone Academy is only one of the academies set up by teams and by communities to foster young players of both sexes. Pollok United Soccer Academy, with a new pitch in Corkerhill, has 250 players. In support there is also the Youth Football Association and the SFA Performance Schools.

Some of this development is a result of a review carried out by former First Minister Henry McLeish. This led the SFA to set out their plans for Scottish football – *Scotland United: A 2020 Vision*. In it, the aspirations are to widen and develop the pool of all talented players and especially to help children in primaries five, six and seven develop their potential.

Junior football is a misnomer as it is not about age but reflects the facts that teams are not in the Premier League or Divisions. The Scottish Junior Football Association is thriving and Glasgow, covered by the West Region, is home to Pollok FC; Glasgow Perthshire, 'The Shire', in Possilpark; Ashfield in Springburn; and St Anthony's in Cardonald. By the way, also in West Region is Ardeer Thistle. Tommy Duffy, my uncle, who played for them was in the *Guinness Book of Records* for scoring the most goals, ninety-seven, in the 1959/60 season.

You can add to this the work carried out by the Scottish Amateur Football Association, founded in 1909. The SAFA works for the amateur game. Originally formed in 1909 by Queen's Park, Glasgow and District FP League and the Schools Association, among the trophies which it sponsors are the Fosters Scottish Amateur Cup and the Scottish Amateur Sunday Trophy, representing the large number of players who turn out on a Sunday.

So, football in Scotland and in Glasgow is thriving. And generally so too are the pitches, great and small. It is a far cry from the days in which there were no women's toilets and in which the loos were no more than an enclosed drain. I remember that when there was the occasional lady, male friends would bar the entrance to the loo to prevent men going in while she was there.

The alternative to using the primitive toilets, giving rise to the statement 'Don't move or you'll get a hot leg pal', was the use of empty cans into which the fans would pee, leaving the can upright on the ground. In those days, before the Ibrox disaster, the terraces were no more than terraced earth kept together by lengths of wood, one higher than the next, which would keep the ground back. Unfortunately, if a team scored and the fans got exited, the cans would go all ways, creating a poisonous pool of earth and pee. Unsavoury in the extreme. Fortunately, the banning of alcohol at games had a dividend in that respect, forcing the primitives to use the toilets. We have come a long way.

Of course, when we talk of the Ibrox Disaster, there was more than one. The first occurred during the 1902 Home International between England and Scotland. There had been heavy rain on the night before the match and during the game the new stands collapsed, sending hundreds of supporters 40 feet to the ground below, killing twenty-five and injuring 517. This accident prompted clubs and authorities to review the type of stands which were wooden terraces joined by steel girders. Although the game was allowed to continue, sensibly in this case, to prevent crowds leaving, the result was declared void and the rematch at Villa Park in Birmingham went to the disaster fund.

On balance, football has a healthy future in Glasgow and in Scotland. And the fostering of young talent of both sexes is the future. There is no real reason why, with good management and resources, we might not see the rise of new teams through the

Scottish terraces in the 1980s. This is a quiet day and a quiet moment as the photographer spots an ex-teacher. At this time the terraces still have a long way to go to be a place to take families. This is probably after the ban on alcohol following violent behaviour at the Scottish Cup Final at Hampden in 1980. Celtic beat Rangers 1-0 after extra time and rioting broke out at the end of the match. On that day, 70,300 fans attended. Given the danger, something would have to be done.

ranks to take their place in the League. It happened at the very beginning of Scottish football, why not now?

And just as we leave Glasgow football I can tell you that we have come full circle as some of the young teams I talked about are now playing at Third Lanark's old ground, Cathkin Park, which is well on the road to recovery after decades of neglect. Standing on the old terraces on a misty day, you can almost see the ghosts of Jocky Robertson and his football adventurers.

Cricket and Much More

You can't deny the predominance of football in Glasgow culture, but as you saw, there was already cricket, as an established West of Scotland Cricket Club in Hamilton Crescent loaned their pitch for the 1872 football match between Scotland and England.

The West of Scotland is probably the best known in Glasgow and I attended one day in the 1960s, with my father. My record of one match is probably better than most Glaswegians as cricket does have a bit of a low profile and is still seen as an English game. This is probably because it was originally played by English soldiers garrisoned

in Glasgow during the Jacobite rising. Along with rugby it was also seen as an elitist sport, taken up by private schools. Football was the game of the masses. West of Scotland still does very well, as do the other clubs in Glasgow such as Glasgow Accies and Glasgow University.

We have also seen that there was an existing involvement in rowing, with football being an extension of this. Indeed, many of the early clubs were involved in other sporting activities. For instance, Celtic FC began its existence as the Celtic Football and Athletic Club and this appeared on its logo till recently.

Rowing was one of these sports and very popular on the upper reaches of the Clyde. There is no doubt that these early sports were popular with gentlemen's clubs and possibly emerged from Glasgow University. The proof might lie in the fact that Scottish footballers travelling down to England to play on transfer were called the 'Scotch Professors', referring to their professional occupations and no doubt their cultured language.

The yearly regatta for Glasgow rowing is the Glasgow Rowing Club's 'Head of the River' on the Clyde, where I rowed as a young man in a clinker-built, very heavy wooden rowing boat. The boats and crews have come a long way since then and rowing is very popular now in Scotland although the Clyde is under used for the sport, and probably undervalued, given the great improvements to the water quality since I was a boy.

Bowling has a special place for the Glaswegian and the Scottish Bowling Federation boasts many members in Glasgow. When the new scheme at Nitshill was built, a bowling green was included. People who live there now might be surprised to hear it but Nitshill was a garden town and looked it. The buildings were no more than three

Whitevale Bowling Green, Dennistoun.

storeys, were light and airy, and each had balconies, which I remember with pleasure. At Newfield Square we looked over a bowling green and tennis court. On the long, hot summer days we sat in deckchairs like on a steamer and listened to the plip-plop of tennis balls, claps from the older people on the bowling green, and general noises from the children in the roads round the square, which was very free from traffic at that time. And, incongruously, I remember regular visits from a rag-and-bone man, complete with horse and cart with car tyres! He would make his way round the square giving away inflated balloons in exchange for old clothes and jam jars.

Carntyne was the home of greyhound racing from May 1928, when a stadium was built there by Jack Nixon-Browne before he became an MP. Races held there included the Scottish Greyhound Derby before moving to Shawfield Stadium in 1968 when Carntyne Stadium closed. Speedway racing, which was much more popular than it is now, was introduced in 1928, and stock car racing in 1966. The stadium closed in 1968.

There was also White City Stadium in Ibrox, which also opened in 1928 and was the home of the Glasgow Tigers Speedway team. White City was one of the victims of the new M8 in 1972 and Glasgow Tigers moved to Saracen Park (or Ashfield Stadium), where they still race regularly.

White City, which I remember well, was an important venue which also hosted greyhound racing, show jumping as well as speedway. The stadium regularly attracted audiences of over 13,000 who were also entertained by motorcycle stunt riding.

While it is many years since Glasgow had horse racing, many Glaswegians would have a day out at the races in Paisley and Stirling until 1854. With the coming of the Glasgow & Paisley Railway, races there became an event for both punters and picnickers, an astonishing 115,000 in 1837. Over time, Paisley, Lanark and Bogside in Irvine closed down, but Glaswegians continue to make their way to both Ayr and Hamilton Park. The more dedicated will also travel to the other three in Musselburgh, Scone and Kelso. With around 100 race meetings a year between them, the sport is in fine fettle.

Around 1974 I saw an amazing play at the Glasgow Citizens Theatre. It was the story of Glasgow boxer Benny Lynch, who was to gain worldwide recognition but sink into oblivion and destitution and death in Glasgow in 1946.

Boxing is now a controversial sport given the violence it displays. However, it was second only to football in working class industrial Glasgow. Many young people from the Gorbals and other working class areas were great followers of boxing and Benny Lynch became an icon. He fought in the Flyweight Division, winning the Scottish title in 1934. He was to follow that by winning the British, European and world titles. His place in history as the greatest flyweight was cemented in a win against Filipino Small Montana in London in 1936.

Benny was not the first, and not the last, Scottish sports personality to let drink get the better of him. By 1938 he had put on so much weight that he couldn't meet the requirements of the Flyweight Division. He was finished in boxing at the age of twenty-five. He was an alcoholic and lost his boxing license on medical grounds. He also lost his marriage and, at thirty-three, died through malnutrition. During his short

career he had won seventy-seven bouts including fifteen knockouts. He also only ten and drew 1.5. He is buried in St Kentigern's Cemetery in Lambhill. Let's not forget Peter Keenan, who was another Glasgow pugilist, a bantamweight who won British, Empire and European competitions.

Another game which mostly derives from academia is rugby, which has the same kind of timeline as football and was also based on the previous rougher, no-rules games. The first significant date for rugby was when Scotland beat England in the first international in 1871. The Home Nations Championships (now the Six Nations) was formed with Scotland in 1883. Of course, Rugby Union differs from Rugby League, with different rules and player numbers. This came about as a split in England which did not affect Scotland, where the game is predominantly Rugby Union, although some Rugby League is played. In Glasgow the Easterhouse Panthers, formed in 2002, have been particularly successful.

The Glasgow Warriors are a Rugby Union side playing at the Scotstoun Stadium. Warriors were formed from two merged clubs, Glasgow Rugby and Caledonia Reds. Glasgow Warriors and Edinburgh Rugby are the only two professional rugby teams in Scotland, playing in the Heineken Cup.

Until I began to research this book, I had no concept of the extent to which sport is both watched and participated in and I haven't even touched athletics, swimming and cycling. You can add to this the revenues which accrue as well as the health and wellbeing elements.

It very strange that Glasgow is still considered to be a very sick city where life expectation is the lowest in Scotland, where, in the east end, it is as low as sixty-three with the highest rates of cancer and heart disease.

As I write this book we look forward to the 2014 Commonwealth Games with high expectations, knowing that they can do as much for taking Glasgow into the future as did the Glasgow Garden Festival. Glaswegians are looking forward to them with excitement and there is no doubt that they will be an enormous success, bringing enormous benefits, not in the least to Glasgow's east end, where the Emirates Stadium is already something the city can be proud of. I would like to think that they will also bring much needed health benefits.

Glasgow at War

Glasgow, the city, got off relatively lightly in wartime. Its citizens were always in the forefront of worldwide battles and suffered terribly. In terms of employment and income it did rather well and contributed hugely to war efforts down the last three centuries, as we have seen in the chapter on manufacturing.

The city never needed fortified walls for any substantial period of time. Even the Romans avoided it except for, possibly, a small fort at Yorkhill. After all, Glasgow was never a seat of kings, only reaching its importance with the widening of the river and the beginning of international trade.

Although the area round Glasgow was sacked by Vikings from their Kingdom of Dublin in the ninth century, it was generally of little interest to invaders. For much of its early years it was simply a fishing village on a crossroads. Even Prince Charles didn't bother. At Christmas 1745, on his way south into England, his army camped on what is now part of Glasgow Green, Flesher's Haugh. Charlie demanded that the city 'donate' £15,000 to his campaign as well as provisions, clothing and footwear.

Glasgow had been doing rather well under the existing regime, and the Provost wrote back saying that as his citizens didn't support the cause, he couldn't help. He was actually more afraid of the reaction in Glasgow than he was of the Jacobite army. A smaller contribution than asked was given even as the citizens prepared to defend Glasgow against attack. It wasn't needed as Charlie headed for Edinburgh and took that instead.

Charlie got as far as Derby, from where he had to retreat. Things didn't go well either on his way home. Having extracted contributions on his way south, his benefactors had no time for him on his way home north. Meanwhile, Inverness and Edinburgh were back in Hanoverian hands and support from France was looking unlikely.

Back in Scotland, he camped at Hamilton; Glasgow still wanted nothing to do with him. However, a portion of his troops went to Glasgow on Christmas Day of 1745. The following day Charlie moved to the Shawfield Mansion in Glasgow, with 6,000 troops camping nearby.

The town was ordered to kit out the army and Charlie demanded new clothes, including coats, shirts, shoes and bonnets. Meanwhile, in a show of power, he

Glasgow Cross. Glasgow was originally a fishing village on a crossroads but look at me now! In the forefront is Glasgow's Mercat Cross marking the place where the market was held. The original was removed in 1659. This is a new one, inaugurated in 1930. In the background is the Tolbooth Steeple, built in 1625 and all that remains of the old Tolbooth buildings demolished in 1921. Until 1814 these were the site of the Glasgow City Chambers. This is where public hangings were carried out.

reviewed his army in front of the town gentry, which was arrayed on Provost Haugh, now part of Glasgow Green. In fact, the audience which turned up was bigger than the army being reviewed. Charlie's army left the city on 4 January 1746, to eventually be defeated at Culloden on 16 April.

Charlie's campaign was the last tangible contact with military combat until the Great War. A recent poll has shown that Glaswegians questioned had shown surprise at the extent to which the city had been involved in the First World War, some thinking that there had been no involvement at all. In fact around 200,000 men from the city enlisted and of these, 17,695 lost their lives, my grandfather among them.

Without the shipyards on the Clyde and without existing Scottish shipping being attached to the war effort, the outcome may have been very different. Add to this the huge numbers of guns and munitions provided to the war by Glasgow's factories, all given over to wartime production.

At Cardonald there was also a National Projectiles Factory, operated on behalf of the Ministry of Munitions by William Beardmore & Co. The government munitions factories were a response to the shortage of explosives but were by no means the only producers. Nobel Explosives was busy producing, as were many more companies.

While some had advocated a system, at the outbreak of the First World War there was no conscription. To begin with there was no apparent need as citizens were signing up in their droves to do their bit for King and Country. Many in government

First World War memorial plaque. The bronze Memorial Plaque was issued after the First World War to the next-of-kin of all British and Empire service personnel who were killed as a result of the war. 1,355,000 plaques were issued.

thought that volunteering would be enough for a war which was supposed to be over before Christmas.

One scheme devised by Sir Henry Rawlinson was the idea of encouraging whole villages and towns to join up. Those signing up did so with the promise of serving together in Pals Battalions. Whole villages, estates, and factories provided the men and officers, continuing the social order as the estate owners and managers would inevitably become officers.

In Glasgow a number of such battalions were formed: the 15th, 16th and 17th Highland Light Infantry. The 15th was formed from Glasgow Corporation Tramways; the 16th from the Boys Brigade; and the 17th, the Glasgow Commercials, apparently from offices and shops. One of these was James Youll Turnbull, who before the war played with Cartha Athletic Club, which was later to merge to form Cartha Queen's Park RFC and which still exists.

As a sergeant in the 17th Battalion (Glasgow Commercials), he received a Victoria Cross for his actions in virtually single-handedly defending an important position. He was killed later on the same day, aged thirty-two. This was the first day of the Battle of the Somme.

The 16th was raised as the 2nd Glasgow, with many recruits and former members from the Boys Brigade. The battalion was also to fight on the Somme and on its first day it lost twenty officers and 534 men. At the Battle of Ancre they lost thirteen officers and 390 men.

Between the outbreak of war and the cessation of hostilities in 1918, over 200,000 Glaswegians either volunteered or were conscripted. We can't talk about all of these but one was John Meikle.

I spent a lot of my youth at my auntie's in Nitshill, in the south of Glasgow, and when I moved to Dingwall in the 1980s it would be natural that I would notice the connection between the memorial which stands at Dingwall Station and Nitshill. It was much later, when I was researching for a book on Glasgow heroes, that I discovered

why this stone should have appeared in Dingwall when the person commemorated was a railwayman at Nitshill Station.

John Meikle was a young sergeant in the 4th Seaforth Highlanders during the First World War. Dingwall has long been associated with the Seaforth Highlanders, one of its predecessors being the Ross-Shire Buffs.

The monument at Nitshill was erected by his railway colleagues and unveiled there in January 1920 by Lady Lorimer. To protect it from vandalism it was removed, in 1971, to Dingwall, where it now stands proudly behind a replica of a makeshift monument originally erected at the Battle of Cambrai in 1917. The 4th (Ross Highland) Battalion of the Seaforth Highlanders, raised in Dingwall, distinguished themselves in this action and John Meikle was the only soldier in his battalion to win the Victoria Cross in the Great War. As Dingwall was the home to the Ross-Shire Buffs, it was fitting that the monument should come here.

On 20 July 1918, near Marfaux in the Ardre Valley, France, the Allies were attempting to push the Germans back over the River Marne. John, armed only with a revolver, single handedly put out of action a machine gun that was holding up the advance of his company. His revolver being emptied, he continued his attack with a stout stick. Seizing the rifle and bayonet of a fallen comrade, he then charged another machine-gun post. He was killed as he was doing so but his bravery allowed the position to be taken by two fellow soldiers.

John was born in Kirkintilloch in 1898 but moved to Nitshill with his parents, where, on leaving school, he joined the Glasgow & South West Railway Company and worked as a clerk at Nitshill Station.

John was apparently an avid football fan and a follower of Nitshill Royal Victoria. He 'answered the Call' on 8 February 1915. John is buried in the British Military Cemetery at Marfaux and his name his also included on the War Memorial in Nitshill.

Dingwall Museum has a very nice display about John, including his Victoria Cross. It is well worth a visit. His award was reported in the *Kirkintilloch Herald* of 18 September 1918:

His Majesty the King has been graciously pleased to approve the award of the Victoria Cross to Sergeant John Meikle late of the Seaforth Highlanders, a native of Kirkintilloch, for most conspicuous bravery and initiative when, his company having been held up by machine-gun fire, he rushed single-handed a machine-gun nest. He emptied his revolver into the crews of the two guns and put the remainder out of action with a heavy stick. Then, standing up, he waved his comrades on. Very shortly afterwards another hostile machine-gun checked progress, and threatened also the success of the company on the right. Most of his platoon having become casualties, Sergeant Meikle seized the rifle and bayonet of a fallen comrade, and again rushed forward against the gun crew, but was killed almost on the gun position. His bravery allowed two other men who followed him to put this gun out of action. This gallant non-commissioned officer's valour, devotion to duty, and utter disregard for his personal safety was an inspiring example to all.

Two First World War lads from the
2nd Scottish Rifles (Cameronians).
In the First World War there were
twenty-seven battalions. Over 7,000
Cameronians lost their lives and a
magnificent memorial in Kelvingrove,
Glasgow, commemorates this.

John was only one of the many who answered the call of the Secretary of State for
War, Lord Kitchener, in the First World War. John was also one of the many who
did not come back. Another was my grandfather, Hugh Meighan, who was one of
the British Expeditionary Force, the first to go, and whose regiment was involved
in the first major action of the war at the Battle of Mons. On 13 August 1914 the
British had been asked to hold back the Germans for twenty-four hours to prevent
them getting behind the French lines. They did this effectively but having done so
were forced to make an orderly retreat until a major counter attack at the Battle
of the Marne.

As the Second World War approached, Glasgow again prepared for war. And
again, Glasgow and the Clyde were to be a vital part of the war effort. It was
going to be different. We couldn't now say that it would be over by Christmas.
Technology had moved on and while Germany was far away, it wasn't far
enough away from the dreadful bombing that was to be a feature of this war.
And just as the Falklands War was reported on an ongoing basis, journalism and
communications had improved and, barring censorship, citizens had a very good
idea of the progress of the war from newspapers and the BBC.

But preparations were very much better. Civil defence planning was in place
and arrangements made for the evacuation of around 100,000 children from

Maryhill Barracks, Glasgow.

RELIABLE SERIES. R1711

Maryhill Barracks, where the Cameronians and many other regiments were stationed over time. The barracks were demolished in the 1960s to make way for the Wyndford housing estate.

Glasgow. The war effort also brought women into the war more than they had been in the past, assembling engines at the Hillington Rolls-Royce factory or making bombs in the factories converted to produce munitions instead of more mundane products like carpets and toys. Women were to join the many services in many roles previously the province of men. My mother became a firewoman in the Auxiliary Fire Service. She and others were to say that the friends they had then and the fun that they had made it the best time of their lives!

In truth, it was the Glasgow servicemen and the mariners on the Russian convoys that were to suffer most as Glasgow actually got off lightly. The bombing that was expected didn't materialise to the level anticipated and Glaswegians were able to get on with their lives in a city jam-packed with war workers and service personnel from Canada, Australia, New Zealand, Poland, and eventually the United States.

But one area did suffer badly. Clydebank was the focus of one of the biggest bombing raids in Scotland during the war. On the nights of 13 and 14 March 1941, 440 German bombers rained down over 105,000 bombs onto the town and surrounding areas. These included magnesium incendiary bombs. The first bombs were to fall on timber yards and distilleries, producing ready targets for the bombers to continue their bombardment. 530 people were killed and 617 were injured. In addition, 48,000 refugees had to be evacuated from a town that never fully recovered from the devastating downpour. While there was a blackout in operation, the accurate targeting was put down to a 'bombers' moon'. The bombers were able to see the harbours, rivers and docks shining with the reflection of the moon.

For the most part, the Luftwaffe was well prepared for the bombing of Glasgow and the Clyde. For example, existing photographs from German reconnaissance aircraft in 1939 clearly show the location of, and give descriptions of, factories and shipyards along the Clyde, including Barr & Stroud, Rolls-Royce, and Barclay Curle & Stephens, all major engineering works. Barr & Stroud did in fact make periscopes, binoculars, rangefinders and other military hardware. It only moved from Anniesland in the 1990s and was taken over by Thales. I worked there in the early 1970s and some of the buildings still had their camouflage paint.

The Luftwaffe had also developed methods of guiding bombers to their target by the use of radio beams sent out from occupied countries including France and Norway. The simplest of these methods, Knickbein, consisted of a beam that broadcast dots and one which broadcast dashes. At the intersection of the beams there was a continuous tone and that is where the bombs were dropped. This was based on a 'blind landing system' developed in Germany and then adapted in Great Britain.

When the British got to know about these systems, countermeasures were set up to try and jam or bend the beams. The Germans responded by developing more sophisticated devices which again were countered. In one case it is said that by jamming the beams, one jamming station sent bombers towards Ireland, where they accidentally bombed Dublin.

Also attacked in Clydebank was the huge Singer sewing machine factory. The factory had already braved the ups and downs of the First World War, contributing substantially to the war effort. During the Second World War, it was making parts for Lancaster bombers, bombs, shells, mines and 60 million rifle components, as well as bullets, bayonets and tank tracks.

It had its own Home Guard unit to defend the plant: C Company, 2nd Battalion (Dumbartonshire), Argyll & Sutherland Highlanders. Sadly, the unit couldn't stop the attacks on the nights of March 1941. Singer's got off relatively lightly with damage to the famous clock tower and a huge fire when incendiary bombs set light to the timber yard. Thirty-nine Singer workers lost their lives at home, but the work went on, with the factory resuming full production within six weeks. Several members of C Company were awarded the George Cross for their bravery.

Glaswegians at War

As we have already seen, we certainly sent Glaswegians away to fight. In fact, Glaswegians attracted to themselves a reputation for ferocious bravery and were often to be found in the front lines (unfairly, thought some) throughout history. It didn't seem to take much for Glaswegians to volunteer as we seemed to be a patriotic type. Nationalism was a novel concept to the Glaswegian, who was as likely only to describe himself as a Scot as a description to foreigners. While the Jacobite cause attracted Scots patriots, it was more to do with promoting a Catholic succession than independence. As we have seen, the Glaswegian was a Hanoverian, quite happy with the lineage and the prosperity that trade brought to the city.

The Royal Visit—Prince and Princess of Wales at Glasgow, 23rd April 1907

The Prince and Princess of Wales at Glasgow, 23 April 1907. The Prince passes the huge crowds outside Grand Hotel at Charing Cross on his way to open the new medical building at the University of Glasgow. He received the Freedom of the City on the same day.

In fact, kings and queens of Great Britain as well as military heroes were fêted as much in Glasgow as they were in other parts of the United Kingdom. Their heroes are remembered in Glasgow if you care to look. If you walk to one of my favourite places in Glasgow, at the top gates is Harry Bates' imposing bronze statue of Lord Frederick Roberts of Kandahar and Waterford, who was fêted as a national hero of colonial wars in the Victorian period. He visited Glasgow in 1903 after having successfully fought the Boers in South Africa. Many Glaswegian volunteers would have fought in these wars.

Another Victorian military hero who was thought by some Scots to have been more important than Lord Kitchener was Fighting Mac, Major General Sir Hector Archibald MacDonald, KCB, DSO. He rose from the ranks to a senior army position and aide de camp to Queen Victoria.

Macdonald was seen as the true hero of the Battle of Omdurman in the Sudan, whose courage and thinking saved the British Army, which was facing the larger Mahdist (Islamic) forces of Abdullah Ibn-Mohammed.

Such was the adulation for him in Scotland that Paterson & Son of Charlotte Street in Glasgow placed him on the front of their Camp Coffee bottle. Very clever, as he is still there, although somewhat altered over the years. The Sikh who was originally serving him his coffee is now a fellow soldier joining him for a wee chat.

Glaswegians volunteered to fight in the Peninsular War, in the Crimea and in India. One gravestone in the Southern Necropolis tells the story of Agnes Harkness, Heroine of Matagorda, later Agnes Reston. Agnes, with her four-year-old son, followed her

husband to the Peninsular War, where he was fighting in 1810 with the 94th (Scotch Brigade). While there, at the fort of Matagorda, near Cadiz, she helped to nurse the wounded and supported the surgeons. She was known to have carried water while under enemy cannon fire.

They both returned to Glasgow, where surviving on an army pension was tough. James died in 1834 and Agnes found herself in dire straits, but working as a nurse in the Town's House, a poorhouse on Clyde Street, in 1844. Her story was told in the *Glasgow Herald* the same year and afterwards a group of military officers organised an appeal to which Queen Victoria contributed. The appeal raised enough to provide an annuity from which Agnes was able to see out her days in comfort, although she decided to stay in the Town's House, paying for her keep. The gravestone of James and Agnes Reston can be seen in the Southern Necropolis and carries the inscription:

In memory of James Reston, late serjeant 94th Regiment, who died on the 24th day of October, 1834, aged 63 years, and of Agnes Harkness, his wife, 'The Heroine of Matagorda', who died 24 December 1856, aged 85 years.

Politics, Radicals and Red Clydeside

Church Rule and the Birth of Democracy

We saw earlier that Glasgow had been made a burgh in by 1175 by King William I (the Lion) of Scotland. A mark of the small size of the town at the time is the fact that around thirty-seven burghs had been created before Glasgow.

The town was effectively controlled by the Church and Archbishop Jocelin was instrumental in obtaining the charter for the burgh. This allowed for the establishment of a local market and annual fair in the town. This trade continued with the development of specific markets trading in flesh, milk, fruit, vegetables, salt and fish. The annual fair was to become the Glasgow holiday, Fair Fortnight. Another important feature of the burgh was that it could be represented in the Parliament of Scotland.

In the original charter there was no reference as to how the town was to be managed. Before 1500, it looks as if most administration was being looked after by the bishops. After this time, rents were being collected and deposited into a town fund and non-legal matters were being dealt with by a council. The officers of the bishops were now a provost, a senior magistrate, and bailies who appeared to act with some autonomy.

From the Reformation in 1560, the management of the town became increasingly secularised, appointing its own magistrates. Many activities of the town had been managed by the burghers, merchants and tradesmen and these responsibilities were also assumed by the town council. In 1611, the town was granted the status of Royal Burgh by James VI; this basically granted, or in most cases confirmed, to the burgh full possession of the lands of Glasgow and the River Clyde, with all revenues of the town on the promise of obedience towards the Crown and Archbishop John Spotiswoode.

With the Restoration of the Monarchy in 1660 and a return of the role of bishops in 1662, the archbishop regained the right to appoint magistrates and it wasn't till 1690 that Glasgow again became a democratic city with full rights to appoint a Lord Provost and Magistrates. In 1895 the Glasgow Town Council formally became the Corporation of the City of Glasgow and this status was to continue up till the re-organisation of local government in 1975. At that date, the City of Glasgow District Council came into being, with the fifteenth-century title Lord Provost of Glasgow used for the leader of the council.

In 1975 a two-tier system of government was created: Regional and District councils, with each Region containing a number of councils. From 1975, the Region looked after police, fire services, transport, water, education, social work and transport. Glasgow District Council had responsibility for refuse collection, museums, libraries and housing. In 1996, the name was changed to Glasgow City Council when the two-tier system of government was abolished.

The City of Glasgow is presently represented in the Westminster Parliament by seven Members of Parliament. These are elected every five years in a 'first-past-the-post' election.

Reading this book, it will come as no surprise to you that in modern times the city has generally voted in left-wing MPs and has given the country a number of prime ministers.

In Victorian times, with the emergence of political parties, the dominant party in Scotland was the Liberals and they continued as a significant party, particularly in the Highlands and the Borders. In 1988 they merged with the new Social Democratic Party to form the Scottish Liberal Democrats and in 1999 made a pact with Labour to run the Scottish Government.

In 2013, Liberal Democrat support in Scotland is at an all-time low. In the 2011 Scottish elections their vote collapsed, leaving them with very few MSPs in Holyrood. The collapse has been put down mostly to the current UK coalition government of Lib Dems and Conservatives, deeply unpopular in many parts of Scotland.

The Scottish Conservative and Unionist Party, the Scottish Tories, was formed in 1965 in the joining of the Unionist Party and the Conservative Party. It has been forgotten in modern times that the Tories were actually the dominant force in Scottish politics between 1930 and 1950. From the 1960s the Tories went into decline in the face of rising support for the Scottish Labour Party. With proportional representation in the Scottish Government, the party can field a number of MSPs, which brings a valuable third opinion in the otherwise polarised politics of Scottish Nationals and Labour.

In Glasgow, the Progressives were the major force in local politics in the 1950s, but were eventually overtaken by the Labour Party. The Progressives were an independent party but were mostly Conservatives and supported by that party. Their main reason for existence seemed to be simply to oppose Labour politics, particularly the growth of 'municipal socialism'. As new opposition in the form of the SNP arrived, the Progressives disappeared.

Formed in 1934, the Scottish National Party is committed to independence for Scotland. Its history is in the amalgamation of a number of organisations advocating Home Rule as far back in the 1920s, at the same time as Home Rule was being sought for Ireland. Nothing if not persistent, it continued as a minority party, finally making some successes, particularly with the 1967 election of Winnie Ewing in the Hamilton by-election. This was followed in 1973 when Margo McDonald won the Glasgow Govan by-election. It continued its upwards growth, culminating in a victory in the 2011 Scottish Parliamentary elections, with the SNP forming a Scottish Government. This allowed them to bring forward proposals for an independence referendum which was held in 2014. While the vote was against an independent Scotland, the referendum

has been credited with revitalising Scottish Politics. Those who voted 'No' were 55.3 per cent and those who voted 'Yes' 44.7 per cent. The turnout, around 85 per cent, was the highest recorded for an election of referendum in the United Kingdom.

Radical Politics and the Growth of Socialism

We have already seen that the 1787 Calton Weavers' protest at reduced wages resulted in Glasgow's first strike and lockout. The strikers had little hope in the face of the continued mechanisation of weaving, but the martyrdom of the dead weavers has gone down in history as the first industrial dispute in Scotland and has been celebrated in song and painting. This was the precursor to what has become Red Clydeside.

Glasgow has a proud record of standing up against unfairness from government and from employers. Before the Weavers' Strike, the riots against the Malt Tax in 1725 demonstrated this. England already had a tax on malt and this was being extended to Scotland. The revenue officers were met by hostile crowds and driven out of Glasgow. The response from the military resulted in eight deaths. Instead of pursuing the perpetrators of the riots, the city magistrates investigated the civilian deaths. This annoyed the Lord Advocate, who had them arrested and taken to Edinburgh, where they were unsuccessfully prosecuted. They returned to a hero's welcome.

It was again the weaving trade which was to bring Glasgow close to major conflict. From 1800, the earnings of skilled weavers were becoming considerably reduced and they petitioned the city magistrates in 1812 for an increase. The result of refusal was a nine-week strike. The authorities were alarmed that the strikers were becoming organised and set up a network of spies to keep tabs on them.

In 1816, on Glasgow Green, the traditional site of radical demonstrations, 40,000 people met to protest against the Corn Laws which were preventing imports to protect British landowners. This kept prices artificially high. The protestors demanded fairness and a more representative government.

In 1820, in what has become known as the Radical War, a proclamation was issued from the Committee of Organisation for Forming a Provisional Government. This called for a strike to demand their 'Rights'. Around 60,000 in the Glasgow area struck. There was also a call to arms, which wasn't successful. There were suspicions that the uprising was actually the work of government agents provocateurs. A group of radicals from Glasgow who did march on the Carron Ironworks were met by the Stirling Yeomanry and captured. This became known as the Battle of Bonnymuir. Forty-seven of the marchers were accused of treason, with the ringleaders all being executed and others sentenced to penal transportation.

The Scottish Reform Act of 1832 brought some relief from the threat of revolution through a major change to the voting system. However, it was said to be inherently favorable to the upper classes as there was no secret ballot, so employees could be persuaded to vote for landowners. However, it did expand the electorate from 4,239 in 1820 to over 65,000 in 1832. The numbers of Members of Parliament also

increased. Later reform acts in 1868 and 1884 further enfranchised ordinary people, although it wasn't until 1918 that women got the vote.

The first indication of what would become a modern militancy was the strike at the Singer sewing machine factory in 1911.

There can be very few people who have not heard about the Singer sewing machine. In Glasgow, although times are changing and memories are fading, there are still many people who could tell you that Singer had a huge factory in Clydebank producing their machines. By 1867 the American Singer company was looking for export markets and the UK was clearly an option given the vast number of vessels plying between America and the UK, and the UK was a gateway to Europe. In 1856 they already had a branch office in Buchanan Street in Glasgow. Their factory at Love Loan, High John Street, near Queen Street Station in Glasgow, was the first outside the US, possibly because Singer's general manager of the time was George Ross McKenzie, born in Scotland and who had emigrated in 1846. He is credited with the expansion of and success of Singer worldwide. By his retirement the company was selling half a million machines each year.

Using machines and parts shipped from New Jersey, thirty machines were being produced each week in 1867. Very soon, expansion took the firm to James Street in Bridgeton, where by 1871 it was the biggest factory in Britain and by 1880 it was employing 2,000 workers. Continued demand and expansion required a green field site, this time on the other side of Glasgow at Kilbowie, Clydebank. Singer's factory, built by Sir Alfred McAlpine, was opened by George Ross McKenzie in 1882. It was the

Singer factory, Clydebank. The factory and the workforce was so large that they built the still existing special station called Singer and the brand became synonymous with the sewing machine, just like Hoover did with the vacuum cleaner.

most modern factory in Europe, incorporating advanced features such as a sprinkler system and fireproof doors, the same features which were to become commonplace in Glasgow warehouses, factories and department stores in later years.

A situation at the factory in 1911 led to one of the most memorable of Scotland's labour disputes and contributed to the image of the 'Red Clydesider'. Between March and April, twelve female cabinet polishers protested against work changes introduced as part of new Scientific Management principles. To them, this would have meant an increase in work and a decrease in wages. The entire workforce of 11,000 went on strike in sympathy.

This was a time of extreme industrial unrest in Scotland, with a fourfold increase in strike days compared to the decade leading up to 1910. Trades union membership increased dramatically in the years leading up to the First World War. The factory owners were suspicious of the motivations of trades unions, given the political and social unrest in Russia at the time, and used strong methods to prevent disruption to work.

At the same time, Scientific Management, introduced by Frederick Wimslow Taylor in the United States in the 1880s and 1890s, was actively being considered in Great Britain. Taylor was the advocate of 'the one best way', which could be found by analysing the workflow. His approaches included what has become known as time and motion study, the practice of breaking jobs down into components parts and setting standard times for each part in order to create efficiency and lower costs. The idea of the white-coated time and motion man is still an image despised in Scottish working history and responsible for any number of industrial disputes.

On the other hand, Taylor's efforts, combined with those of Henry Ford, are said to have made a major contribution to the efficiency of armaments factories during the First World War and this set the scene for modern management practice, theory and a move towards further experimentation leading to less intrusive and demeaning practices than are considered to have been originally advocated by him.

But back at Singer's the solidarity shown by otherwise disparate groups of workers within the factory is attributed to the influence of both the Industrial Workers of Great Britain (IWGB) and the Socialist Labour Party. In the face of solid support, Singer's closed the factory and threatened the workers with moving it elsewhere in Europe as well as blacklisting those on strike. This was no mean threat as many industrialists disliked the idea of organised labour, breaking strikes with intimidation and using 'scabs' to replace striking workers.

Following this ultimatum, the strike came to an end after a ballot. The workers voted to return unconditionally on 10 April 1911. They had achieved nothing except solidarity. The company, however, retaliated against the strikers, sacking all of the leaders and members of the IWGB. One of those among the 400 sacked was Arthur McManus, who would go on to become the first chairman of the Communist Party of Great Britain, in 1920.

As the First World War approached, working class opposition to the war was increasing. A Clyde Workers Committee was formed, with David Kirkwood and Willie Gallacher at its head. Much of the work focused on the armaments factories.

Demonstrations simply resulted in Gallagher and Kirkwood being jailed for their activities, as were John McLean and James Maxton, both to be remembered as heroes of the working class 'struggle'.

Following the war, the Scottish Trades Union Council (STUC) and the Clyde Workers Committee (CWC) were seeking a major reduction in the working week in order to alleviate the worrying rise in unemployment; they thought that it would make it fairer for the thousands of tradesmen returning from the front to their factories and shipyards.

On 27 January 1919, a workers' meeting was held at St Andrew's Halls, where 3,000 gathered. The same day, 40,000 workers went on strike and by 31 January the numbers had grown to 60,000. That day, there was a mass meeting in George Square, where the Lord Provost Sir James Watson read out the government's response to a request to intervene in the dispute.

While the CWC delegation was in the City Chambers discussing with the Lord Provost, fighting broke out in the Square. Leaders David Kirkwood and Manny Shinwell immediately went outside to try and stop the battle. However, they were set upon by police and Kirkwood was knocked to the ground. He, Manny Shinwell and William Gallacher were charged with inciting a riot.

Sheriff Mackenzie attempted to read the Riot Act but was prevented from doing so by the mob, who tore his copy of the act from him. Naturally, one side blamed the other. One account had the police baton charging the mob in an unprovoked attack. Whatever the reason, the prime minister, David Lloyd George, was not impressed with the inability of the police to control the situation.

Overnight, tanks began to arrive in Glasgow and were held in readiness in the cattle market in the Gallowgate. Mortars were set up around the City Chambers and machine guns were placed on buildings surrounding the square.

'They are not here for War Savings purposes', said the *Manchester Guardian*. Martial law had arrived in Glasgow and the reputation of the police was in tatters. 10,000 troops were to arrive in the city and stay till the end of the strike on 11 March. Glasgow-born troops were deliberately excluded from the force.

It is safe to say that the government and city's response to the dispute consolidated Socialist feelings in the city and country. In the 1922 Parliamentary elections, Scotland elected twenty-nine Labour MPs including Manny Shinwell and David Kirkwood as well as those on the CWC.

While it went down in Glasgow mythology as Bloody Friday, it was probably overly dramatised, as such things are, and not as bloody as painted. And there were to be no more such conflicts in Glasgow, which was mostly happy to follow Parliamentary democracy until the Poll Tax demonstrations in 1990, when Margaret Thatcher changed local authority taxation in Britain. Domestic rates were replaced by the Community Charge, renamed by objectors the Poll Tax. The tax meant larger bills for poor families.

Prime Minister Thatcher had clearly not thought through the effects of introducing such a tax in Scotland, which might have been the most likely area to object strongly, and object it did. Almost 30 per cent of the population of some local areas refused to pay. The resultant sheriff officer 'poindings' in Glasgow brought people onto the streets.

David Kirkwood on the ground outside the City Chambers. Previous images show him being beaten by policemen. Willie Gallacher was also hurt; he is in the background holding his head. I am fairly sure that is Manny Shinwell in the foreground.

Along with other areas in Britain, the civil unrest was a major factor in the demise of Prime Minister Thatcher. While she was already unpopular in Scotland, the Poll Tax virtually wiped out the Conservatives as a party in the west of Scotland. The Poll Tax was replaced by Council Tax in 1993.

Perhaps they had learned a strong lesson when, in 1994, the Conservative government produced plans for the privatisation of water supply and services throughout Great Britain. Under the reform of Scottish local government, the water and sewage services were moved from local authorities into new water authorities with an eye to privatisation in the future.

It should have been known that the people of Scotland would object to this. In a pre-emptive strike, Strathclyde Regional Council halted any government moves to privatise water by holding a referendum on the issue. Seven out of ten voters, 97 per cent, 1.2 million people voted against privatisation. The policy was dropped, with Scottish Water being created in 2002. Naturally, the Conservative government were furious and branded the referendum a 'meaningless exercise and a disgraceful waste of council taxpayers money'. Scottish Water remains in public hands.

Religious Scotland

The Roman Catholic Church in Scotland

We have already seen that Glasgow was established primarily as a centre of worship and pilgrimage to the shrines of St Mungo and St Enoch. The size of Glasgow Cathedral shows the influence and growth of the Catholic Church before the Scottish Reformation, not only in Glasgow but in Scotland. It is by good fortune that the cathedral survived the Reformation and is considered by some to be the finest Scottish building surviving from the thirteenth century. The cathedral was defended from destruction by citizens determined to protect it from the mob.

While Christianity came to Britain with the Romans in about the second-century, it only reached the lower parts of Scotland. The accepted tradition is that Scottish Christianity came with Ninian, a Cumbrian, in the fourth century. Ninian had studied in Rome and became the first Roman Catholic Bishop to visit Scotland, establishing the first church in Whithorn.

While the Church wasn't particularly strong between this time and AD 563, the Irish monk Columba and his followers established a monastery on Iona. Monks from there went on to establish communities and monasteries throughout Scotland and Europe. Lindisfarne, or the Holy Island, was one of these.

The Catholic Church in Glasgow, established by St Kentigern about AD 518, had a long existence. He was also the first bishop within the British Kingdom of Strathclyde, based at Dumbarton Rock.

The first stone cathedral dates from 1136, when it was consecrated in the presence of King David I. This original stone building was destroyed by fire. Its replacement was consecrated by Bishop Jocelin in 1197.

The Roman Catholic Church continued to expand in the city as the population grew and as the cathedral grew in importance as a place of pilgrimage to St Mungo. The Franciscans (Grey Friars) arrived around 1475, with a chapel to the Virgin Mary dedicated in 1477. They remained in the area until the Reformation and the buildings were probably destroyed around 1566.

Following Catholic emancipation in 1829, they were to return to Glasgow in 1868 with a mission in the Calton. They also established a parish in the Gorbals the same year and they prospered, with a new chapel being built in 1881.

The Dominican order, the Black Friars, also established a monastery on gifted land north of the cross, on High Street, which was largely undeveloped in 1246. Following the Reformation, the buildings and thirteen acres of land were given to the university by Mary Queen of Scots in 1566 and served as their parish church. The buildings were demolished to make way for the City of Glasgow Union Railway College Goods Yards when the university moved to Gilmorehill in 1870.

By the time of the Reformation in 1560, the Roman Catholic Church was in difficulty throughout Europe. The Black Death, a dreadful disease spread by rats and fleas, had caused many people to turn from the Church. A major split within the Church from 1378 to 1418 had also severely damaged its reputation. There were competing claims to the Papacy and the Church had become politicised and corrupt and many were looking for change.

The changes to come in Scotland started with the excommunication from the Catholic Church of Henry VIII in 1538. The Act of Appeals of 1532 is said to have been the beginning of the Reformation in England. It outlawed any appeals to the Pope on any matters, whether religious or secular, in England and Wales.

Following this, Henry VIII's Act of Supremacy in 1534 placed him as the head of the Church, declaring that he was the 'only supreme head on earth of the Church in England' and that the English crown shall enjoy 'all honours, dignities, pre-eminences, jurisdictions, privileges, authorities, immunities, profits, and commodities to the said dignity'. These acts allowed Thomas Cranmer, Archbishop of Canterbury, to grant Henry his divorce from Queen Catherine of Aragon to allow marriage to Anne Boleyn. While he was said to be infatuated with Anne, he was also moved by the desire to provide a male heir, which Catherine was not able to do.

Interestingly, Henry was reluctant to remove the core beliefs of the Catholic Church. He retained a number of Catholic doctrines, including celibacy of the clergy. He was just as harsh to those defying his statutes as he was to Catholics denying the King's supremacy. Being hanged, drawn and quartered was the grisly punishment.

These events heavily influenced the Reformation in Scotland. Henry was also attempting to influence Scotland away from its Auld Alliance with France as he was concerned about a French invasion through the back door of Scotland. In the 1540s he sought a treaty marrying his infant son Edward to Mary, Queen of Scots, daughter of James V of Scotland, also still an infant.

This treaty was opposed by Cardinal Beaton of the Archdiocese of St Andrews, the last Scottish Cardinal of the Catholic Church before the Reformation. He pursued the alliance with France and railed against Anglicisation of Scottish culture. He was also very afraid that James V might decide to appropriate monasteries in Scotland, just as Henry was doing.

Beaton was blamed for the war with England and a major defeat of the Scots army at Solway Moss. He was taken into custody and in his absence a marriage treaty, the Treaty of Greenwich, was set up between the infant Mary and Henry's son Prince Edward. However, Cardinal Beaton got back into power and tore up the treaty.

Henry's push for a marriage treaty and his rough treatment of Scottish merchants trading with France caused anger in Scotland. The Scottish Parliament

rejected the Treaty of Greenwich. All of this culminated in the 'Rough Wooing', a series of raids by Henry into Scotland. This led to young Mary being sent to Dunkeld for safety.

In May 1546, Cardinal Beaton was murdered in a plot led by Norman Leslie, master of Rothes. Beaton's mutilated corpse was hung from a castle window in Beaton's home, St Andrews Castle. This was soon after the burning at the stake in St Andrews of the Protestant preacher George Wishart. Wishart was instrumental in promoting the teachings of Calvin in Scotland. This burning probably precipitated the murder of Beaton.

However, with Beaton dead, the Protestant assassins were left besieged in the castle. For those who have visited the castle and seen the mine and countermine built from both sides by besiegers and besieged, this was the result of the conflict which lasted over eighteen months in 1546 and 1547.

When assistance for Scotland was sought from France, a naval force was sent and bombarded the castle from both land and sea. The Protestants were captured and sent to France as galley slaves or imprisoned. These included John Knox, who was acting as a preacher to the besieged Protestants.

Henry was none too pleased with Scotland going back on the original marriage treaty and sent an army which captured Leith and burned the Palace of Holyrood. France came to the rescue and sent a fleet to occupy Leith with 8,000 men. The English retreated and French influence, culture and trade arrived.

Meanwhile, the English army, which had been sent to assist the Protestants, arrived too late but did occupy a great deal of the south of Scotland, defeating the Scots at the Battle of Pinkie, near Musselburgh. It was at this time the Scottish Parliament refused to agree to terms and this was when Mary was spirited off to France, where she married the Dauphin of France, cementing the Auld Alliance. The defeat of the Scots was attributed by some to a lack of morale and a disorganised army. However, the growing belief in English religious policies was also a major factor.

The Reformation in Scotland and the Birth of the Church of Scotland

The Protestant Reformation was started by Martin Luther, John Calvin and others with the publication of Luther's *Ninety-Five Theses*. The Reformers protested the doctrines of the Roman Catholic Church, the pomp, the rituals and the leadership. While the south of Europe continued in the Catholic faith, the Protestant movement was adopted with enthusiasm in the north, with the exception of Ireland. The schisms resulted in warfare throughout central Europe and in Scotland, a lower level of violence, but nevertheless a complete reversal in the religious order.

The Reformation Parliament of 1560 passed the laws which laid the foundation of the Protestant church in Scotland as well as the denial of Papal authority. The establishment of the Church of Scotland was to have a major influence in influencing the establishment of Presbyterian churches worldwide.

It was John Knox who was to have the major role in establishing a Calvinistic approach to Protestantism. While he was exiled to Europe, the Reformation was gathering pace, promoted by nobles called the Lords of the Congregation.

Returning from exile in Geneva in 1559, supporters gathered round him and he joined forces with the Lords of the Congregation. In Perth, he delivered a fiery sermon which spurred his supporters on to violence against Catholicism. Such was his influence that his 'rascal multitude' began vandalising and destroying churches, particularly the idols, or statues, windows and relics which he railed against.

Mary of Guise, Queen of Scotland as wife of James V, and mother of Mary Queen of Scots, asked France for assistance against the wave of destruction. English forces met an entrenched French force at Leith. The French had been in possession there for twelve years, since the invitation in 1548. However, with the death of Mary of Guise in 1560, violence was at an end with a peace treaty, the Treaty of Edinburgh. The resulting negotiated settlement allowed for the right to summon a parliament, which effectively played into the hands of the Protestants.

The new government renounced the authority of the Pope and the propagation of the Catholic faith and celebrating mass was made illegal with severe penalties. Following ratification by Parliament in 1560, the first General Assembly of the Church of Scotland met in Edinburgh and the *First Book of Discipline* was published. These established the Calvinistic doctrine as the basis for the Scottish Protestant Church.

Following the death of her husband, King Francis, Mary was to return to Scotland in 1561, to a tense political situation, given that she was a practicing Catholic in a Calvinist country. Mary's short reign ended in disaster when she was captured and forced to abdicate in favour of her infant son, James VI. She was imprisoned in Loch Leven Castle while James Stewart, Early of Moray, was appointed Regent in place of her son.

Mary Queen of Scots' abdication from the throne was not popular with many Scots and when she escaped from Loch Leven Castle, it was welcomed by many. With an escort drawn from the Scottish nobility, she gathered a force of 6,000 in a very short time with the intention of entrenching herself at Dumbarton Castel to wait for reinforcements before mounting a challenge for the throne. However, at Langside, her forces, led by an inept Earl of Argyll, Archibald Campbell, were defeated by the Regent, Moray. She fled to England expecting her cousin, Elizabeth I, to help her regain the throne. However, she was put into protective custody by Elizabeth and eventually beheaded. Mary had made it clear that she had a claim to the throne of England and her intrigues finally persuaded Elizabeth to put an end to her.

Schism in the Church of Scotland

In 1584, James VI of Scotland re-introduced the system of rule by bishops (episcopacy) into the Church of Scotland in an effort to bring it as close as possible to the church system in England. Following him, his son Charles I was also keen to see the Church in Scotland develop along the lines of the Anglican Church. In 1637 he introduced a Book of Common Prayer intended to impose a regulation of the liturgy. This created

riots. A meeting of the General Assembly in 1638 rejected the rule of bishops and demanded that the Book of Common Prayer be abolished.

The 'established' Church of Scotland was in reality not very well established. While it was recognised by Parliament as the national church, there were serious divisions. The Church of Scotland had always claimed independent authority over its own affairs. This was re-affirmed by the Act of Union in 1707. But the Right of Patronage existed wherein wealthy patrons were able to appoint ministers of their own choice. This right had been restored in Scotland in 1712 despite the objections of the Church. While a conservative element of the General Assembly had not wanted any confrontation, a new, evangelical majority in 1834 passed a Veto Act which allowed parishioners to prevent the appointment of ministers nominated by patrons.

This brought both elements into conflict and produced a major schism in the Church. In 1843, 121 ministers left the Church of Scotland and set up the Free Church of Scotland. Eventually, 474 ministers moved over to the new Church.

This was not to be the end of it, as in 1900, most of the Free Church joined with another fragment, the United Presbyterian Church of Scotland, to form the United Free Church of Scotland. Those not joining carried on as the Free Church and still exist, commonly called the 'Wee Frees'.

In my home area of Anderston none of these divisions were of any interest to me as a boy, and I suppose I might have wondered why there were so many 'Proddy' churches. In fact, just off the top of my head I can count around thirty in the area from Central Station to Finnieston and from the Broomielaw to Kelvingrove Park. Many of these were abandoned or used as stores or workshops. We used to play inside one or two of them. These, of course, were churches set up by the various factions which died a death or were re-united. Some became too big for the congregations and were abandoned, contributing to the scenes of desolation in Anderston in the 1950s and 1960s.

Gaelic Churches

It was not till many years later that I was to learn that three of the churches that I mentioned were Gaelic churches of different denominations.

The huge industrial expansion in Glasgow, aided and abetted by harsh conditions in the rural economy, was attracting migrants, mainly from Ireland, the west Highlands and from Lanarkshire and Ayrshire. This influx of new Glaswegians dispersed throughout the city to work in the factories, the mills, the chemical works and in service. In the nature of immigrants, they met together where they could. A popular place for the Highlander was at the Central Station bridge over Argyle Street. This was to become known as 'The Hielanman's Umbrella'.

Hielanmen possibly met there after their church services at St Columba's Church of Scotland. 'The Highland Cathedral', dating back to 1770, backed onto Central Station until the station expansion, when it closed. With the proceeds of the sale to the Caledonian, a lovely new church in red sandstone was built in St Vincent Street, where it still stands and still provides services in Gaelic to the church community. Also, in

Gordon Street, there was the Free Church's Hope Street Gaelic Chapel, built to cater for those who had left the Church of Scotland.

Like Irish culture, the Gaelic language of the Highlands and Islands has diminished considerably over the past couple of centuries as English has become the predominant language. However, it is said that 10 per cent of Gaelic speakers reside in Glasgow. Over the past twenty or more years, there has been a resurgence of teaching of the language, particularly in primary schools and playgroups. The new growth of Gaelic culture, representing the music of the Highlands and Islands, as well as Ireland, is represented in the popular Celtic Connections winter festival in Glasgow which has become one of Glasgow's high spots.

Catholic Emancipation and a Split in the Church of Scotland

The return of the Catholic faith, or emancipation, began in Scotland following the death of James Francis Edward Stuart in 1766, with the process being formalised by the Roman Catholic Relief Act in 1829. This was precipitated by Irish Lawyer Daniel O'Connell. Bearing in mind that Ireland was then a part of the United Kingdom, O'Connell was barred from taking his seat in Parliament because he was a Catholic. He had won a by-election in Clare, defeating a sitting Anglican. While there was resistance to the idea of emancipation from many, the Prime Minister, the Duke of Wellington, Arthur Wellesley, and the Home Secretary, Sir Robert Peel, feared more that Ireland would erupt in revolution.

The Duke of Wellington was an ardent supporter of the bill and threatened to resign if it didn't receive Royal assent. When enacted, the bill repealed many of the restrictions on Catholics as well as the penalties for following the faith. Of course, a major one which was not repealed was the ban on Catholics taking the throne. This is still an issue and is raised often.

The hierarchy of the Roman Catholic Church in Scotland was re-established by Pope Leo XIII in 1878. In the nineteenth century, Catholicism was again on the rise, primarily because of mass Irish emigration due to the failure of the potato crop and subsequent famines in their own land. To a lesser extent, but still mostly Catholic, Italian, Polish, Lithuanian and other immigrants from Europe began to swell the numbers. Even more recently, traditionally Catholic peoples, Polish as well as Spanish, have been arriving in Scotland.

While there was Catholic emancipation in Scotland in law, this doesn't mean to say that there was general acceptance, because there was deep suspicion of the Irish immigrants. In 1923, the Church of Scotland produced a report which blamed the Irish Catholic immigrant population of undermining Presbyterian values and being the main cause of drunkenness and crime: *The Menace of the Irish Race to our Scottish Nationality*. John White, a leading churchman, went as far as to call for a racially pure Scotland, a term which was to have echoes in the forthcoming global conflict precipitated by such ideals in Nazi Germany. He also called for the ending of emigration by Irish Catholics to Scotland and the deportation of any convicted of

Christian Institute, Glasgow.

The Christian Institute, Bothwell Street. Besides over forty churches in the Anderston/Park area, there was also the Christian Institute, occupying an entire block. It was paid for by Rutherglen chemical magnate James White. It was demolished in 1974 and replaced by an office block. The Institute was part of the Young Men's Christian Association, who also ran an adjoining hostel.

a criminal offence or living on state benefits, sentiments which we have become so familiar with when applied to more recent refugees.

While this institutional racism began to subside, it was not until 1986 that the General Synod of the Church of Scotland expressly repudiated the report and in 1990 both Churches founded the Churches Together in Britain and Ireland to work together to fight sectarianism.

Beyond Catholics and Non-Catholics

Before we move on, we should perhaps recognise that religion in Scotland was never polarized, with Catholics and non-Catholics on either side. The Scottish Episcopal Church has always had a strong identity very different to the Presbyterian Church and, like the Catholic Church, can trace its origins back to the original church founded by St Ninian, St Columba, St Kentigern and the Bishops of Glasgow.

The story of the Jewish community in Glasgow probably started before 1190, possibly as refugees from anti-Jewish riots in England. It is a pleasant thing to say that, of all European countries there has never been any state persecution of the Jewish faith in Scotland. Most Jewish immigration appears to have been after the Act of Union and there is a record of the University of Glasgow's first Jewish graduate, Levi Myers, in 1787.

Following persecution in the Russian Empire, Jews settled in the Gorbals, many of them using Glasgow as a staging post to North America. Later on, of course, many Jews, fleeing Nazi persecution, settled in Scotland and Glasgow became the largest settlement, with many in East Renfrewshire. Glasgow has six synagogues.

Calderwood Lodge Jewish Primary School and Nursery is Scotland's only Jewish school, based in Newlands in the south side of Glasgow. It is run by East Renfrewshire Council.

The Glasgow Central Mosque of Islam is a place of tranquility not far from the centre of Glasgow, in the Gorbals. Built in 1983 in the traditional arabesque style with minaret, it is enclosed by gardens. The building combines Islamic architecture with the traditional red sandstone of Glasgow buildings. It can accommodate 2,500 worshippers and is generally open to all on Glasgow's Doors Open Day.

I well remember my father explaining to me, in the 1950s, who were the dark people in the long white shirts and white caps. He told me that these were 'lascars' from Asia. Round about the docks there were toilets as part of the warehouses which were signed 'Lascars only'. Segregation, but apparently more to do with prevention of diseases from abroad.

In 1903, the records of the Glasgow Sailor's Home show that about a third, or 5,500, of all boarders were Muslim 'lascars'. However, many of these may have been in transit and the vast majority of Muslims arrived as immigrants during the twentieth century. Some of these came as refugees from Uganda when the dictator Idi Amin expelled them from 1972.

Many Asians were welcomed and often worked as bus conductors and drivers. Even back in Anderson in early 1960, we made friends with an Asian who set up a little sweet shop in Argyle Street opposite our house. When I think back, no-one taught us to be intolerant of newcomers from other lands. But yes, we were very surprised when we met out first black people, in my case a dentist from Africa.

And of course, we very firmly welcomed those who set up the first 'Indian' restaurants, a misnomer as most of these were opened by immigrants from Pakistan or Bangladesh. These were to form the basis of a vibrant Muslim community in Glasgow. Very quickly the cuisine of the Indian subcontinent was taken to heart by Glaswegians, although 'Chinese' restaurants were not so far behind. The *Shish Mahal Cook Book* from the restaurant of the same name ranks high along with the famous *Glasgow Cookery Book* which originated in Glasgow's 'Do' School.

If you are new to Glasgow and you would like to know a bit more about our religious history, you could visit the award winning St Mungo Museum of Religious Life and Art, which is beside Glasgow Cathedral.

Bigotry

While there are now amicable relations between the Church institutions, this does not mean that there are such relationships between the followers. As we go into the twenty-first century, there is divided opinion about whether or not there is continuing religious intolerance. I am also hesitant about covering bigotry in a chapter about religion as I think it has more to do with tribalism than it has to do with defending or promoting individual faiths.

I am third generation Irish, a Catholic, born in Glasgow and, as I found out recently, I am eligible to hold an Irish passport. I doubt whether any of my contemporaries

whose grandparents or parents came from Ireland actually do or even know, or care, about their eligibility.

I don't understand bigotry and never did. Perhaps because of that I am not the person to explain religious and racial prejudice as I was brought up with amicable relations between Protestant, Catholic, Jew, Italian, Pole, and eventually Asian refugees from Africa, as well as economic migrants from the Indian subcontinent.

I grew up in Anderston, in a mixed community where those with Irish Catholic backgrounds generally co-existed with those from other areas, from the Highlands and Islands, from Ayrshire, from Poland, and even original Glaswegians, whoever they were.

Those Irish, like my grandparents, who arrived in Scotland generally accepted Scottish culture but were keen to preserve their own. After all, they still had family in Ireland and, for a time anyway, there would be travel back and forth. The Irish identity was precious and preserved within the family or wider community. Even the local newsagents would stock *Ireland's Own*, which would probably be bought along with the *Weekly News* or the *Sunday Post*.

We went to Catholic primary school and on to Catholic secondary school. We had a Catholic Scout troop while the non-Catholics went to Boys Brigade. We had a Catholic youth group. And of course we mainly supported Celtic. In that sense there was little overt prejudice against the Irish community, certainly not to the degree

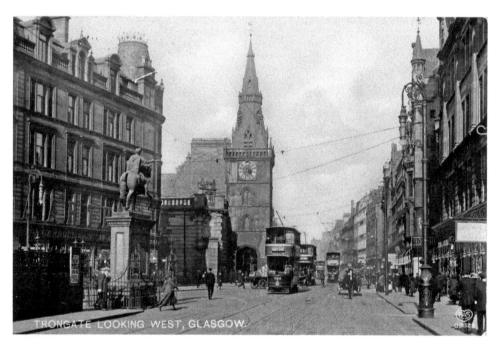

The statue of King William of Orange. Originally at the Trongate behind Glasgow Cross Station, the statue was moved in 1923 to the much quieter Cathedral Square at the top of the High Street, where it still stands. Although the story was that it was getting in the way of traffic, Glasgow Cross had become heavily populated by Irish immigrants and the statue was being constantly vandalised. The tail has a ball and socket joint and it sways in the wind.

experienced in Northern Ireland, although many would disagree with my analysis. I will come back to that in time.

Glasgow had become a merchant city and one of its first trading partners was Ireland. There had been a great deal of travel between the two countries and in many cases, shared myths and legends. In fact, given the difficulties in travelling on roads, the relationships between Ireland and the west of Scotland were extremely strong, with many people settling in the south-west even before the great potato famines. By 1840 there were many Irish living in Wigtownshire, Dumfriesshire, Kirkcudbright and Ayrshire.

While many stayed around the city centre and established parish churches like St Patrick, Anderston, and St Peter, Partick, many also moved out to other areas. Coatbridge by 1850 was almost 30 per cent Irish, with many working in the steel mills and iron works in the area. Dundee attracted many to work in its linen and jute factories. Many moved to Dumbartonshire, to the Turkey red factories along the River Leven, and made their homes in Bonhill, Alexandria, Renton and Jamestown.

Much of the bigotry in Glasgow and the west of Scotland relates to the relationships which some Scots have with the Loyal Orange Order, or Orange Lodge. The Lodge is a fraternal organisation which originated in Belfast in 1796 and celebrates King William III, who defeated the Catholic King James II at the Battle of the Boyne in 1690. Through the many past relationships between the west of Scotland and Northern Ireland, the Lodge has a strong presence in Glasgow.

It is a Protestant organisation which has been criticised by many as being sectarian and provocative, particularly during its 12 July Battle of the Boyne Celebrations. Much of this relates to parades passing close by Catholic churches, inflaming the sensibilities of Catholics. I would agree with a Presbyterian friend of mine who says that 'Few people would disagree with anyone who wishes to celebrate culture and history. It is the bigotry which accompanies some walks which is an embarrassment to our religion. It belongs to the past'.

There is a current debate whether there is still prejudice against Catholics in Scotland. Much of this centres on the bigotry surrounding the Glasgow Old Firm of Celtic and Rangers football games. The term '90-minute bigot' has been coined almost to apologise for the sectarian ranting that accompanies a small minority of the crowds. This is considered by many to be no excuse.

On 1 March 2012, the Scottish Government brought in the Offensive Behaviour at Football and Threatening Communications Act. The Act criminalises behaviour which is threatening, hateful or otherwise offensive at a regulated football match, including offensive singing or chanting. It also criminalises the communication of threats of serious violence and threats intended to incite religious hatred, whether sent through the post or posted on the internet. The Act will criminalise behaviour likely to lead to public disorder which expresses or incites hatred, is threatening, or is otherwise offensive to a reasonable person.

This seems sensible on the face of it although many see it as unworkable and difficult to police, particularly in the middle of a football match. There are others who say that the law is destroying football. Of course, as we saw in the chapter on sports, the Old Firm of Celtic and Rangers are now only a small part of Glasgow football and culture.

Much of the sectarian behaviour comes from and belongs to a past industrial Glasgow where Catholics or Protestants were routinely barred from workplaces and sectarianism brought violence to the football terraces.

Industrial Glasgow has gone and many of the barriers to equality of employment have gone too. Much of this is down to the professionalism in personnel practices brought in through employment laws and European legislation where hiring and firing is taken out of the hands of the foreman. In fact, the European Union has done more for Glasgow than anything in making it a welcome place to live. Open borders have allowed Europeans from many countries to live and work safely in Glasgow. I believe that through the laws above and simply through the integration of the new Glaswegians, it will be a more equal place to live.

I am glad to say that in modern Glasgow, those of a religious mind are free to pursue their own beliefs and customs. As in any society, past, present and anywhere, there will always sadly be a tribal minority which will pursue and harass 'different' people simply because they are different. That has always been the case and except for the shameful internment of all Glasgow Italians during the Second World War, they have always been welcome and make a significant contribution to Glasgow. Even here I am patronizing, as they are part of Glasgow's heritage and are Glaswegians. We are 'All Jock Tamson's Bairns', as we say in Scotland.

All welcome to the Scottish Fun Run in 2010. Scottish Sikhs to the forefront.

Cultural Poverty and Culture

We have already addressed the issue of poverty in Glasgow and some of the myths surrounding it. There was the poverty of overcrowded houses, the smoke and the grime of the industrial city. While we were brought up in the middle of this in the 1950s and 1960s, we had no conception of the word poverty. The school photographs earlier show that most people were actually well fed. We were as clean as we could be, with Corporation washhouses and swimming pools provided throughout the city.

There is also the poverty of the mind: lack of education, lack of opportunity, lack of culture and lack of security, lack of the opportunity to play. But you know, in 1950s Glasgow, there was none of that. We have already seen that education for all was provided and was excellent. The National Health Service was new and we felt safe and secure. We knew that the pandemics of the past were of the past.

When I think back to what was art and culture in Glasgow in the 1950s, what I remember were the long hours I spent at the Glasgow Art Gallery, the People's Palace, the Mitchell Library, the cinemas and the theatres. Add to this the regular music coming to us from the BBC through the school loudspeakers. We also had the school projector showing us such early documentaries as the *Night Mail* and the Walt Disney nature films.

We were rich in culture and it was free and open to all. I, and many of my friends, appreciated it. But culture was not just this. It was the opportunity to meet in the café, at youth clubs, at Scouts and Boys Brigade. It was the opportunity to play in the huge playground that was the City of Glasgow, with its many huge municipal parks as well as small play parks. It was watching the many parades – the Orange Walk, the May Day processions, the carnival parade and the switching on of Glasgow's famous Christmas lights.

That sounds like an idyllic and false picture and I suppose much of it was aspirational for many people stuck in the buildings still to be cleared. The fact is much of it was true but also, much of it evaporated during the 1960s and 1970s as a direct result of the Bruce Plan and the expansion of the city into housing 'schemes' that were, according to some, to become the new slums.

The fact is that the town planners did not understand the psychology and sociology of the groups of people they were forcing onto the outskirts with none of the support mechanisms and facilities that they were used to. Young people would have leadership

and role models in guide leaders and youth leaders, in boxing and other clubs. Yes – many people were poor. Incomes were low and conditions could be harsh. But many people were far poorer for moving to the schemes.

They moved to the outer reaches, with little money to make the often long journeys into town and while it may have lasted a while, it often tailed off as they got older. They were left in nice new houses in a sterile environment with little access to the cultural, sporting and other activities in which they were occupied. Other, less productive, activities filled the vacuum.

Glasgow was, and is, an industrial city, and it is to this we return to discover the origins of Glasgow as city of art for the people. For Glasgow can be marked among the best cities in Europe for its public art displayed in, and on, some of its great buildings. For even before becoming a Capital of Culture it was, in 1999, City of Architecture and Design.

It was Glasgow's industrialists who were behind the beautiful mansions, shops, offices and warehouses which were to be a feature of Glasgow's streets. In particular, over 300 sculptors were to be commissioned to produce some of Britain's finest sculptures and statues. I was lucky to have these pointed out to me as a young boy. It was only as I grew up that I began to appreciate the depth and extent of the work.

One of the greatest of them all was the firm of J. & G. Mossman, which produced sculpture for Charles Rennie Mackintosh, Alexander 'Greek' Thomson and J. J. Burnett's buildings. They also produced a considerable number of the magnificent monuments in the Glasgow Necropolis. John Mossman was the 'Father of Glasgow Sculpture'. The firm still exists, although its head office is now in Alloa.

The great industrialists wanted to make their mark on the world in something less grubby than exports and imports. This could be done by building impressive factories and warehouses and decorating them with sculpture. Templeton's carpet factory, 'The Doge's Palace', at Glasgow Green is a perfect example of this.

And it was industry and commerce which were behind the beautiful Kelvingrove Art Galleries and Museum. But before that there were the McLellan galleries in Sauchiehall Street, funded by Archibald McLellan, a partner in a coach-building business. McLellan was a patron of fine arts and a friend of many distinguished painters and sculptors in which he invested, building up a varied collection of fine arts, these to be the core of Glasgow's world-famous art collection when he bequeathed his collection of sculpture, paintings, gold and silver to the city. His patronage of the arts brought him into contact with many of the sculptors, musicians and artists of his day.

The McLellan Galleries were entered from Sauchiehall Street but were behind the famous Treron's department store. The building also housed the Glasgow School of Art from 1869 to 1899. The McLellan has housed many temporary exhibitions over the years. It is now being offered for lease as an arts venue and very recently, as a result of the Glasgow School of Art fire, housed the school's 2014 degree show.

The Kelvingrove Art Gallery and Museum, which became the home of Glasgow art and which is still enormously popular with the Glaswegian and the visitor, was

partly funded by the 1888 International Exhibition. It was to be built as the Palace of Arts for the 1901 Glasgow International Exhibition. The Spanish Baroque sandstone building heavily featured the architectural sculpture. One myth which surrounds the galleries is that it was built back-to-front and the architect committed suicide when he realised his mistake. Well actually, the galleries were always intended to point towards Kelvingrove Park, where most of the exhibition had been built.

While my best memories of the galleries were the vast number of ship models, representing the output of the shipyards, the galleries also host a huge collection of fine art, including Old Masters and Impressionists, as well as the Glasgow School. The ship models have now moved to the wonderful new Waterfront Museum, leaving space in the newly restored and enlarged Kelvingrove for the widest range of artworks as well as a world renowned collection of arms and armour.

The investment in culture of the City of Glasgow has been impressive and was rewarded by Glasgow becoming the European City of Culture in 1990. The Glasgow Art Gallery in Kelvingrove has recently been renovated and tastefully extended. It is truly wonderful and deserves its position as one of Europe's most visited attractions, much of this by Glaswegians. While the Kelvingrove Art Gallery and Museum was opened in 1901, in my youth and infancy it was dull and a bit intimidating to a wee boy like me but it was on my patch and therefore fair game for a visit. However, I do remember at the tender age of 12 or 13 being taken by the scruff of the neck by a blue-coated attendant and placed in the confines of an office till the police were called.

The Administrative Buildings, the Scottish Exhibition of History, Art and Industry, Glasgow 1911. The main reason for this exhibition was to raise money to endow chairs of Scottish History and Literature at the University of Glasgow. It stretched along Kelvin Way from Sauchiehall Street to Gibson Street. It had palaces of history, industry, fine arts and machinery. It also featured an aerial railway as high as 130 feet above the River Kelvin. Sauchiehall Street is in the background and the buildings still exist.

And all for going round and round the swinging doors. Who could resist? I was then ejected when it was felt that I had suffered enough. They obviously lied when they said the police had been called.

Anyway, exciting changes to the gallery started in 1952 with the exceedingly brave decision of Tom Honeyman to purchase Salvador Dali's painting *Christ of St John of the Cross* for the enormous sum of £8,200. This was to prove controversial because of its religious connotations and in 1961 it was attacked and damaged by a maniac. It was repaired and takes pride of place in its own special gallery.

Tom Honeyman was the Director of the Gallery at the time and was to bring to it a wealth of experience in the private art world as well as an adventurous spirit which didn't always sit well with his political masters at Glasgow Corporation. His friendship with Salvador Dali brought Glasgow not only the painting but the copyright and sales of the image have paid for the painting times over as well as being a huge draw to the galleries.

The Glasgow School

The Glasgow School was the collective name for circles of modern-thinking artists who flourished between the 1880s and 1910 and to whom we owe the Glasgow Style.

The Glasgow Boys is the collective name for a group of artists associated with Glasgow. In 2010 I was privileged to visit the Glasgow Boys exhibition at the Kelvingrove Art Gallery. That exhibition set a record of 120,000 visitors to an exhibition at the Gallery, surpassing the record set by a Van Gogh exhibition in 1948. It was the first major exhibition devoted to the Glasgow Boys and included works by George Henry, Joseph Crawhall, Arthur Melville, E. A. Hornell, James Guthrie and Edward Walton. Following the exhibition there is now a permanent Glasgow Boys collection.

The exhibition represents the best of this school, which was a loose-knit group of like-minded artists who were influenced by rural life and which produced some fine works mostly between 1880 and 1900. The group is important as it is seen as replacing the 'glue-pot school' of dark Victorian scenes of industrial life.

Less well-known was the group now called the Glasgow Girls, of around the same time. These were a group of Glasgow women artists and included Frances MacDonald, Margaret MacDonald and Jessie M. King. In 1990 Glasgow Art Gallery presented an exhibition: 'Glasgow Girls – Women in Art and Design 1880–1920'. The exhibition was truly wonderful and brought together the widest range of art, embroidery and silverware. It has given this important school a wider audience.

The 'Spook School' or 'The Four' were probably those who were to ensure the inclusion of the Glasgow School as part of the wider European Art Nouveau movement. These were painter Margaret MacDonald, MacDonald's husband Charles Rennie Mackintosh, her sister Frances MacDonald and Herbert McNair.

Fra Newberry had recently been appointed to the Glasgow Art School and he helped the four to put together an exhibition of metalwork panels, furniture and

silverware for an 1896 Arts and Crafts Exhibition in London. This was instrumental in their work eventually appearing in the influential *Studio* magazine. The title 'Spook School' came about as a dig at the ghostly images often portrayed. However, their 'Glasgow Rose' took root and was and is now used widely within the Glasgow Style.

The Glasgow School of Art may have become just another art school if it had not been for the appointment of the enormously creative Fra Newberry to the post of Director. For it was him who was to ensure that Charles Rennie Mackintosh was to be the designer of the new school, as well as encouraging The Four and other adventurous artists to develop new and creative styles.

Fra Newberry's influence was to build the school into one which is internationally known and respected. While there was a national curriculum, he encouraged a breadth of activities, partly through the establishment of an art club. But he also wanted quality in basic drawing skills and developed classes in embroidery and crafts in which the Glasgow Girls particularly excelled.

Charles Rennie Mackintosh

Charles Rennie Mackintosh was born in Parson Street in the Townhead. He took up work with the Honeyman & Keppie Scotland's architectural practice. His first project was the *Glasgow Herald* building, now The Lighthouse, Scotland's Centre for Design and Architecture. His most famous work is the Glasgow School of Art, completed between 1897 and 1909. The majority of his body of work was for private individuals, such as the publisher Walter Blackie's Hill House in Edinburgh.

While his output was relatively small architecturally, his building designs incorporated fixtures and fittings. This can be seen most effectively in the Glasgow School of Art, whose rooms were designed entirely by Mackintosh, with much of the original furniture on display or in use.

Mackintosh was before his time or perhaps Britain couldn't yet appreciate his vision and his body of architectural work was actually quite small. He had possibly intended to move to Vienna, where his work had previously been well accepted, but the outbreak of war prevented this. He moved with his wife Margaret to Walberswick in Suffolk, where he was arrested as a spy because he had been receiving letters from abroad!

Mackintosh couldn't establish himself as an architect at a time when the style was moving back to the Classical. He did receive some design work and a commission to redesign a house for the toy and model maker Wenman Joseph Basset-Lowke was his last architectural commission.

Mackintosh gave up any ideas of pursuing more architecture. He and Margaret left England for the south of France in 1923 and he devoted himself to painting the most wonderful watercolours. He died in London, of cancer, in 1928.

Mackintosh deserves to be acknowledged as the person most responsible for taking forward the Art Nouveau movement in Great Britain. The House for an Art Lover was built in Bellahouston Park in 1989, to the designs of Mackintosh and his wife

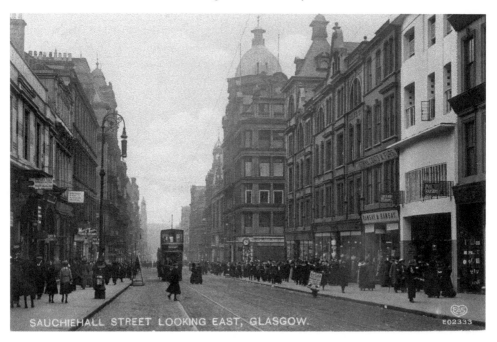

SAUCHIEHALL STREET LOOKING EAST, GLASGOW. E02333

Miss Cranston's Willow Tea Rooms stand out in stark contrast to the other dark buildings in Sauchiehall Street. Kate Cranston was an entrepreneur in the development of Glasgow tearooms. She was a patron of both Charles Rennie Mackintosh and Margaret MacDonald. The tearoom here is still in use, with many of the original fittings.

Margaret, and is a fitting tribute to them. The House is owned by a charitable trust set up to stimulate an interest in visual art. There is also a Mackintosh trail based in Port Vendres in France, where Mackintosh produced some of his best artwork.

The Burrell Collection

We already met Sir William Burrell in the story of merchant shipping. In 1944 Burrell gave away almost all of his art collection to the City of Glasgow along with a bequest of £250,000 to house it. Burrell was knighted in 1927 for services to art and the city. He died in 1958 and is buried in Largs.

It was again Tom Honeyman who was instrumental in attracting the bequest of Sir William to the city. With the very strict rules concerning where his great collection was to be shown, it was many years before Glasgow got round to building the excellent Burrell Gallery in Pollock Park, which opened in 1970. This is itself a great venue for exhibitions, where I saw the Van Gogh exhibition as well as just visiting what is one of Scotland's loveliest buildings.

It may also be of interest to you to know that Tom Honeyman was also involved in setting up the Scottish Tourist Board and, along with James Bridie, founded the Citizens Theatre.

The tendency is to overlook other Glasgow artists because they may not belong to the Glasgow School but there have been many others including Hanna Frank.

I am not entirely sure whether I had ever heard of Hannah Frank before I came across and bought one of her drawings around 1973. I certainly was aware of Charles Frank in the Saltmarket as I would often look at the expensive telescopes and binoculars in the shop window.

But it was in 1973, when I was in what was then called Arnott Simpsons in Buchanan Street, that I discovered Hannah Frank. I was home from university and hunting for a Christmas present for my parents. There, hanging in a row, were several Hannah Frank drawings and I was immediately taken by them, having difficulty choosing, but finally going for *Moon Ballet*. I was struck by their clear, fluid lines and by the balanced contrast of black against white. The drawing is still hanging in my parents' house.

Hannah Frank was born in Glasgow in 1908 to Russian émigré parents Charles and Miriam. Charles had been a mechanic and went on to open his famous shop at 67 Saltmarket. He sold and repaired photographic and scientific equipment. Hannah went to Strathbungo School, Albert Road Academy and then Glasgow University, where she graduated with an Arts degree in 1930.

It was when she was seventeen that Hannah started to produce her black and white drawings under the pen name 'Al Aaraaf'. Al Aaraaf is the title of a poem by

Moon Ballet.

Edgar Allan Poe and was the name given by the Danish Astronomer Tycho Brahe to a discovery in 1572 of supernova which appeared and grew brighter, only to suddenly disappear after a year and a half. It is also, in Arab lore, that place midway between heaven and hell where souls wait for God's forgiveness to proceed on.

Hannah took to sculpture in 1950, studying under Benno Schotz. She has exhibited her work in the Royal Academy, the Royal Scottish Academy and in the Royal Glasgow Institute of the Fine Arts. She continued to work up till the 1990s, when she moved into a Glasgow care home with her husband, where she died in 2008.

She was a member of the Glasgow Society of Women Artists, who have said that 'her work has been called the last link to Art Nouveau and the Arts and Crafts Movement'. Throughout her long life Hannah was an active member of the Glasgow Jewish Community.

Ian Hamilton Finlay was one of Scotland's great innovative and whimsical artists, known for his 'concrete poetry' and his sculptures. In 1990 he re-interpreted the columns of the first Central Station bridge as a work of public art. The quote is from Plato's *Republic* and a loose translation is: 'For all great things are perilous and beautiful things are hard.' I like to think that a more apt Glaswegian interpretation would be, 'It's a hard life if you don't weaken.' Without demeaning Finlay's classical bent, I would think that the latter might appeal to the Weegie.

Old Central Station bridge column.
'All greatness stands firm in the storm'

Opera and Ballet

In 2012, Scottish Opera celebrated its fiftieth year as Scotland's national opera company. Founded in 1962 by Sir Alexander Gibson, it moved into the Theatre Royal in Hope Street, which became Scotland's first opera house. While opera has had a name for being elitist, the Scottish National Orchestra is far from that, performing throughout Scotland in schools and village halls. In 2013, one of my highlights of the Belladrum Tartan Heart Festival was a small troupe from the Opera doing a condensed *Don Giovanni*. Marvellous.

The strange thing about Scottish Ballet is that it originated in Bristol as Western Theatre Ballet, which was founded by Elizabeth West and Peter Darrell. It moved to Glasgow as Scottish Theatre Ballet but changed to Scottish Ballet in 1974, moving into the Theatre Royal along with Scottish Opera in 1975.

Like the SNO, Scottish Ballet is truly a national organisation, performing throughout Scotland.

The Royal Conservatoire of Scotland

As we leave the history of Glasgow I would like to point you to one final institution which illustrates why Glasgow has been growing in importance in arts and culture, and why young people see it as the City of the future. We have already seen the importance of technical colleges, universities and the Art School to the city. The Institution is the Royal Conservatoire of Scotland. Glaswegians have previously known this as the Royal Scottish Academy of Music and Drama (RSAMD). Together with the Art School they provide a comprehensive education in music and the arts.

Just as a medical school emerged to compete with Glasgow University when it moved to Gilmorehill, so did the Glasgow Educational Association establish courses in 1845. This was to become part of the Glasgow Athenaeum in 1847. The Athenaeum provided courses in a number of disciplines including languages, mathematics and music. Charles Dickens opened the establishment in which he said that 'The Athenaeum set an educational example to the rest of Scotland.'

While parts of the Athanaeum were to go on to join Strathclyde University, the Glasgow Athenaeum School of Music became the Scottish National Academy of Music in 1929, becoming the Royal Scottish Academy of Music in 1944. A drama department was started in 1950 and was the first such to incorporate a television studio.

In 1993, the again renamed, RSAMD became the first drama and music college in Great Britain to grant its own degree awarding powers. In September 2011 the RSAMD became the Royal Conservatoire of Scotland. It now offers courses in digital film, ballet and drama as well as the technical subjects required of all those who manage the huge range of cultural events taking place in Scotland.

The list of the alumni of the Conservatoire gives a clue to its importance to Cultural Scotland and to Glasgow. These include; Jack Bruce of Cream, Dougie Vypond of Deacon Blue, Dennis Lawson (Local Hero), James McAvoy (Shameless), David Hayman, Allan Cumming, Tom Conti, Bill Paterson, Elaine C. Smith, David Tennant, Daniela Nardini, Ruby Wax, and many, many more.

A particular aspect of the Conservatoire is its outreach to schools, encouraging young people to see acting and music as a future, whether in employment, or just for the fun of it.

The 2014 Commonwealth Games were held in Glasgow from 23 July to 3 August. It was the largest combined sporting event in Scotland ever and hosted nearly 5,000 athletes from seventy-one nations.

The Commonwealth Games were not just about sport. While the core was sporting achievement, they nevertheless encompassed Glasgow culture, the Glaswegian spirit of fun and probably endurance.

It has been recognised as one of the best-organised games ever and much of this was down to the commitment of staff and volunteers. These latter, the Clyde-siders, gave up their time to help the hundreds of thousands of participants and visitors take full advantage of the games and this was well rewarded in the accolades received.

It has also left a wonderful legacy in the sports facilities provided or improved, the social housing converted from the Athletes' Village, the restoration of contaminated land, city improvements and new transport links. Above all, 88 per cent of Glaswegians believe that it has had a positive impact on the city.

Glasgow has embarked upon a vision of Glasgow in the next fifty years in the Future Glasgow City Vision. The games have surely provided a benchmark and a springboard for improvement of Greater Glasgow for our forthcoming generations of Glaswegians.